Isabel McLaughlin, *South Shore, Bermuda*, 1953
Oil on Canvas, 61 x 80.8 cm
The Robert McLaughlin Gallery, Oshawa.

*This book is dedicated to
Isabel McLaughlin,
whose support for the arts in
Canada has been life-long.*

Other Books by Joan Murray

The Beginning of Vision: The Drawings of Lawren S. Harris
(with Robert Fulford)

The Best Contemporary Canadian Art

The Best of the Group of Seven

The Best of Tom Thomson

Daffodils in Winter: The Life and Letters of Pegi Nicol MacLeod

Kurelek's Vision of Canada

The Last Buffalo: The Story of Frederick Arthur Verner

Letters Home: 1859-1906. The Letters of William Blair Bruce

Northern Lights: Masterpieces of Tom Thomson and the Group of Seven

Tom Thomson: The Last Spring

Tom Thomson: Design for a Canadian Hero

Home Truths: A National Album, from Paul Peel to Christopher Pratt
(forthcoming)

Confessions of a Curator

Confessions of a Curator
ADVENTURES IN CANADIAN ART

JOAN MURRAY

Dundurn Press
Toronto • Oxford

Editor: Doris Cowan
Designer: Sebastian Vasile
Printer: Best Book Manufacturers

Canadian Cataloguing in Publication Data

Main entry under title:

Murray, Joan
 Confessions of a curator: adventures in Canadian art

Includes index.
ISBN 1-55002-238-5

1. Art, Canadian. 2. Art museum curators – Canada. 3. Art museums – Canada. I. Title.

N6540.M87 1996 709'.71 C95-9311840-2

Publication was assisted by the **Canada Council**, the **Book Publishing Industry Development Program** of the **Department of Canadian Heritage**, and the **Ontario Arts Council**.

Care has been taken to trace the ownership of copyright material used in this book. The author and the publisher welcome any information enabling them to rectify any references or credit in subsequent editions.

Printed and bound in Canada

Dundurn Press
2181 Queen Street East
Suite 301
Toronto, Ontario, Canada
M4E 1E5

Dundurn Press
73 Lime Walk
Headington, Oxford
England
OX3 7AD

Dundurn Press
250 Sonwil Drive
Buffalo, NY
U.S.A. 14225

Contents

Preface

Provenance and Exhibition History

A new kind of consciousness has brought me to this exercise in autobiography. Postmodernism has meant, among many other things, the re-examination of the texts and discourse of our field, and the result has cast doubt on every aspect of the practice of art history in this country, including my own work.

My background set me on a direct course toward art. I grew up in New York in a home stuffed with art, apprenticed in Toronto at the Art Gallery of Ontario with Sybille Pantazzi, then became director of the Robert McLaughlin Gallery in Oshawa under the kindly eye of Isabel McLaughlin. Throughout my career I have tried to examine both the "birth certificate" of the Canadian work of art and the conscious intent of the artist. Now postmodernism had set me adrift as if the maker of my mental epic had asked a question in mid-movie, and I couldn't answer. Like the figures in Gauguin's famous painting, I was faced with questions: *Where are we going? What are we? Where do we come from?* There was a gap between my public commitment as a museum director and curator and my private inclination as a writer. I decided to examine my ambivalence, to question whether what drives me may not also drive the world in which I have spent so many happy years.

The profession is an unusual one. Many curators and art historians are in it by chance, stowaways who might have hap-

pened upon a ship bound for another destination but for some reason did not. We who direct museums are like directors of plays, for we put the artists on stage. We're like conductors of orchestras, but our players write the scores. The choice of how to create an art museum remains our own.

I believe that a great collection is its own reward. Since my early days in the ranks of curators I have helped to build two such collections, the first at the Art Gallery of Ontario, the second at the McLaughlin Gallery.

Some days, playing an old game, I ask myself, What kind of picture would I be, if I were a picture? Modern, I reply sadly, but, alas, no longer contemporary. Perhaps it is almost time for a conservation job. (But I am still on view, and I hope not to be de-accessioned.)

Joan Murray
Oshawa, 1996

Acknowledgements

Leslie Fiedler's *What Was Literature?* provided considerable inspiration for this book. Professor Fiedler sat on the jury that awarded me a Woodrow Wilson Fellowship in 1966; I thank him for his help, even though I only met him once. Robert Fulford has been kind enough to read some chapters, and offer suggestions. Linda McKnight, my agent, was helpful and hopeful. Many others responded to my questions; their help is acknowledged in the text.

My chapter on Harold Town is based on an article I wrote for the *Journal of Canadian Studies* in Spring 1991, "The Voice: Recollections of Harold Town"; the chapter on "Empowerment" on a lecture I gave for International Women's Day at McMaster University in Hamilton in 1992, entitled "Building Power: Canadian Women's Art." It appeared in *Artpost* in 1992. The chapter on *The West Wind* appeared in *Art Impressions* in 1995. Some of the contents also appeared, in different forms, in catalogues I have written for the Robert McLaughlin Gallery: I thank the trustees and staff for their patience with me.

Most of all I thank Isabel McLaughlin, the benefactor of the gallery and my friend, for the time she has spent on the project and her generous help. Without her timely aid, I could not have realized this book in its present form.

Geoff Butler, "*I think this art will be a good investment*", 1985, (detail) (*Art of War series*)
Alkyd on board, 22.9 x 30.5 cm
Private collection

Confessions of a Curator

Who Was Joan Murray?

◆⊰❊⊱◆

The American critic Leslie Fiedler, in *What Was Literature?*, his 1982 book on American culture, asked himself who he was. We thought we knew the answer. He was the supreme Freudian analyst of the American novel, a critic who broadened the range of literary studies to include America's half-hidden myths and legends. He was the man who gave us *Huckleberry Finn* as a homoerotic dream, and gave us arresting insights into books of apparently transient historical interest like *Uncle Tom's Cabin*.

I thought I knew Fiedler. I remember him because he sat on the Woodrow Wilson Fellowship jury in Toronto in 1965, the year I received a fellowship. A curious incident cast a strange light on our meeting. Just before my interview, I was glancing through a magazine in the waiting room, and I discovered between its pages a long analysis, by Fiedler, of one of the other candidates. The words jumped out at me: "I recommend this individual not receive the fellowship as he is sure to receive others." As I went into the room I handed the form to Fiedler, and put what was written on it out of my mind. When I heard that I had been awarded the fellowship, I wondered whether I had been given it because the jury thought I might not

receive any other. For this small but permanent self-doubt, I did not blame Fiedler. To me, he was always one of the leaders in the critical world.

With *What Was Literature?* Fiedler introduced us to quite another man, someone whose lifelong task had been to abolish the distinction between high and popular literature but who believed he had become a critic only by default. He had wanted to be a writer, he said, but had not made the grade. He had regrets. As a critic, he felt he wrote too much, too variously, and for too many sponsors. He answered the question about who he was in a wry manner, more like a genial philosopher than a scholar. He wrote as though in conversation – in a tone reminiscent, to me, of the man who had interviewed me for the fellowship.

The question Fiedler asked himself is of course the essential one, which must be asked in any stocktaking. I ask it now of myself. Who was Joan Murray? After more than twenty-five years in the gallery world curating shows of Canadian art, I ask myself, pretending I'm Fiedler, whether my profession perpetuates an unfortunate distinction, not between high culture and popular culture, but between Canadian and American art. That one is high and the other "low" is an idea based – perhaps – on the American art world's assumption that Canadian art is provincial. Americans (and many Canadians) believe that to be a real artist a Canadian must get a toehold in New York.

It is an odd notion, that a country's artists must achieve a reputation elsewhere, but the idea underlies the decisions of many curators in the larger institutions, and perhaps even decisions of the juries of the Canada Council and other granting agencies. The idea is never explicitly stated, but we in the field have learned to wonder about the artists who are preferred.

That artists are interesting *because* they are Canadian is an important idea for a scholar of Canadian art. I like to find proof of the individual's development in his home town – say, for instance, Paul Sloggett's development in Oshawa, where he went to the Robert

McLaughlin Gallery in 1971, saw an exhibition of loans from local collections, fell in love with a print by Richard Diebenkorn, and never looked back. He trained at the Ontario College of Art, formed friendships with a peer group that included many of the Young Turks, and is today an abstract painter, firmly rooted in the visual culture of his country and his region. His origin, his influences, and his work are all Canadian.

Joan Murray, unlike Sloggett, had a terrible secret. It was true that she grew up in Toronto and cut her teeth at the University of Toronto. She became an art historian because she liked the courses, and indeed, art history was one of the few areas in which she showed real talent, along with English language and literature. In her heart, like Fiedler, she had always wanted to write, though each year, as she determined to change her course, her English teachers persuaded her that fine art was an excellent preparation for a literary career. But what was Joan Murray's secret? That she was born American. She was a convert rather than someone born into the faith.

I've often been introduced as "our Joan Murray" when speaking in Canada on Canadian art, but I was born not at Toronto General, but at Presbyterian Hospital in New York City, the second child of Lucia de Castro Charlat, a former nurse, and Sidney Arnold Charlat, a dentist. When I was born they had just moved to an apartment on the West Side, the second in which they had lived: it had high ceilings, six elegant rooms, and a stunning view of the Hudson River.

I grew up in an unusual, culture-driven family, of a kind that was not as familiar to Americans as it is now. In 1939, a year after they married, my parents were introduced to antiques by a charming friend, the interior decorator Marcelle Hirsch (later, she became Marcelle Morgenthau, wife of Henry Morgenthau Jr., secretary of the treasury under Roosevelt). Marcelle and her first husband Stephen (a manufacturer of Lurex textiles) took them on a tour of the dealers. That day, they were reborn as collectors. Marcelle helped shape their taste as collectors as

From left to right:
Dr. Sidney Charlat, Carol Charlat, and Lucia Charlat, New York, 1942. Behind them on the wall is the eighteenth-century Venetian mirror that was my parents' first purchase from French & Co.

did George Basso de Breux, a dealer who loved fine Italian furniture. French & Company, when they discovered it later, also helped to form them. As a child, I played under French and Co.'s tables while my parents studied the stock, or went with them as they toured exhibits at the Metropolitan Museum of Art. They learned about works of art pragmatically, by buying them. They were deeply in love with the field of decorative arts, but they had sceptical minds, and they were choosy.

A museum was like a church, they believed. They were worshippers of art. Dad would vary the idea by saying that a museum visit was like "intimacy," and mother would chime in that it was as good as seeing a beautiful woman – for they loved beauty everywhere, even in the live specimen. They themselves were beautiful: Dad looked like movie director Vittorio de Sica; Mother had a perfect complexion, tiny figure, and vivacious ways from her French background. Their effect of glamour was part reality –

good bones and good health; and part art – grooming, and dress. "She looks beautiful," was Dad's constant refrain about Mother. Not "she is beautiful."

He himself always had enormous style, presence, and wit. One day in an art gallery the attendant at the desk by the door, struck by his dignified bearing, tweed jacket, grey pants, bow tie and matching silk pocket handkerchief, said, "Pardon me, sir, but haven't I seen your face somewhere before – you were on television today, weren't you?"

"Not today, dear," my father assured her.

Art was, like their personal beauty, their magic carpet; it transported them from monotonous routine to a fascinating world where they played at being king and queen. On the other hand, they owned the object, and through proper care, conservation, and research, "sharpened it up."

To collect for them was like going on holiday or to a party. They never knew what they were going to find as they made their weekly visit to the twenty-six dealers and auction houses they frequented, but they loved the objects and the gossip, and they always had fun. Yet their own description of what it meant to them to collect is evidence that what they did was mysterious even to them: they collected dreams, discovering desires impossible to fulfil in any other way.

At home, because the focus was on art, we spoke a specialized telegraphic language of centuries, descriptions, techniques, prices. On our weekly visits to the Metropolitan, my parents introduced us (my sisters Carol and Adele, and my brother Richard) to the infrastructure and apparatus of the museum. They were as interested in the labels, especially the donors of funds used for purchase, as in the work of art. As a result, their account, so lively and entertaining but filled with information, piqued our imagination, fashioning in our minds the places where such great objects had once found their home, and even suggesting to us the attitudes we could strike were we one day to act as guides. Choosing words carefully, as though giving a lecture, father would explain why the work was of interest – or why it was not. Then, turning to mother, he

would ask, as though seeking affirmation, a question I still ask myself, "What do you think?"

Mother, more volatile, was given to emphatic declarations. "I want it," she would say. Their favourite work at the Met was the handsome Western Asian *Head of a Ruler* from the late third millennium B.C., always on view in the Early Near Eastern hall. Its rich green colour came from many centuries of oxidizing copper. They loved the Islamic section. In 1975 Dad was named to the acquisition committee; and they studied every piece and understood each change a curator made to the display. Yet they were catholic in their taste; they liked many different periods and different styles, and as a result they collected with unusual breadth of taste. The only period they did not like was contemporary art; not much that was new pleased them.

Since they were observant, they helped develop our powers of observation. We developed an ability to judiciously infer from what was observed, then thoroughly analyse the result. They were discerning collectors, tastefully choosing and selecting. Even their children had been carefully chosen, we felt. They trained me. After I read *Kim*, I thought of him as a child who, like me, had to be taught to see. Father showed me how to recognize when an object was old and distinguish it from fake (Basso once had sold them a "wrong" table). Besides their collection, my parents' lives were filled with the visits of curators, dealers, collectors, and even directors of great institutions: James Rorimer, head of the Metropolitan Museum from 1954 to 1966, was a close friend and visited often. He was less a showman than a curator (yet it was he who purchased Rembrandt's masterful *Aristotle with a Bust of Homer*, painted in 1653, and so started the museum on its path as an attendance draw). I remember him looking, studying, talking about the medieval art in house. His favourite work of art, he told my father once, was a medieval carved wooden figure of an Apostle Saint of the Spanish school in the Cloisters Museum where he had once been a curator. Mitchell Samuels, the head of French & Co., was another constant visitor, who over dinner talked about art and auctions of

Courtesy of the author.

Top of the book case in the Charlat dining room, New York, 1982. Because of the number of objects, my parents' home recalled the open storage of some museums.

Courtesy of Carol Nace, Dallas, Texas.

Interior view, the Charlat Home, 1995.

Courtesy of Carol Nace, Dallas, Texas.

Interior view, the Charlat Home, 1995. The photograph at the right-hand side of the chest is of me in 1959.

the day. Gossip about museum and commercial gallery staff and their conflicts, prices, purchases – it never ended.

"After all these years, one thing I have learned is what makes a museum object," father would say as he slowly paced the apartment analysing his collection. Hopeful curators told him which ones their museums wanted, and he carefully recorded this and other kinds of information in the catalogue he and mother made. He applied his acute knowledge of the auction market, supplying detailed prices, currencies, percents charged by auctions, sales, "call-ins." Mother was intelligent and swift; she observed better. Together, accomplices in adventure, they made a formidable team. She checked one side of an antique dealer's gallery as he checked the other. They never stopped working at collecting; it was their way of living, an all-consuming obsession.

Through the years, father sold only a few objects. The collection was his life work, he felt. However, when he decided to sell an object he was delighted if it sold quickly at auction. Interest, bidding, these were signs that he had done the right thing in focusing so totally on ownership.

"The prices went to the sky," he liked to say when recounting recent auctions. Then he would add twenty-five percent to the cost of the work (15 percent for the house, $8\frac{1}{4}$ percent sales tax), and give a quick computation.

"What good is paper money, anyway?" he would finish by saying.

He liked to ask, as though looking for approval, "Have I ever mentioned money?" (Actually, he did, often.) What he meant was that he was without social pretension and this was perfectly true. He did not speak of lineage or family, only of the value of art. His office was one block from the gates of Columbia University, at Riverside Drive and 116th Street, so he met and befriended academics, people like the philosopher Jacques Barzun, metal expert Deson Sze, the Library of Congress head, Luther Evans. Yet his love for art was emotional, not intellectual. He had to fall in love with something before he bought it, he said, and he felt that it was love alone that drove him, love of beauty.

"I fell for it," he said when he bought an antique.

The objects that so charmed them were often small, and our home had a claustrophobic feel from so many tiny things crowded into the space. The scene was what I imagined Hadji Baba's cave to be: stuffed with treasure. Tables were covered with groupings of silver snuff boxes, spoons and miniatures, window sills with chests, the beds with layers of carpets, shelves with dishes, vases, African containers, old dolls. Walls were covered by Oriental screens, Islamic and Indian miniatures, Islamic tiles and dishes, Victorian needlepoint, paintings and etchings (these they bought for the frames rather than for the artist, as they mistrusted paintings – too much conservation, they felt), antique mirrors. My parents also hung pastels and paintings by my older sister Carol, who had attended the Art Students' League in New York and become a professional artist, and by my younger brother Richard and little sister Adele, who had gone to the same school but remained talented amateurs.

We were never treated much like children, or as children are supposed to be treated. We were treated like connoisseurs-to-be or the cheering section of the galleries. An article by Jared Diamond in *The New York Review of Books* about biologist Edward O. Wilson discusses the physiological and sensory apparatus that influences what we are capable of doing well and what fits our self-image. Wilson had a fishing accident which left his right eye permanently blind and his hearing impaired; yet he retained acute near vision, and as a result it suited him to study ants. Diamond also points out that ornithologists, like himself, share acute far-distance vision and memory of sounds, and tend to be quick-moving people with the high metabolic rates of birds. Zoologists, on the other hand, he says, are notorious for being slow-moving, fond of the hot sun, and rising late, like the reptiles they study. Then he stops the flow of his conjecture to say, "This all may sound naive and silly."

However, when I reflect on my parents, I wonder if there is an application of this train of thought. They did not study living things, but objects. Father's gift for this

work was a special kind of retentive memory: he could store and recall at will accurate images from books, magazines and catalogues, and he kept this faculty acute through constant practice. Mother, with her sharp eyes, helped him. Theirs was a shared game, an expression of their love, something at which they worked as a team: and they worked hard. The journey was what counted most for them, but once they had acquired the things they sought, they treated them like surrogate children, to be admired and handled, repaired if they had been damaged, then placed properly, and always kept clean and safe. Yet, for all the pleasure they took in collecting, they never seemed happy. After I read Freud I understood them better. He explains in "Inhibitions, Symptoms and Anxiety" (1926) that the restriction of an ego function leads to inhibition but at the same time to increased eroticism, which is expressed through substitutes. These can be much reduced, displaced and inhibited – but cannot provide lasting satisfaction. "When the substitutive impulse is carried out there is no sensation of pleasure; its carrying out has, instead, the quality of a compulsion."

We did not have a particularly happy childhood. We too, were their acquisitions. Like objects put on a shelf and forgotten or brought out to be admired, we were, our parents believed, theirs, their possessions. We were to excite admiration in which they could bask, and to that end be beautiful and accomplished. Beauty was the point, not good marks in school, particularly for the girls. No one ever guided us much in any other matter. As a result, our experience was limited in scope, though not in intensity. René Gimpel, in his *Diary of an Art Dealer*, observed that the daughters of antique dealers were called corner cupboards because, like those awkward pieces of furniture, they were hard to place. Because of my upbringing, so sophisticated yet so restricted, I felt like a misfit.

Mine was certainly not the childhood recounted by Hollywood movies. We did not play: I kept my dolls neatly, preserving them, in much the same way as my parents preserved their antiques. We did not participate in sports

although we ran and roller-skated through nearby Straus Park (named for Isidora and Ida, who had lost their lives in the Titanic disaster. "In their death they were not divided" read the deeply cut words on the cement wall of a lengthy seat and fountain in their memory in the park). We played at art: one game, at which my father excelled, involved identifying pictures from across the room.

My early memories are of art or of being in museums. For me they were not dusty mausoleums but places of drama. My parents were always friendly with guards, who allowed them unusual access: they could stay late or even be unguarded in the galleries. Once when we were the last of the stragglers to be escorted out of the Met at closing time, I saw a mysterious scene, which I treasured for years after. We were walking through the large galleries of the Egyptian section. Most of the lights had been turned off, and in the dim illumination, the colossal granite temple guardians and a nearby sarcophagus took on awesome dimensions and an air of mysterious grandeur.

In my imagination, I became an intrepid explorer. I explored museums. I haunted the Met, my parents' favourite place. I studied the medieval champlevé enamel and Romanesque ivory, and although my study was a visual one, I can still form a mental picture of the cells that hold the enamel. At the Museum of Modern Art, where I took Saturday morning art classes, I stalked the halls, stopping to stare in fascination at the full moon and the gently lifted tuft on the tip of the lion's tail in Henri Rousseau's *The Sleeping Gypsy*. I studied the wonderfully conserved *The City Rises* by Umberto Boccioni, trying and always failing to find any trace of the damage suffered when it was burned in the 1958 museum fire. I gazed intently at Mondrian's sprightly *Broadway Boogie-Woogie*, wondering about the brilliant night spectacle of Manhattan, which I had only rarely seen at night. On the staircase was Oskar Schlemmer's *Bauhaus Stairway*: it was a landmark of my youth, and it still hangs on a stairwell in the museum today, although not the same one. Sadly, another landmark, Picasso's *Guernica*, is no longer there, but Meret Oppenheim's fur-lined teacup, saucer and spoon are still on view.

From left to right:
Lucia Charlat, Sidney Charlat, and Joan Murray, Toronto, 1978. On visits to Toronto, the Charlats enjoyed looking at collections of Canadian art.

Courtesy of the author.

The galleries of these museums were less crowded, but viewers had the same reverent attitude. Noises were the same — the gently echoing, shushing footfalls of visitors in ones and twos: tours were rarer. Movies were free at the Museum of Modern Art, and I watched one, or part of one, every time I came, with the result that I hanker for classic movies even yet. *The Family of Man*, the 1955 exhibition of photographs, taught us to love what until then we'd thought only appropriate for *Life* magazine.

My main goal as a child was to grow up. I can recall being about six and looking up to a mirror in the front hall, wanting to look into it. But I was too small. The idea of being grown up was somehow intensely desirable. So was collecting, which was what grown-ups did. Years later, when I met an old classmate from Hunter College Elementary School, Julie Winter, she said I was the most mature sixth-grader she had ever known.

I read a lot, starting on the library at 102nd Street near our house. I was interested in the classical world, particularly the Spartans – they started me on a course of self-discipline. Venturing farther, I investigated the Donnell Memorial Library, opposite the Museum of Modern Art. Here, I determined to read my way through fiction, beginning with "A." I discovered Sholom Aleichem, then H. E. Bates. Yet my maturity was very unevenly distributed. I only spent a short time in nature, a few autumn afternoons in Scarsdale, near the city, visiting with cousins (we threw a ball, I remember, something rare for us), a few weeks at Girl Scout camp in Upper New York State.

When I was fifteen, I rebelled. I had been writing to a friend in Canada, whom I had met on holiday in Bermuda (he was twenty-eight; I had told him I was twenty-four). When he wrote proposing that I come to Toronto and marry him, I decided life as my parents' collectible artefact was no longer bearable. I would escape! I did (and we are still married!).

When I moved to Canada, I entered an entirely different life. I was astonished at the luxury. People owned *houses* here, not just apartments. They had gardens of their own, not wooden cream-cheese cartons set outside on the window sill with cut-off carrot tops tucked in the soil. Too embarrassed to be married and attend the end of high school, I completed grade thirteen at Cantab College, a cram school, then took a degree in Honours Fine Arts at the University of Toronto.

My childhood preoccupations had a way of showing up in surprising ways in later years. One day at university, a professor gave us a mystery slide on the medieval exam. When I saw the rich blue image, I knew at once that it was the stained glass of Chartres Cathedral, though I didn't know exactly *how* I knew. I must have seen it somewhere, perhaps in a book or an art magazine, my parents had piles of them in their back hall, and something had stayed in my memory. Yet that my eyes could remember something I had not consciously seen was a trick I had known in only one person: my father.

CANADIAN ART HISTORY IS BORN

Thirty years ago Sybille Pantazzi, the librarian of the Art Gallery of Ontario, liked to announce imperiously that she would never read articles on Canadian art. Only European art was worth the attention of serious scholars. But even then, perspectives on Canadian art history were changing. At the AGO, the slow accumulation of gifts, which eventually built the Canadian collection into one of the most important in the country, was gathering momentum. By my time there, in the late 1960s, holdings in Canadian art had grown into a huge terrain that demanded to be charted.

Sybille's was the typical European's view of Canada's artists (she had come to Canada from Romania in 1947), but such ideas were beginning to fade. Sybille herself was a good example. Even as she made her announcement, she had begun to prepare articles on specialized aspects of Canadian art. The one she wrote on the graphic art of the Group of Seven is still the standard in the field.

In the mid-1960s a new generation was emerging from the universities. At the University of Toronto, I took the usual fine art courses, from medieval to modern. On Canadian art, in 1964, we only had one week of lectures, given by Stephen Vickers. He made much of how the Group of Seven created art out of the country's geography, its ice and snow. I remember that he said an early Thomson sketch recalled Corot – and, like Corot, was lacking in

Sybille Pantazzi, Art Gallery of Ontario, Toronto. Sybille could be daunting, although she meant to amuse.

structure. Yet even that glimpse of Thomson and the Group of Seven was tantalizing. The subject needed thorough examination – and luckily for us, my class had a professor who was as interested as we were in undertaking it. Scott Symons, later well known as a novelist, gave his lectures at the Canadiana Gallery, where he was the curator. The University of Toronto was affiliated with the Royal Ontario Museum, and the Fine Art Department had come up with the idea that the ROM curators should give courses.

One of Symons's great loves was Canadian decorative art, and his enthusiasm was contagious. I remember one lecture in particular: a long, vivid talk about the early Quebec censer, the incense-holder, which is swung on a chain. He showed us a great maple refectory table he had lent the gallery, and spoke lovingly of the early Quebec masters such as Joseph Légaré. It did not harm our image of him when we heard that he had suddenly left the gallery, abandoning his museum career to elope with his lover – and to write.

One other teacher inspired us: J. Russell Harper, the greying, avuncular scholar whose carefully trimmed white moustache and short beard, just concealing his full chin, made him look like a burgher from a painting by Frans Hals. Harper must unconsciously have recognized the appropriateness; he played on it, stroking his beard as he thought. Perhaps he felt like the men in those civic portraits, men who took politics and the welfare of the people to heart. Harper certainly believed he was upholding similar principles for Canadian art. Like such civic-minded folk, he spoke simply, so that he could always be understood; but with a certain gruffness and a slight hesitancy to his speech, as though somehow you should already know the answer and he was only confirming it. (I was always afraid I wouldn't know it.) "I have no use for sham of any kind," he said to me.

He had been a curator at many institutions with great Canadian collections, such as the Beaverbrook Art Gallery in Fredericton, the National Gallery of Canada in Ottawa, and the McCord Museum in Montreal. In Toronto, he had been cataloguer at the Canadiana Gallery, working with the collection formed by F. St. George Spendlove. The number of jobs Harper held reflected his belief that a curator should only stay in a job for three or four years, long enough to learn the collection, before moving on. In all

the places he worked he kept detailed notes on the works of art he had seen. In 1965, on a year's leave of absence from the National Gallery, he turned these notes into his monumental *Painting in Canada: A History*, a book still in use. We learned from it that the Canadianness of Canadian art lay in its subject matter, and that Canada, however isolated, however small or poor the community,

Courtesy of the author

Russell Harper, 1980; he holds his chin in a characteristic gesture.

had always supported its artists. It gave us names, a structure, 300 biographies, a bibliography, and most important, 378 illustrations, 72 of them in full colour, to study. Along with the handy catalogue from the National Gallery of Canada – the Canadian School, reprinted in 1967 – it became our bible. Harper had broken the trail of Canadian art historical writing.

This pioneer never wrote for money. He told me that once, long after 1971, when he had published *Paul Kane's Frontier*, he had turned up a number of deluxe editions that had been forgotten in a cupboard. He gladly sold them at a profit. He had hardly ever made any money from his books, as he told me, since most of them had been written when he worked for an institution. "God, I'd have starved or be in my grave if I'd counted on royalties from books to ever keep me," he said.

In 1980 I saw him in Alexandria, Ontario, near Montreal. On that visit he told me that as he wrote he always tried to remember his neighbours in Caledonia (the small town south of Hamilton where he was born in 1914) and to write in a way they would understand. His desk was set before a window. On the ledge, along with three plants, a clock and some greeting cards, one of which had a detail of angels from a Flemish painting, were small works of folk art: a fox carved in wood, four birds perched on a branch. He liked to handle them to remind himself of the audience to whom he was speaking.

Harper believed that folk art – or the vernacular, as he called it, ordinary speech for everyday people – was as legitimate (to use his word) in its own way as a Michelangelo drawing. Folk art said something about people, especially those in the immediate community. For Harper a good work of art was a manifestation of the spirit of people who were trying to talk about the world around them.

His interest in Canadian art was awakened early. He recalled that one rainy Sunday afternoon when he was eight, he read about Tom Thomson. In 1936 or 1937, at McMaster University in Hamilton, he studied fine art with Stanley Hart, the Ontario regional editor for the newly founded *Maritime Art* magazine, which later became *Canadian Art*. One year of university was all he could afford. Then, hard up, he went to Toronto to get a job. He found work as a private secretary to a legal firm that worked

for the Ontario government. He lived on Grenville Street, then Toronto's artistic "village," in a house where Manley Macdonald and eventually F. H. Varley had their studios; down the street lived folk singer Wade Hemsworth. In the years from 1939 to 1940, he studied at night at the Ontario College of Art with Franklin

Courtesy of the author

The window over the desk in Russell Harper's study, Alexandria, Ontario. Note the folk art on the sill of his window; he liked to look at it to remind himself of his audience.

Carmichael, who taught engraving – he found his teacher's perfectionism marvellous to watch – and with painters such as J.W. Beatty and F.S. Challener. Big, tough Beatty, who wanted students to use a bright post-impressionist palette, believed the bane of his existence to be black paint. He would, if he found it in a paint box, take it out and fire it at the wall. As a result, the walls, ceiling, and floor of his room at the college were covered with paint splatters. Harper went sketching on Saturdays with John Alfsen. They'd travel the open countryside around Toronto, to places like Meadowvale, then green pasture, or to the Forks of the Credit.

In the Second World War, Harper served in the air force. Afterwards, with other returning veterans, he drifted into university. About 1945 or 1946 he decided to go to the University of Toronto. Upon meeting Homer Thompson, the head of the Department of Art and Archaeology, who was excavating the Agora at Athens, he decided to study with him. By the late 1940s, he was digging with Kenneth E. Kidd at Rice Lake, where in a native gravesite he discovered the first pre-European silver objects – beads and a knife – ever found in Canada. He also excavated Indian graves in New Brunswick at the mouth of the St. John River. At the time, these red paint burials were the oldest human remnants ever found in the Maritimes. While in St. John, he excavated Fort Latour, an early French fort of the 1630s, then worked at Louisbourg, where he was the first to be placed in charge of the excavation of the great fortress.

At the University of Toronto, Harper studied with Northrop Frye. Frye gave him insight into philosophy, and something philosophic always tempered Harper's outlook. His view of history was all-encompassing: everything – art history, society and philosophy – was seen existing in an inter-related world. Art, he believed, particularly in a pioneer society like his great-grandfather's in Caledonia, had more meaning as a social phenomenon. In his work, he liked to analyse changing times, thoughts, and production (by this he meant art). His art and archaeology studies had included a course on American art, with four lectures from Stephen Vickers on Canadian art tacked on at the end– presumably the same ones I heard in 1964. As with me, the subject quickly became the focus of his interest. In his master's thesis, with the

help of the first curator, Yvonne Hagenbrook, he catalogued in detail the collection at Hart House at the University of Toronto. Part of his thesis was published as *Canadian Paintings of Hart House* (1955). It was after this that he became chief cataloguer at the Royal Ontario Museum.

In Paris in 1957 on a trip, Harper met Lord Beaverbrook. The two brisk, matter-of-fact men hit it off, and for the next two years Harper travelled around the world as part of his entourage. His duties were varied; they might involve accompanying Beaverbrook on his morning walk, or, in Fredericton, helping to move his collection into the art gallery. In Monte Carlo, Harper met his spiritual opposite, Jean Cocteau. He didn't like him much and later used one of his favourite critical words to describe him – he called him "mundane." Harper said Cocteau said mundane things polished to a glittery surface. He could have added – but didn't – that it was opposite to his own way of speaking.

Beaverbrook, who had long dreamt of setting up an archive of great moments in New Brunswick history, offered Harper his first job as an archivist, and so, on his return from Europe, Harper made his home in Saint John. For four years, he worked at the New Brunswick Museum, looking after the Gagnon room which had archival papers and some early paintings, and preparing his second book, *A Historical Directory of New Brunswick Newspapers and Periodicals* (1961).

His next job took him to Ottawa where he had been hired to be in charge of the historic archives of the National Museum of Canada, but since in its budget the administration forgot to include a salary for him, he became curator of Canadian Art at the National Gallery of Canada from 1960 to 1963. When he arrived at the gallery, he found only one other individual on the staff working on Canadian art – Donald Buchanan. Harper later recalled how hard of hearing Buchanan was. He wore a hearing aid and would turn it off if he was bored, but he knew "good pictures" – he had an eye.

Harper always gloried in the memory of his four years at the gallery. He went to one Biennial in Venice, spent three weeks in Paris with Riopelle, and went to Brussels to see his paintings. After the state banquet that opened the show, at which Alberto

Giacometti was awarded the grand prize, he went to the opera with Louise Nevelson. After the opera he, Nevelson, and Riopelle went for a walk in the great square in front of St. Mark's Cathedral. There had been a shower, and the chairs for passersby were empty because they were wet. Only one person was sitting there – Giacometti. Harper later told of being haunted by the memory of the artist sitting by himself, thinking; shortly after that day, Giacometti died of cancer.

Following his own rule, he moved on after learning the collection. Harper went in 1966 to the McCord Museum in Montreal as chief curator, then in 1967 (and from then until 1979), taught at Concordia University (with time out in 1974 for a six-month stint at the Art Gallery of Ontario.) By now he was assembling all of the notes he had taken since the late 1940s into comprehensive books. In Montreal, he wrote *Notman: Portrait of a Period* (1967), *Early Painters and Engravers in Canada* (1970), and his Kane book, which included a *catalogue raisonné* of Kane's work and was accompanied by a show at the National Gallery. At the same time, he geared up for a show in 1973 of folk art, *A People's Art*, at the National Gallery of Canada. In 1976, he published a small book, *William G. R. Hind (1833-1889),* and in 1979, a major book on Krieghoff, with a chapter on misattributions and a provisional list towards a *catalogue raisonné.*

Harper's concentration on early painters and folk art reflected his origins, and the way he wanted to look at art in his life. He wanted to be Everyman's art historian, to introduce his subject to a broad general audience. "I write simple things that everybody can understand," he said to me. To this end, he tried to write well – informatively, accurately, simply, but vivaciously, and with appropriately applied colour. He showed me how he did it: he used descriptive language, a lively quote. "It's much easier to write an interesting narrative, and sometimes push in a truth," he said. At the same time, he applied the grand scale of his hero, Sir Kenneth Clark. "I don't want to be too low-brow," he said, but he admitted, "I do like his writing."

Harper's Achilles heel was that he never much liked modern art. I remember one time when he visited the Art Gallery of Ontario, I asked his advice about a Tom Hodgson collage I was

considering purchasing. Upon catching sight of it he gave a snort, then turned away, disgusted. Bemused, I wondered what I had done wrong until the registrar, Charles McFaddin, explained to me that Harper hated modern art. Later, he told me that he found much of it not relevant. Much modern figure painting was "mundane" (that word again) and bad, he felt, although with his attachment to a faithful record, he did occasionally find sympathetic the painting of Alex Colville and Ken Danby. He carefully qualified even this conservative view: he liked only the odd Danby painting, and Colville always gave him an uneasy feeling. As Harper said of himself, he was a simple person with curious overtones.

When I spoke to him in 1980, he was thinking of doing a book that would combine art with philosophy, religion and social life, but had only just started. He told me that it took him a long while to write: he always reworked his material at least six times. By 1978, as I heard later from his editor at the University of Toronto Press, he had become more interested in research than in writing. He brought in the Krieghoff book as a pile of notes. "You do the writing," he said. "You're the editor."

I'd heard from people in the field that Harper always brought up his health. "He has a bad heart, he says," they told me, implying that he was a hypochondriac. When I visited him, he mentioned that his health was poor. The doctor had given him orders to lose weight. When his wife gave us tuna sandwiches for lunch, he poked at his, disappointed.

"Is that all?" he turned and asked her. Then he turned to me and said, "They starve you to death ..."

In 1983 I heard that he was ill, and I phoned him. His wife answered, but when he heard that it was me, he came to the phone. When I asked how he was, he said, softly, in his gruff voice, "They say my heart is bad." Three days later, I heard that he was dead.

With such inspiration as Symons and Harper's *Painting in Canada*, it is no wonder that both Dennis Reid and I were soon to hold similar positions. From 1967, he was the curator of Canadian art at the National Gallery of Canada. I, in 1970, was appointed to the same position at the Art Gallery of Ontario – the first of its kind at the AGO. When I was hired I was told that the position

had been created to combat the loss of gifts in the Canadian area to Robert McMichael, who was then building up his gallery in Kleinburg. No mention was made of exploring the rich existing collection of the gallery. Yet this is the thought that occurred to me as I familiarized myself with the material in the vaults. The same idea had occurred, of course, to Reid.

He chose to work on the Group of Seven, and brought the fruit of his research to light in two of his first shows. In 1970, he re-created the original Group of Seven's show in 1920 at the Art Gallery of Toronto; then he organized a major show and catalogue about the Group of Seven at his gallery. For my part, I decided to study Tom Thomson, and worked towards a major retrospective of the painter, *The Art of Tom Thomson*, which opened in 1971. I began a Thomson *catalogue raisonné*, on which I am still at work.

Thomson seemed to me of particular interest because I felt that in him lay the seeds of a national genius, beneath a thin varnish of imported European style. Previous writers had portrayed him as a mythic figure, a natural man of the wilderness, but I tried to add substance to his life as an artist and to the meaning of his art. He seemed to me an artist who, cued by a boyhood dream, translated the dynamic phrases of the painters of his group into enduring design.

From that moment, in any case, Reid and I both worked to add to the existing model of Canadian art history and culture, challenging all curators with gallery collections to come to their defence – and appealing, specifically, to individuals like ourselves to whom the past as seen in their vaults was reassuring, and the future difficult to assess. Moreover, whatever has become of us in our institutional life (Reid, in 1979, moved to the Art Gallery of Ontario; I, in 1974, to the Robert McLaughlin Gallery in Oshawa), we have stood by our original commitment to this day. We have been joined by other voices, such as Charles C. Hill, who became the National Gallery's curator of Canadian art in 1979, and has examined the Group of Seven anew for a major retrospective at the gallery in 1995.

In those early days, when "Canadian art" was a synonym for boredom, I hoped to develop an image of Canada as an important haven for modern art. I viewed my subject, and especially Thomson, as the context in which Abstract Expressionism devel-

oped at mid-century. Thomson's abstract experiments were essentially Canadian, I said, and I related his work to later ideals in art.

Almost all of Thomson's ventures into some form of early modernism were made in 1915 and 1916, on small sketches he painted during the autumn, sometimes on the back of other works. His imagination was slowly evolving towards a major step in his large canvases, but he died before he could realize his vision. He was an artist whose work simultaneously pleased both those who love the landscape of Canada and those who love abstract art.

For the next twenty years, I watched Thomson's art ascend in value, while the public saw him as the fulfilment of a populist dream. His art was so well liked that it was soon mass-produced and mass-marketed, appearing in reproduction in prints and on T-shirts, placemats, and watches. Somehow, his work revealed a deep truth about what we aspired to become. We should look at the ubiquitous reproductions of his painting in the context of other "pop" products, such as Superman and Wonder Woman: it was as popular in Canada as similar art products from American culture, such as Roy Lichtenstein's comic-book subjects reproduced on T-shirts by American museums. Canadians have learned to see it as our own myth, embodying the wilderness as understood by a youth born in a small town. Thomson's art is our pop culture. His story echoes ancient mythology: he went into the wilderness, he painted, he mysteriously died.

Thomson's life in nature sent later artists on a migration into the woods. It all began with *The West Wind*: it released a dream. It was Thomson's influence when, in the 1930s, Pegi Nicol MacLeod painted trees by a lake near Ottawa, or today when Rae Johnson paints the dawn near Flesherton. This is one of the points at which our authentic painting school can be said to have begun. A dialogue with Thomson continues among artists to this very day.

In 1994, some of the most interesting work influenced by Thomson is in the painting of David Alexander of Saskatoon. It borrows his experimental technique, but the final result extends the possibilities of the form. Above all, Alexander has absorbed Thomson's sense of rapture before nature. His is the properly reverential, simple and passionate attitude of those who look seriously at our threatened environment.

"Humph," "Pshaw," Russell Harper might have said if I tried this idea on him. Or would the burgher of Caledonia react sympathetically to this clear manifestation of the favour of the Canadian people, which ranges so widely, from – to use his word – the vernacular? Today, the use of the words "Tom Thomson" has come to be synonymous with "true patriot love." Russell Harper, you live again.

O Canada!

I became interested in Canadian art only while in graduate school in New York City, at Columbia University, where I had gone on the fellowship Fiedler had helped me win. At Columbia, many of the students were deeply interested in North American studies, especially studies in modern art. They told me that I was lucky to have such an opportunity for my own area of research. (They thought their own areas too crowded.) My father also told me to specialize in Canadian art since, as a woman, I would have no job otherwise.

I decided to return to Canada, and commit myself to it. It was then, in 1968, that I got my Canadian citizenship. When I left my doctoral studies at the University of Toronto to take a job as head of education at the Art Gallery of Ontario, my "vacation" from my Ph.D. program was only to be for a year. It turned out to be for a lifetime.

I was happy at the AGO. I learned that I liked to talk to people, not live in the library with a stack of books. I became research curator, and then curator of Canadian art.

When I first came to the gallery, I was (like any doctoral student) desperately serious. My work, even in contemporary art, was scholarly, but my job, directing a group of bubbly docents and working with students, helped me understand how to approach the

public. I had to make art accessible. What I needed was some kind of story plan: I brought to my tours basic information and the attitude that the discussion of a work of art could be the equivalent of good entertainment. When I became a curator, I carried this idea with me. I also carried my background. It was because I had been brought up in an almost totally urban environment that Tom Thomson and the Group of Seven hit me so hard. Their work looked simple, almost blunt; it was direct, unemotional (or so it seemed). Yet their paintings were invigorating; through looking at them I found myself meditating about Canada, visualizing an autumn day in Algonquin Park; the swamp country of the northern woods or the northern lights, snow in Algoma with an infinite vista of receding red-brown and purple hills; gale-force winds in Georgian Bay, and all the powerful quality of northern nature. With Thomson I learned to know the trees, the jack-pines, the white birches growing in stands, the black spruce and maple. What their pictures gave me was my own dream, a brief, deceptive rainbow arching over another life: the experience of growing up in Canada.

I speak of myself in the past tense because the girl with the long brown hair is truly distant from me. She was an idealist and beneath her cheerful veneer, very vulnerable. Nothing, not even having children, toughened her up. She was busy trying to be generous, a quality she would always believe in. She was overdue for a wake-up call. It rang when she least expected it, when she was sharing research.

Research is difficult. It is a little like ironing, necessary but time-consuming. I had been working on Tom Thomson since 1970 in preparation for a retrospective of the painter at the Art Gallery of Ontario in 1971. As I worked, I began to document his paintings with a view to creating a permanent record, noting materials, sizes, inscriptions and stamps, front and back. I wrote to collectors who owned Thomson works, asking them to bring them to the gallery to be photographed. The cost of photography was prodigious, since the paintings had to be removed from their frames by a professional preparator, recorded, photographed, then replaced in their frames, again with the help of a preparator. For distant works, I wrote for photographs; my correspondence grew massive. In the catalogue for the show, I analysed Thomson's paintings, his development as an artist, and the placement of his work

in the context of Canadian art. I prepared a 96-page book, a pictorial history, with 44 black-and-white plates, 17 colour plates, and 123 black-and-white photographs. After the show, *The Art of Tom Thomson*, I continued to work on Thomson and my catalogue. This wasn't easy at the Art Gallery of Ontario because there were other priorities, but I soldiered on, sometimes achieving a long-sought photograph or a new bit of knowledge. Wherever I was in Canada, I looked for his work.

One day in 1976, when I was in Oshawa at my new job, David Silcox and Harold Town came to call. They asked if they could look through my files in preparation for a book they planned (it came to be called *The Silence and the Storm*). Both of them loved Thomson's work and were enthusiastic over their project. They were an antithetical pair. Silcox, who had been undergraduate secretary of the Hart House collection, later worked as an arts officer at the Canada Council before moving to York University, where he became associate dean of fine arts. He is of medium stature with a cheerful smile. Town, the talented artist and one of the central figures of Painters Eleven, was tall and aloof, and usually glowered (at least at me).

The idea for their book had originated, Town told me, at a party at Pierre Berton's house. A. Y. Jackson had been present and had told Town that an article he'd written on Thomson was the best thing he'd read on the artist. His words were overheard by Jack McClelland, who suggested Town write a book, and Town had thought this a good idea since he loved Thomson's work. He'd first seen the work in reproduction in the halls of his public school in Toronto when he was nine years old, and again in his teens in the halls of Western Technical School. By this time, he was visiting the AGO where he got to see *The West Wind*. "It was with me always," he said. "Thomson sat on my head." The purpose of his book, he said, was to make people for once *look* at the paintings.

I assumed Town's book would be an artist's look at another artist, and since it would widen the knowledge of Thomson, I gladly helped, not only sharing my research into Thomson's life and art but giving full access to my files. I read Silcox's text, made suggestions (he did not believe in the series Thomson painted the last spring of his life, for instance), and helped with ideas and photographs. When their book was published, I found that besides my

ideas (which often appear when Silcox uses the phrase "Some say"), they had used twenty-seven photographs I had taken of works I had discovered. These were listed under the photographer, Ron Vickers, and not as being from the *catalogue raisonné*. Later, in talking with McClelland, I found that they had never mentioned to him that so many photographs had come from my files. (The works should have been dated, he said. That would not have been hard to do, I said, since my files are set up in date order. Silcox and Town must not have noticed the dates on the file folders. Is that where they got them? he said.) The authors, however, did thank me in their acknowledgements, saying that without my extensive study their work would have been immensely difficult and pro-tracted: "… she freely gave us access to her files and notes, made useful suggestions, and aided in every way possible."

Silcox told me once, after the book was published, that the money he had made came in handy: he had paid off the mortgage on his house, he said. Town, I imagine, promptly forgot what he and Silcox had done. In talking to me, he mentioned with pride that he was reproducing in his book a work no one had seen before – it was one of the ones I had found – but he spoke of it as though I could not possibly know it. Perhaps some faint residue remained in his mind of his behaviour, however, because he told me later that a phrase I had written in 1986 in a book about Thomson, *The Best of Tom Thomson*, was so apt that he had decided to borrow it for an article on Charles Trick Currelly. No one would notice, he said. Did he think that because no one had noticed about his book with Silcox, I wondered?

After *The Silence and The Storm* was published, I worried over the owners of the Thomsons which Silcox and Town had used in the book: they had not been asked for permission to reproduce. I received a few angry letters complaining about this, but one owner of two works reproduced in the book only noticed their Thomsons more than fifteen years after the book was published. I had a bigger problem now that Silcox and Town had used my ideas. I had to develop new ones – and that took time. In the meantime, their showy book, with its volume of colour plates and handsome design, swamped the market. Critics such as Gary Michael Dault said it was the definitive book on Thomson, but of course in the world of books there are very few that are really the

last word on a subject. Silcox's essay, particularly his unfortunate explanation of Thomson's death (he wondered if Thomson did something as foolish as to try to stand up in his canoe to relieve himself and slipped and struck his head on the gunwale), was superseded. New evidence led to new interpretations. Much more remained to be written about Thomson.

Their book, published in 1977, was a watershed in my life. While I was glad it had helped to bring Thomson's work to national awareness, I was a little annoyed by the passive role I had played in it. I resolved, in the future, to publish my material before others published it. The experience, though unpleasant, added "grit" to my personality. At the same time, I reconfigured, reimagined, and redreamt my Thomson material and my own work. I asked myself whether I was writing only for the few who buy a catalogue in the art gallery or for a larger group of people. Would my work be of interest only to scholars and *cognoscenti* or could it be a statement for a larger public?

In 1990, Town died of stomach cancer, and Silcox today, after a career with the Ontario government, is at work on a catalogue of David Milne. In the meantime, as I continued to catalogue works by Thomson, I dug in and did more research. I would write about him, but I wasn't sure when. It took a request from a professor at Trent University in Peterborough, the historian John Wadland, to "recall me to life," to use a phrase from Dickens. Professor Wadland asked me to give the 1991 W.L. Morton Lecture, which is named for the University of Manitoba historian who became the first Master of Champlain College at Trent in 1966. Morton's theories helped establish a respectable basis for western history. He believed that the distinctive geography of the Prairies must have changed the way people thought about their institutions. An important feature of his work lay in his contention that Canada had been profoundly shaped by the existence of the North. He believed in its northern economy, northern way of life, and northern destiny.

Since Trent planned to celebrate the opening of a new environmental sciences centre with my lecture, I thought it an opportune moment to lay the groundwork for a new area of Thomson studies – Thomson as an environmentalist who did not know the word. Since Wadland is deeply involved with the history

of ideas and particularly with landscape theory as it applies to Canada, and with the history of Canadian landscape art, I applied his area of scholarship to my work. It opened new vistas.

With Thomson, for instance, we can ask what Algonquin Park meant to him personally. The park's establishment in 1893 came long after biologists had begun agitating for a tract of land to be set aside in the province as a preserved area. The Toronto Entomological Society was founded in 1877 by Thomson's uncle, Dr. William Brodie, a naturalist greatly interested by tree galls, the excrescences produced by insects on plants, especially on oak trees. In 1878, the group, recognizing that it should have a larger role, changed the name to the Natural History Society of Toronto. The members knew from their extensive natural history program how quickly the forest and wildlife were disappearing; they were particularly concerned with conservation. In 1885, the society amalgamated with the Royal Canadian Institute to become its energetic biological section. In 1886, the association petitioned the government to establish a national park for the preservation of nature animals. From 1887 to 1888 and 1891 to 1892, Brodie was a member of the council of the institute, and must have helped frame the representations the association made to the Crown Lands Commissioner of the Ontario government, Timothy Pardee, then to Arthur S. Hardy, his replacement.

While the desire to preserve wildlife would have been of primary consideration to Brodie, he would also have concerned himself with the other issues involved in creating the park: watershed management, maintenance of the water supply by preserving the forest cover on the headwaters area, and recreation. Thomson, born in 1877 into a family that valued fishing and hunting, would have heard about Brodie and the plan. Later, from his uncle in Toronto he learned the art of collecting specimens. No doubt his uncle, too, would have spoken to him in glowing terms of the park as a place of health and refuge. The institute had already in 1891 written that it would help to foster a patriotic spirit and be a means of increasing interest in Canada abroad. From his uncle, too, given his nineteenth-century orientation towards science, he may also have heard Algonquin Park compared with Paradise – as for naturalists, it was. In this defined space Thomson was later to shape a new imagery, hinting at the idea in his vision of the land.

Through his imagination and that of his audience these pictures have created for us a collectively held image of a mythic landscape. In interpreting what he saw, Thomson imagined the land as possessing an inherent emotional symbolism, and his perceptions were strongly influenced by his knowledge of natural science; in his paintings, he tried to convey what he felt. We should apply to our explorations of his work an understanding of how a society creates its collective idea of natural beauty.

It would be going too far to say that all my subsequent work on Thomson was the result of the Trent lecture, but it is true that the effort required to create the lecture led to a second watershed in my life. Before the lecture, as the director (and usually the curator as well) in Oshawa, I organized shows of Painters Eleven, the first abstract painting group in Ontario, shows by the individual members of the Eleven, their contemporaries, and the generations of related artists who came after, or before them. I felt that I was the archivist of the living Canadian artist. Like a latter-day Marius Barbeau, I interviewed as many as I could. I also worked on Victorian artists. After one book on the Buffalo painter Frederick Arthur Verner was criticized as "too scholarly" by Christopher Hume of the *Toronto Star*, I developed a more readable style ("too popular," he called me, three books later). After the Morton lecture, I focused on developing the lecture into a book. I came back to the Thomson material, and re-examined it. In time, a miracle occurred: my work was accepted for publication. *Tom Thomson: The Last Spring* was born.

In the book I presented my most recent thoughts on the sketches he painted in the last spring of his life. I accompanied an analysis of the works with two biographical chapters, and a last chapter about his transformation into one of the enduring myths of Canadian art. Now that I had this off my chest, my imagination was unleashed. I found I could face questions about Thomson that deeply concern me – his outbreaks of temper, his anger, and its relation to his sudden maturation as an artist. Hence, my second look at his biography, *Tom Thomson: Design for a Canadian Hero*.

CANADIAN ART HISTORY AS AN INSTITUTION

◆⊷⋙◆❋◆⋘⊷◆

The idea of Canadian art as distinct from the art of other countries has haunted the minds of artists since the beginning of Canada as a nation. At first such an art meant little more than immigrant artists who changed masters, becoming dependent on new patrons in a new country. With the unification of the Canadas in 1867, the new economic context meant a new environment in which to encourage an indigenous art. By 1900, the fostering of an original Canadian art was accepted as one of the aims of artists' groups such as the Ontario Society of Artists. C.M. Manly, president of the society from 1903 to 1904, said artists should eagerly record the historical, characteristic and picturesque features of the land. The next president of the society, F.M. Bell-Smith, reiterated the point that the definition of what was Canadian lay in a vision of the land. "Our country is ripe for the development of a distinctly Canadian art," he said.

Now, in the last decade of the twentieth century, Canadian art, no longer a tender new growth, is defined as that which is exhibited in our Canadian museums and galleries and taught by the universities. Within this closed circle, curators and critics sometimes applaud old-timers in the ranks, sometimes welcome

new talents. Canadian art has not only become a legitimate area of study, it has become institutionalized.

The change from idealized loved one to marriage partner came about not only through the work of artists but also through the efforts of their champions. The artists were often the sons, or occasionally the daughters, of the Canadian ruling classes, sometimes eccentric but always well-bred. Typically, they had trained in universities and abroad, in Germany or Paris, whence they returned convinced of the virtues of advanced art. Their standards were determined by the values of Victorian England, which had reigned in the world of their youth. Some of their ideas included leftovers from earlier ages of British art, such as the Picturesque. These ideas were challenged by forces from within British art even before the outbreak of the First World War, and particularly by certain non-academic exponents of new ideas about painting, in Canada as well as in Britain.

These artists and critics, who came to be called modernists, sprang for the most part from the same privileged ranks as the traditionalists. If they were writers they prided themselves on being able to write about art, though they might muddle it at times with philosophy. Their cause was something like a religion.

If we fit names to the situation, we might think of Lawren Harris, Isabel McLaughlin and (in England) the critic Clive Bell, whose book *Art*, first published in 1914, created such a stir in Canada. *Art* was owned by Harris in 1916 (he wrote the date on the flyleaf of his copy), and was read with enthusiasm by J.E.H. MacDonald, who told students such as Carl Schaefer about it. Another student, Lowrie Warrener, probably under the influence of MacDonald, his teacher, praised it in letters he wrote to Schaefer from Europe. Bell's idea of "Art for art's sake," his moral seriousness, and his fascination with strong design influenced artists to develop the formal side of their work. In a letter giving advice to Schaefer, Warrener put it this way, "Keep to your houses, trees, and turn everything into a form you can take hold of, or feel that it has sides." Two members of the Group of Seven, Arthur Lismer and F.H. Varley, who came from Sheffield, England, and therefore had every reason to look to British art and criticism for advice, also emphasized design. So did other members of the group. In the 1930s, for instance, Franklin Carmichael told his

students – among them Charles Goldhamer – to try to give even the clouds in landscapes a three-dimensional shape.

In Canada, the English connection fostered both art and curating. The first director of the National Gallery of Canada was Eric Brown. Born in Nottingham, he held the post in Ottawa from 1913 until his death in 1939. His feeling for excellence had developed from the opportunities he had to learn about painting from his brother, Arnesby Brown, a prominent British landscape artist, and his brother's wife, Mia, a portrait painter. In the summer months Arnesby and Mia joined the artists' colony at St. Ives in Cornwall – and Eric went with them, according to Maud Brown, his wife. There, in what was known as the Newlyn School of open-air painters, he absorbed much of the artists' outlook, learned about the Old Masters, and developed his own purpose and ideals. He believed his job at the National Gallery was to build the Old Master collection, adding British and French art.

In England, he also learned a love of the outdoors. As a youngster in the Midlands, he was brought up on tales of Robin Hood and his Merry Men. A great-grand-uncle had written *The Annals of Nottinghamshire,* and Eric's father took pains to hand down the history of the area. Sherwood Forest was near his home and he made many trips there. Coming to Canada reawakened his love of nature; he found the country and climate inspiring with its brilliance of colour, mighty forms and complete changes of season and aspect (as he wrote in 1926 in the catalogue for an annual exhibition of Canadian art he introduced at the gallery.) He particularly loved the north, and enjoyed camping. In her book, *Breaking Barriers*, his wife reproduces a photograph of them, relaxed and happy, on a trip to Algonquin Park. They stand opposite each other as if discussing provisions. Something about the way their hats are cocked towards each other and her charming attentiveness suggests they were deeply happy as a couple.

When he saw the paintings of the Group of Seven, Brown immediately responded to their excitement about Canadian landscape. He recognized in the Algonquin Park School, as it was first called, new adherents to the tradition of open-air painting that dates back to John Constable, and before him to the precise realism of the seventeenth-century Dutch landscape painters. It was the Newlyn School all over again, but wilder, stronger, bolder.

Brown was quick to show his support. The National Gallery was the first public institution to buy a painting by Tom Thomson; it did so in his lifetime. Brown bought many Group of Seven paintings and followed their adventures with keen interest. He arranged for their work to be sent to London for the Wembley exhibition in 1924 and 1925, with the result that they received their first international recognition. British critics like C. Lewis Hind found, he said, "these Canadian landscapes, I think, the most vital group of paintings produced since the war – indeed, in this century." It was Brown who was the catalyst who helped them receive their due; he was their first champion.

By the 1950s the focus in art had changed from London to New York. *Life* magazine permeated the consciousness of Canadians, and artists as well as the general public found themselves turning its pages wondering whether Jackson Pollock was the greatest artist in the world, and what Willem de Kooning thought he was doing in his abstractions. Abstract Expressionism, the style of the New York avant-garde, influenced Canadian painters, especially those of the first abstract painting group in Ontario, Painters Eleven. Only a few hours from Buffalo, these artists soon found themselves discovering the work of their heroes at the Albright-Knox Art Gallery.

Canadian public art galleries were slow to reflect the change in the philosophy of art, but by the 1960s in Toronto, the curators reflected the new dispensation. Mario Amaya, who became chief curator of the Art Gallery of Ontario in 1969, had been a member of the art community in New York, then lived in London as founding editor of *Art and Artists* from 1965 to 1968. His career thus bridged the two worlds, making him an excellent candidate for the job. In his book *Pop as Art* (1965), he set American and British art side by side – just as he set the two communities side by side in his dossier.

Born in Brooklyn, New York, in 1933 of American and Cuban descent, Amaya was, like Brown, bourgeois in origin. Unlike Brown, he was thoroughly urban. He represented a world with very different tastes, and sought to bring attention to less well-known but potentially fashionable areas of interest, such as European Salon and Symbolist painting. With his wavy, light-brown hair, classically handsome face, appealing brown eyes,

Mario Amaya, Yoko Ono and John Lennon, and Dennis Young at
the Art Gallery of Ontario, Toronto, c. 1969

smartly cut suits, and bitchy gossip, he was a favourite of *haute* Toronto. At one formal opening he said cheerfully to me – perhaps referring to what he assumed to be my mixed American-European background (though I was never sure why he said it)– "You and I are the only mongrels in the room." Still, with his pink-and-white polka dot tie and the pink silk handkerchief in the breast pocket of his powder-grey suit, he added to our diet an ingredient we had long missed in Canada – glamour.

Amaya had been shot and wounded along with Andy Warhol by Valerie Solanis (he had been shot in the buttocks). John Lennon and Yoko Ono, his friends, came to visit "his" gallery the day after they did their lie-in in Toronto. His shows had panache, especially *The Sacred and Profane*, which he recreated in 1969 after a show held in Turin, Italy, and his exhibition of Edouard Vuillard, with a catalogue written by his friend John Russell. Although he had no ironic sense of himself, he occasionally made a funny comment. After one of the gallery's high-powered political dinners, when I asked him if he knew the name of the lady who had been seated next to him, he said, "Who cares what her name is? All I care about is the size of the diamond on her finger."

Amaya had his down side. He had a terrible temper, which continually boiled up. He was a screamer – the volume of noise from his office could be alarming. He found gallery life frustrating, and staff members like me, champions of Canadian art, horrifying. Not only was I involved with Canadian art, which he didn't like, but I was a woman. When I was home from the hospital with my first child, I received a sudden call from my secretary, Maria Carland.

"He's moving our offices," she cried.

He made her pack our belongings, and changed our room to one next to the registrar, on the other side of the hall from the curators. No explanation was ever given, beyond "I needed the space."

Mario did not hide his ideas about Canadian art. Emily Carr's paintings were all right to be hung in the tea room, he said, even though the door to Grange Park made climate control impossible. Thomson was better, he felt, good enough for the corridor leading to the tea room. When he wrote an article for *Art in America* in 1970, he couldn't resist wisecracking that the paintings

of the Group of Seven looked like calendar illustrations – or, worse, like paintings-by-number in "Gifte Shoppes." (One prominent collector cut out the words and kept them in his wallet, to be produced with a flourish and read aloud to me and everyone he knew, as proof of the gallery's lack of interest in Canadian art.)

Toronto also was boring to Amaya, after a while. On Thursdays he left for New York and didn't return till Monday night; his work week, especially toward the end of his reign, was two days long. He was the kind of chief curator who was too busy to speak to his staff, but scribbled silly notes on the memos we sent him. One time he wrote on one of mine, "What exactly would you suggest?" (The words haunt me still.) His gift to Toronto was – as he told me – his ability to buy with wisdom, and after de-accessioning a minor Monet owned by the gallery, and a few other works, he had the funds to buy a painting by René Magritte, and some good nineteenth-century work, bargains at the time, such as Jean-Léon Gérôme's lovable *The Antique Pottery Painter*, in which the attractive woman painter sits pertly cross-legged on a box in front of a table of half-painted figurines.

Amaya was followed in 1973 as chief curator by Richard Wattenmaker. He came from Philadelphia, and had been curator of the Rutgers Gallery of Art in New Jersey. Wattenmaker had a cute, dimply face. He looked like a naughty little boy, and he could be devilish. Once he went to dinner at the home of the collector, and staunch gallery supporter, Kay Thompson. As he sat at her table looking at her prize David Milne canvas, he rose to the occasion by saying, "Maurice Prendergast influenced Milne." Not content with that, he added, pontificating, "Prendergast was a *better* painter." Kay was so enraged that she quit her job as a gallery docent, and returned to teaching piano.

Like Amaya, Wattenmaker regarded Canada as a jumping-off point. Canadian collectors and curators regarded such men in a hostile light. By 1970, there was a Canadian curator at the art gallery (myself) and the load of work in that area of the collection was the heaviest. I had shows to organize, and the gallery's many loans (primarily to politicians at Queen's Park), to handle, and, since scholarship was beginning to proliferate in different areas and on different artists, researchers who wanted to consult me and to view works. When the vault was moved, I prepared a report on

GÉRÔME, Jean Léon, French, 1824-1904, *The Antique Pottery Painter*
Oil on canvas, 50.2 x 68.9 cm
Collection Art Gallery of Ontario, Toronto
Gift of the Junior Women's Committee Fund, 1969

how to organize it. I answered requests for information from the public (I did this so well that even after I moved to another job, the phone operator used to give them my number). I not only researched my own work but also answered requests for information from the director and chief curator. I prepared condition reports, checked labels, and organized (with the education department) travelling shows. Claire Hagen, the head of extension, and I once organized one such program over a summer weekend, in her

apartment, wearing only our slips because it was so hot. One aspect of the job was helping to catalogue the many gifts received by the gallery. In this task, the curator assisted the registrar, a job ably filled by Charles McFaddin, a former army supply master who was painstakingly careful. I remember Charles wandering, disconsolate, through the halls near the vault; the painted sailcloth green pickle for Claes Oldenburgh's *Giant Hamburger* was lost. It was found after a four-hour search: it had been wrapped in brown paper, and left behind when the big sculpture was moved.

Charles was invaluable. He taught me how to properly measure and record a work of art, knowledge that was extremely useful to me later, especially when I worked on Thomson.

The atmosphere of Canadian art was changing. Among the collectors of Canadian art were many non-WASPs. They loved Canadian art because they had visited the art gallery as children and liked what they saw. Now they collected with taste and daring. One couple even mortgaged their home to buy a Thomson canvas when they were lucky enough (their words) to be offered one. This group of friends, like my parents, were not social climbers but true *aficionados* of culture.

One member of the circle of Canadian art collectors was Robert McMichael. The development of his collection into an institution prompted the hiring of a curator of Canadian art at the Art Gallery of Ontario – so, in a curious way, it was the collectors' circle that led to the institutionalizing of Canadian art. The collectors dreamt of ever more shows of Canadian art, more of the Canadian collection to be on view, a finer, larger Canadian collection, and more funds. All of this could not help but arouse the affection of the Canadian curator, who, like the collectors, usually possessed dogged persistence. (It was a quality that was not always part of the emotional equipment of chief curators.) They stayed; they remained committed; they kept working. Shows followed and collections grew. Time was on their side, and they needed lots of it for research. To find the sketches I selected for *Tom Thomson: The Last Spring*, my 1995 exhibition at the McLaughlin Gallery, took me over twenty years. Five years per job is more typical. Curator Christopher Varley, for instance, accomplished the writing of his 1977 monograph on F. H. Varley over a five-year period, but, to

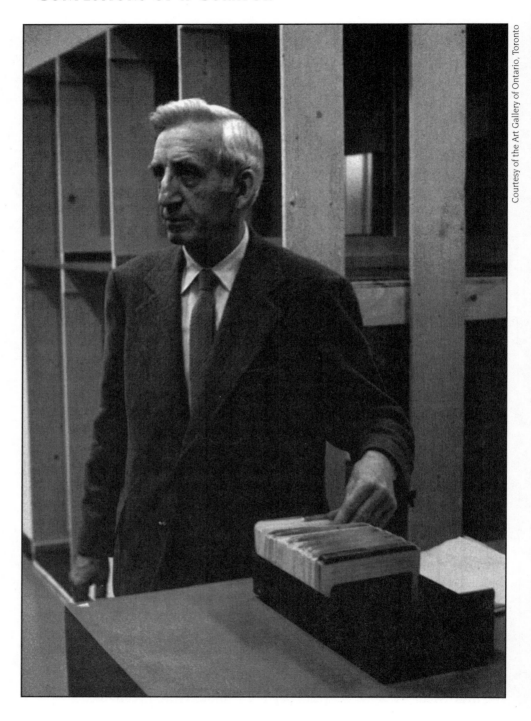

Charles McFaddin, registrar (1953–75), Art Gallery of Ontario, Toronto. The cards Charles fingers are the location cards for the vault.

think over and weigh the material about his grandfather, he said, took him his entire life.

These early staff members recall to me the hero of the movie *The Shawshank Redemption*. Consigned to prison for life, he takes twenty (or so) years to dig a tunnel to freedom, then escapes to a brave, new world. When the curators of Canadian art dug their way to freedom, they found that in that bright, new world into which they emerged everyone, by and large, liked Canadian art.

McMichael and Me

Robert McMichael is one of the giants of Canadian art history. He was more a businessman than a scholar, yet the idiosyncratic collection he amassed, and the institution he started, the McMichael Canadian Art Collection in Kleinburg, are the foundation of Canadian art history. He was the rock on which it was built.

I first learned about McMichael in a particularly painful way. As a curator at the Art Gallery of Ontario in 1970, I was sent by the director, William Withrow, to visit Colonel R.S. McLaughlin to talk about a long-promised gift of Clarence Gagnon's *Maria Chapdelaine* series. This group of paintings, of unique importance to Canadian art, had been created by Gagnon to illustrate the enormously popular book about charming Maria by Louis Hémon. The rural Quebec setting brought out the best in the artist, who loved the French-Canadian landscape. Over three years, from 1928 to 1931, in illustrating the book, he painted some of his masterpieces. The fifty-four tiny paintings (most of them are only 18 x 25 cm), in media from chalk to gouache on paper, had been promised to the art gallery by the Colonel for years.

I took the bus to Oshawa and soon found myself in Parkwood, the baronial McLaughlin home. Mr. English, the Colonel's secretary, ushered me into his presence. I remember that I was wearing a very short turquoise tunic (miniskirts were in fash-

ion) which I thought harmonized well with my long hair (it was my Prince Valiant period). Certainly no one dressed in such youthful fashion had entered the Colonel's house in a long time. His bedroom had been designed by John Lyle, one of the top architects in Toronto, assisted by Herbert Irvine of Eaton's College Street decorating department. The room had minty green walls, white trim, and a white ceiling. Green was everywhere, from the shades on the silver-plated lamps on either side of the bed to the brocatelle fabric on the chaise longue on the opposite side of the room. On the wall behind the bed was a large vertical painting of three polar bears stationed on an iceberg. They were in a green-and-white setting, too. The Colonel's bedroom had a curiously peaceful quality to it; but it was cold, I thought as I sat by the bed. On the opposite side of the room a plaster moulding of a pair of deer was inset over a white marble fireplace: these distant prey faced the bears. The Art Deco setting was modern for the time it was designed – in the late 1930s. Irvine called it the best modern he ever did, and compared it to the work of Leleu, the French furniture maker of the 1920s. Along with the house, it had been constructed when the Colonel was at the height of his powers. However, by the time of my visit he was ninety-nine years old, propped up on pillows (he lived to be over 100). Despite his years, he was a lively conversationalist.

I approached my subject gently, introducing myself and my mission, only to be told, brusquely, that I was too late. Shortly before, Robert McMichael had come with Premier John Robarts and a bottle of Scotch (the Colonel stressed that it was a good brand). The *Maria Chapdelaine* series had gone to McMichael. So had most of Colonel McLaughlin's Group of Seven and Emily Carr works. With these I was not so concerned, since our collection was strong in these areas, but the loss of the Gagnons was grievous. There had been no focused collecting by the gallery in French Canada, and my hope was to fill in the gaps. I said goodbye, and stood up to leave, deep in thought about how best to break this news to the director, when Colonel Sam spoke.

"Young lady, I have just one thing to say to you."

"What, sir?" I asked, leaning closer to the bed.

"You have damn good legs."

For a moment, I had the impression that he was going to jump out of bed.

McMichael, in his autobiography, *One Man's Obsession*, puts the Gagnon matter delicately. "As far as I knew," he wrote "the paintings were still not committed to any public institution." From the careful phrasing of the words, the reader can surmise that he was aware of the Art Gallery of Ontario's interest – but correctly banked on there being no legal agreement between the Colonel and the AGO.

McMichael tells how he applied horse sense to his talk with the Colonel. He told him that his gift would be one-hundred-percent deductible from his income for tax purposes since, through the kindness of the Ontario government and an amendment to the Income Tax Act, making a gift to McMichael was the same as a gift to the Queen.

"I'm pleased to know that the government has at last learned how to say thank you," said the Colonel.

With that, McMichael scooped the Group of Seven paintings. Later, he got the Gagnons – and arranged for Paul Peel's *After the Bath* to come to the Province of Ontario. (Years later, I heard from James Fleck, the Premier's assistant, who told me that McMichael didn't want the painting: it was outside his mandate. I gladly accepted it for the AGO.)

In later years, I found McMichael a constant source of irritation. Although in person he acted excessively humble, behind your back he would pursue his own aggressive course. He was forever writing the director, asking to borrow a few trifles, like *The West Wind*, since we were not using them. The Canadian collection had no permanent hanging space, and I arranged exhibitions called, variously, "Treasures of the Canadian Collection," or "Our Canadian Heritage." McMichael had a list of ten favourites he wanted, a top ten hits of Canadian art, and he thought the gallery should give them to him. He had not been able to acquire much in the way of the very finest in Group of Seven canvases, and he needed these masterpieces.

I often heard gossip about McMichael's way of collecting. He was a hard dealer. Naomi Jackson Groves, Jackson's niece, told me about the time she had wanted to give the McMichael Gallery a group of Jackson's drawings, the ones she had used in her book

AY's Canada. McMichael talked her into selling them to him. Because it was him, she set a low price, but then McMichael personally donated them, at full value, to the collection. She was livid. Later, the Thomson family wrote me that McMichael took Thomson works, without appropriate authorization, from the home of his sister Margaret Tweedale, as she lay dying. (Two of these pen-and-ink illustrations are today at McMichael.)

I rationalized these sad incidents by telling myself that he was simply an avid collector, eager to get the best for his gallery. What he did, especially buying cheaply, was no more or less than any collector would have done. It was the wolf in him, the aggressive, amoral, territorial side of the collecting personality. The problem with his style of acquisition was that in 1965 Premier Robarts had arranged for the McMichael home and art collection to be made into a public institution under the auspices of the provincial government and the Metropolitan Toronto and Region Conservation Authority. The province of Ontario had generously added thirty acres of conservation land to the McMichaels' original ten acres, and hired the staff to care for the establishment. From 1965 to 1972, it assumed all expenses for the operation. Within this new institution, the McMichaels served as unpaid curators. In 1972 there was another change to the status of the institution: the Ontario Legislature passed an act to establish the McMichael Canadian Collection and Robert McMichael became the paid director. Ironically, as director of a public gallery, bound by the strict code of ethics that governs the director/curator, McMichael's way of collecting as a private citizen was no longer suitable. The code is strict on several points: no member of professional staff shall take advantage of professional status by engaging in the art trade, and acquisition of museum items from members of the public must be conducted with scrupulous fairness to seller or donor. Robert McMichael, through the intensity of his commitment, and the energy with which he pursued it, brought about his own comeuppance.

Everyone should have reservations over mere ownership – even when the collector knows the artist, there is more to learn. One time in McMichael's galleries, as I catalogued his Thomsons, I mentioned that on the back of one of the sketches that he had titled *Sunrise*, the great friend and patron of Thomson, Dr. James

MacCallum, had written the words "wild cherry trees in Spring – May 1915." MacCallum had often visited with Thomson in Algonquin Park and Toronto and keenly followed the progress of his work. After his death, he wrote on the back of his sketches what he recalled as their date: though an amateur, he was Canada's first art historian. MacCallum's words should be the title of the sketch, I suggested.

"MacCallum wrote that?" McMichael asked.

"Yes," I said, turning over the sketch to show him the doctor's handwriting.

"What did he know?" McMichael said.

Such nonchalant disrespect for the doctor struck me as sad. "*He was there*," I wanted to say, but didn't. Everyone is entitled to an opinion, I thought, even a wrong one.

McMichael's story is rather touching. He had made money in a new business, wedding photography, but more from business acumen than from talent as a photographer. His shop was on Avenue Road in Toronto, north of the Park Plaza Hotel but on the same side of the street, in an area now made into a parking lot. In an era when wedding portraits were usually taken in church, he thought up the production of a storybook of pictures taken in the home. He added promotion to the idea, a booklet dealing with wedding etiquette. He developed a wedding "kit," a group of products to be mailed to new brides by the newspaper that published announcements of the wedding. He developed other "Paks" including a baby kit, even more successful, for newborn babies. The list of those to receive such kits was drawn from birth announcements in the papers. (I received this package in 1970 on the occasion of the birth of my first child, Laura.)

Along the way, he had fallen in love with the work of Tom Thomson and the Group of Seven. I remember him mentioning Charles Band in this context. He told me that in 1959 Band, the great collector of Canadian art, had hired him to photograph his son John's wedding. McMichael saw Band's collection, with its Group of Seven paintings, and was deeply impressed.

In his autobiography McMichael says that he learned to love the work of Thomson and the Group of Seven at the art galleries. He visited distant relatives of Thomson's, named Brodie, who suggested he should visit Thomson's sister, Margaret. The

sight of the Thomson panels at the Tweedales inspired him, McMichael wrote. "Some day, some way, I vowed, there would have to be a place where all Canadians could see what I was seeing." He decided, he says, that we needed a unique, accessible sanctuary for the art of Thomson and the other artists who had been inspired by our country to produce a truly Canadian art.

His tale, though dramatic, is plausible. Many a collector has an enthusiastic vision of the importance of the work he collects. The story, and especially the word "sanctuary," suggests the immense importance to McMichael of his discovery. Tom Thomson and the Group of Seven validated his own life, as though in buying their work he bought immortality. Through them he became that special person, McMichael, who deserved to be left alone in his temple/home.

From his account, we recognize another side of the meaning of the Group for McMichael. In his book, he is at pains to describe his innovations in business, and especially the Paks. He does not say much about his education, and in fact he seems to have had more a commercial turn of mind than a critical one. He had trouble remembering the names of people he knew in the field, from his conservator, Ed Zukowski, to the friendly critic of

Robert McMichael signing the gift agreement with the Ontario government, 1965. (McMichael is seated next to Premier John Robarts. Signe McMichael sits on the other side of the premier.)

Courtesy of the McMichael Canadian Art Collection Archives, Kleinburg

the *Globe and Mail*, Kay Kritzwiser. Through his account of the development of his collection he gained credentials: he was a friend of Colonel Sam McLaughlin and of his distinguished third daughter, Isabel, the painter and president of the Canadian Group of Painters. He was a pal of this Group member and that; he was their business partner; he knew the politicians … but sometimes his account is a little hard to believe.

For McMichael, institutional matters – certainly by the time he wrote the book – had become uncomfortable. Though he stepped down as director in 1982, and retired at the age of sixty-five in 1986, he retained the position of founder director emeritus. He wanted to continue to have input, but the board of the gallery, since it needed a more professional staff and status, had moved the direction away from his influence. In his book, published in 1986, he told the story of a proud man; but he must have felt that, at least by implication, he was being called to account. Making Thomson his partner in a miraculous vision avoided discussion of the problem. Thomson may have had bad habits but his generous ways were well recorded – especially how, unless prevented, he would give away a sketch to almost any passerby. What McMichael had accumulated was slipping away from him into the institution he had created. As he felt hostility closing in around him, he recreated ever more boldly the happy companionship of Thomson's shade and of those of the magical Seven.

Among the influences on the growth of his thinking about the value of Canadian art, he should really have mentioned the importance to him of Charles Band, but to do so would have been like thanking a parent, and McMichael saw himself as self-made. Band was the person who caused in McMichael the shift from pleasant interest to idolatry. Band would have added to his conviction of the wonders of the Group's art and of its lustral quality, by telling him such works were a wise investment. Money was something Band knew about: he had worked with the Dominion Bank in Toronto, and with insurance and business companies. But his interest in art was not financial; it was a genuine love.

Band's life was collecting. Although I never met him (he died in 1960), his legend lived on when I joined the AGO. From 1945 to 1948, he had been president of the board, and in 1947 expressed the pleasant idea that a gallery should be involved with

Judging the Ontario Society Artists Exhibition, 1946 (Rolph Clarke Stone award) Charles Band, A.Y. Jackson, H.O. McCurry, A.J. Casson.

the community. I liked to hear about straight-backed Charley who always attended art openings (not a usual characteristic of board members), and how he liked to know the artists he collected. He told John Band, his son, that this was how he found out if the artists were sincere or not. "Never collect by ear," he said.

Born in Thorold, Ontario, the son of a prominent miller, he graduated from Upper Canada College along with his friends Vincent Massey and Lawren Harris, and began collecting in 1914 in New York City, where he held his first job. His early purchases were of American artists, such as Winslow Homer, but in 1923, when he moved back to Canada, Harris introduced him to Varley, Jackson, and Lismer. He started to buy their work, and then that of Emily Carr. Band kept up with the changing times by buying paintings by Jean-Paul Riopelle, Paul-Emile Borduas, and Jock Macdonald. His elegant and gentle wife Helen was my special friend at the gallery, and I frequently visited the spacious Band house on McKenzie Avenue in Rosedale. Each year I hung works he had given to the gallery, such as Emily Carr's *Indian Church*, Harris's *Miners' Houses, Glace Bay*, Varley's *Nude on a Couch* and his *The Cloud, Red Mountain*. Band had more than an eye; he knew what was good. What he bought showed breadth of mind, good

will, energy, and the ability to be bewitched and entertained by both old and new. He even bought great drawings, such as Varley's *Nude with Apple*, and drawings, like Canadian art, were not commonly appreciated by Canadians, then or now.

McMichael, like Band, insisted on knowing the artists he collected. He says in his book that the first member of the Group of Seven he met and befriended was Lismer. Then he met A. J. Casson, and so on, till he had met six of the remaining members of the Group. The way he tells the story of his first look at Thomson's painting stresses the family connection, almost as good, he suggests, as knowing Tom himself.

McMichael took Band's idea one step further: he arranged for Group members, when they died, to be buried on the gallery grounds. In a cemetery at McMichael are buried Casson and his wife Margaret, Harris and his wife Bess, Jackson, Frank Johnston and his wife Florence, Lismer and his wife Esther, and Varley. McMichael thoughtfully had Algoma boulders raised to mark the graves. The idea evolved from Jackson who, in his old age, lived at the gallery, and it seems wanted a nearby plot. As with his business, McMichael developed the idea into a grandiose scheme, one that could and did transform even the wishes artists and their families might have had for their remains: Varley, for instance, had wished to have his ashes scattered over a lake up north. The strangest part of the story has yet to occur: when they die, Bob and his wife Signe will be buried in the same plot of land.

Clearly, McMichael was obsessed with his collection. Because of his unflagging interest and the quantity of his purchases in the Group of Seven area, as well as the fact that his commitment led to the creation of a major institution, he was in the long run more influential than Band. It was his purchase of Thomson's sketches that created public interest, giving the market its biggest push. From 1956 on, the date when McMichael bought the first sketch from Archie Laing (G. Blair Laing's father), Thomson's work has steadily increased in value. From this time too, we must date the interest in Thomson's life – and the even greater interest in his death. Till then, as Jackson said, nobody wanted to hear much about Thomson. McMichael, like the archangel Gabriel, brought glad tidings of great joy, at least in retrospect, to the field of Canadian art history. Till then, nobody had wanted to hear much about that either.

THE TASK OF THE CURATOR

<div align="center">◆ ⟡❈⟡ ◆</div>

"Is it a full-time job?" people asked, when I said I was director of an art gallery. When I said I curated shows I was faced with expressions of amusement or condescension, as though they knew the job wasn't really "work." I have even been asked (by the assistant to the City of Toronto archivist) what it was like "to have sex with artists" – she had heard that that was what I did when curating shows of contemporary art.

Every director brings different skills to the job. Some are best as administrators, some as fund-raisers, some as curators and collection-builders (this last is my strength). It is definitely *not* part of the job to have sex with artists: to do so would be to cross an invisible line of conduct, like the one that forbids a psychiatrist sleeping with a patient. Some do cross the line: some curators have even married the artists they are working with – for instance, the American art scholar Barbara Rose married Frank Stella, and the video curator Peggy Gale married Michael Snow. It can be a lucky marriage – the artist gets a personal curator, the curator gets a front-row seat to study the subject – or an unlucky one: Rose and Stella divorced. As for me, I've found that an artist who appears to be interested in more than a normal friendship often has another motive: to divert attention away from the work in hand, or to avoid concentrating on the development of his show. I have some-

times wondered, with such artists, whether it was a sign that their art was going through a bad phase.

When I chose the living Canadian artist as my subject of study, I felt that I was already an experienced observer. My sister is an artist, and I grew up studying her. I had listened to her tales when she came home from her classes at the Art Students' League in New York, and I had gone there with her to take some lessons myself. I observed her, and she used me as a model. "Hold that

Courtesy of Charlotte Rosshandler, Montreal

Interview with Rita Letendre, Toronto, 1977. I enjoyed listening to artists: they reminded me of my sister.

pose," she would command as I arched a foot to pull on a sock, and I would hold my foot obligingly as she settled down with a sketch pad.

My sister conditioned my attitude towards artists. I have always found them fascinating. Over time, my penchant for listening to them developed into a professional discipline – and a collection of over 700 audio and videotape interviews, most of them now on file at the National Archives in Ottawa. It is a unique record of Canadian artists, many of them now long dead; it is also, I understand, the largest oral history in Canada.

Listening to artists is still an essential part of my work. For the historical curator who does not have the artist to interview, gathering the evidence is more difficult: she must interview family or friends, immerse herself in the historical period, examine documents in libraries to create an exhibition history. Then, once these records have been collected, the work of interpretation starts. As P. M. Kendall, the historian of biography, points out, biographical forms extend through a wide spectrum. (On the far left of the scale he places the novel, as fictional biography; on the far right, interpretative historical biography.) The biographer's objective, he says, is a living picture made faithfully from a careful analysis of the materials at hand. The art historian also first gathers facts, then forms them into a coherent work. This allows curators a wide range; they usually choose an eclectic approach, drawing upon past ways of exploring the field, from connoisseurship to iconology; they may relate the work to its social background, or to semiotics, or to the psychoanalytical understanding of the creative process. A curator may have to delve into background reading, from Sigmund Freud to feminist criticism. The work may require a close focus on a specific area; for example, Diana Nemiroff researched recent publications about the eroticism of clothing for the catalogue essay of her 1991 show of Jana Sterbak at the National Gallery of Canada. It may mean quoting from contemporary music, as Ihor Holubizky, the senior curator at the Art Gallery of Hamilton, did when writing about multimedia sculptor Dorothy Cameron (to expand on the personal angst and masochism in her work he discussed the half-spoken songs of the English performer Ian Dury). But interpretation, while important, is not the only task of the curator.

It is the show that counts, and an exhibition is as ephemeral as theatre. It can only be understood by the viewer who attends in person. Reproductions can never adequately convey the colour, shape, size, or placement of the work. To some extent, the curator previews the work on our behalf, then presents her conclusions in the thesis of the show, and if she is wise, identifies this thesis in a condensed form in the catalogue so that the viewer can become familiar with it. Often, enamoured of their subjects, curators are enthusiasts, and their essays have a sympathetic tone; but they only rarely give a first-person response. Seeing is cumulative, so the curator welcomes comparison of different perceptions, among them the artist's. Curators' appreciation of artists can make them a mark for critics because it is the critic who judges the value and relevance of the work. The critic's response is often at variance with the viewer's, but a critic who has reviewed art over a long period of time and established his reliability as a witness will also have created a relationship with the rest of the viewing audience, based on an interplay between their responses and his.

The curator, however, cannot play the role of the critic. Thomas P. F. Hoving, director of the Metropolitan Museum of Art from 1967 to 1977, himself once a curator of medieval art at the Cloisters Museum in New York, has suggested that the focal point of the curator's task is collecting. For him, *The Chase, The Capture* (as he titled his 1975 book on collecting at the Metropolitan) is romantic. Not for him any mention of the boring routine of the job: pleading with the preparators, the conservators, the registrars, the cataloguers: he sees his profession as an adventure. Hoving speaks of pursuing art with massive purchase funds; he does not speak of parlaying modest amounts into a collection. Yet that is what most curators must do. It is what I did when I was curator of Canadian Art at the Art Gallery of Ontario, and what I do now in Oshawa at the Robert McLaughlin Gallery. What a curator needs most is what Odysseus was famous for: guile. Curators must be wily. In their task, only cleverness and patience will serve. Aggression doesn't much help curators; they must wait, and then wait even longer – and work, it seems forever, to organize their subject.

"Curator" comes from the Latin verb *curare*, to care for. The curator cares for the collection through preserving it, expand-

ing it, putting it into perspective, organizing exhibitions to show it, cataloguing it, checking wall labels to see that they are correct; if necessary, the curator also sweeps up.

A certain personality type characterizes the curator. The word in Roman times meant a public administrator. It could also mean the caretaker of the estate of an adolescent, a spendthrift, or a person of unsound mind: someone who could not care for himself. Something avuncular is still associated with the job in the museum world today. Curators are often considered to be absent-minded professor types, "fuddy-duddies." Hollywood characterizes them as officious, obsessive, and stupid. In the movie *The First Deadly Sin* (1980) the detective (played by Frank Sinatra) is helped by the arms and armour curator of the Metropolitan Museum.

"Sergeant, I'm an aging armoury expert who sits around going to waste – use me," says the curator. His amateur sleuthing helps establish the murder weapon, an unusual form of ice-axe used in mountain climbing, and he's a smart scholar, but he's also a buffoon: as he searches out the correct tool, a hardware store attendant asks him what the tool he wants might be used for.

"To kill someone," says the curator.

"Wundafull," says the salesman, wondering whether he should call the police.

Curators are not always researchers; their work calls on many different talents. In so far as they are critics they may be suspicious, grumpy, and negative, but in so far as they create shows, and therefore partake of the qualities of mountebanks or minstrels, they can be magnetic, humorous, and enthusiastic. They can be narrowly knowledgeable in an academic sense, but because they are in close contact with works of art, and because they deal with the products of civilization, they are also, in their hearts, humanists and idealists. Curators of contemporary art hold the record in this regard. Philip Monk, for example, said, upon starting a new job at Toronto's Power Plant, that curatorial practice is the "constant negotiation between institution and current art practices as mediated by themselves" – something like the job of a lawyer in a tricky divorce suit. Only a curator who works with the living artist would define his role in such dynamic terms, as one that changes with the velocity of fashions of art: in European museums, curators or

"keepers" as they are called, are historians who maintain life-long roles. Monk has also said that when he worked at the Art Gallery of Ontario he tried to rectify the lack of attention the gallery paid to its own art community by documenting its origins and development, say from the late 1960s, when, in his opinion, contemporary art started in Toronto. Only a contemporary curator would dare such a choice of date. His new job, he says (sounding like an artist), gives him a chance to reinvent himself. Monk's ideas point us towards another characteristic of curators, an endearing one: innocence.

In their universe, curators must maintain the conviction of innocence. The market never influences them, although they never underestimate the sham side – the greed, the egos, the intrigues, the fickle public, the temperamental critics. They are always hopeful; they bet their own reputations and sometimes museum money on nothing more substantial than opinions, often their own. They believe, too, as Monk said, that with new knowledge they may "reinvent" themselves. Their jobs are not stable. Especially today, the term "independent curator" may be a euphemism for "unemployed curator"; many are left hurt and broken by the wounding experience of being laid off or fired. But they are amiable, even between jobs; they are rarely aggressive, though when they defend scholarly turf they are like muskoxen, who at the sight of intruders form a ring to defend their young. Sometimes a lion gets into the group and, like Hoving, fights his way to the top. As director he looks back fondly at his adventurous youth, seeing the job of curator as one of chase and capture. Today such directors exhibit what we think of as more characteristic of dealers: unflagging energy and inexhaustible charm as well as a certain hovering attentiveness, especially in the presence of collectors. Directors, to be successful, must generate funds – or, if not funds, then objects. It is a lesson that can sometimes be learned by the curator.

At the Art Gallery of Ontario in my day, the sum of $10,000 a year for the purchase of Canadian art was the lowest of all the sums allocated to the different sections of the collection (the highest, at $60,000 or even $80,000, went to European art). The amount wasn't enough for me to compete at auction with a private collector, let alone McMichael, yet this was the competition in

which I was engaged. I decided to use the gallery's resources, especially its name.

The gallery had a long-standing relationship with Queen's Park, and since I was the curator who, along with the registrar, arranged over 300 loans of paintings to offices, I got to meet everyone from the premier's assistant to the secretary whose desk was stationed outside his door. She loved a watercolour we had loaned, of a field of flowers by Betty Mochizuki, and she would not have it changed, but others liked to redecorate. Cabinet ministers were mine for the time it took to discuss with them whether they liked "their" paintings: I was happy to change what they didn't like for more suitable works. I soon learned my way around.

One of the people I met at Queen's Park was the interior decorator; he clearly felt overwhelmed by the works of art in the collection. The storage was chaotic, and conservation, even for important works, impossible. As I toured with him the dark, echoing corridors and pastel-painted offices, he showed me a large painting by Florence Carlyle called *The Tiff,* in which a sweet-faced girl with a spit curl over an ear, wearing a flowered white organdy party dress, sulks at a table, while on the far side, his head turned away to look out of a window, slouches her dejected beau. The story is about the young lady, and particularly about her diaphanous dress and the charming red petticoat which peeps out when she lifts her dainty foot. To paint the dress so successfully, Carlyle must have looked closely at John Singer Sargent's virtuoso handling of textures and light, or at the portraits of the New York painter Cecilia Beaux. I fell in love with the painting, and in a moment, my plot was born. I would bring it into the AGO collection, the best home I could imagine for any work of art.

Later I found more paintings at Queen's Park that I wanted to transfer to the gallery: from the strong, bold, early Thomson canvas, *A Northern Lake,* to J.E.H. MacDonald's *Morning Shadows,* to Archibald Browne's *Moonrise* with its delicate silvery sky and glimmering distant water, to an early Ernest Lawson painting, *Winding Road* (which I found in a closet). I was particularly interested by paintings that had entered the collection at the turn of the century, by artists such as Frederick Challener and Laura Muntz Lyall. They were of high quality, and like the Carlyle and the

MacDonald, had as their subjects the gentle stories favoured by juries of an earlier day. Lyall's *Interesting Story* shows two children sitting on a sofa reading a book; light from windows behind the charming heads falls on the book and their clothes. It is a quiet work, like MacDonald's painting of two couples walking up a snow-covered hill, in which the blue and lavender shadows recall some extravagant Persian carpet, or the paintings of Gustaf Fjaestad, which MacDonald had seen in Buffalo in a show of Scandinavian art at the Albright Art Gallery in 1912.

During this period of piracy, I discovered a large group of watercolours by Lucius O'Brien and other Canadian Victorian watercolourists, such as Frederick Arthur Verner. These all *needed* to come to the gallery, I knew. It could provide professional conservation and better humidity and climate control. I enlisted the help of the director in visiting the minister involved; he quickly saw the justice of our request, and signed over the paintings to the gallery. Of course, I was careful to reward individuals who helped me find such objects with a nicely framed contemporary print from the collection. I did not want to be thought ungrateful.

In Oshawa the situation was worse, if possible, than in Toronto. Before my time, the director, curator and the board of trustees had put into effect a Painters Eleven guideline. In an inspired burst of spending, they purchased paintings which used the funds years into the future – as it happened, my future. Time was proof of the wisdom of their selections, many of which, such as Harold Town's *The Fence*, turned out to be cornerstones of the collection. Time was also proof of how wrong they were to spend funds years ahead. For purchasing art, Oshawa, like many a public gallery, used the interest from an endowment that decreased in amount, and so the debt, which was supposed to take only a few years to pay off, hung over our heads far longer than anticipated.

From 1974, when I came to Oshawa, till 1982, yearly cheques were sent to members of Painters Eleven in payment for works the gallery had agreed to buy. The artists came to regard them as pension cheques. Town wrote funny reminders. "Happy New Year!" he would write in mid-January. "And now for the bad news … you owe me money. I am tired of my auditors nagging about this matter."

Dennis Burton, *Mothers and Daughters*, 1966
Oil, acrylic copolymer and graphite on linen canvas, 152.2 x 152.6 cm
The Robert McLaughlin Gallery, Oshawa, Purchase, 1976

Louis de Niverville, *Early Morning*, 1969
Acrylic on canvas, 152.9 x 244.4 cm
The Robert McLaughlin Gallery, Oshawa, Purchase, 1976

I was tired of my auditors nagging me about it too.

The amount that remained for purchases, after all those commitments, was $8,000. That bought some good paintings, but only one or so a year. Planning on the basis of my knowledge of the AGO collection, I applied the money in a regular pattern to build up the collection around the Painters Eleven core. Thus, I might buy a Ron Bloore canvas or a vintage Gershon Iskowitz such as his *Orange Blue Mauve Painting*; I bought works by John Meredith, Joyce Wieland, and Michael Snow (a great Walking

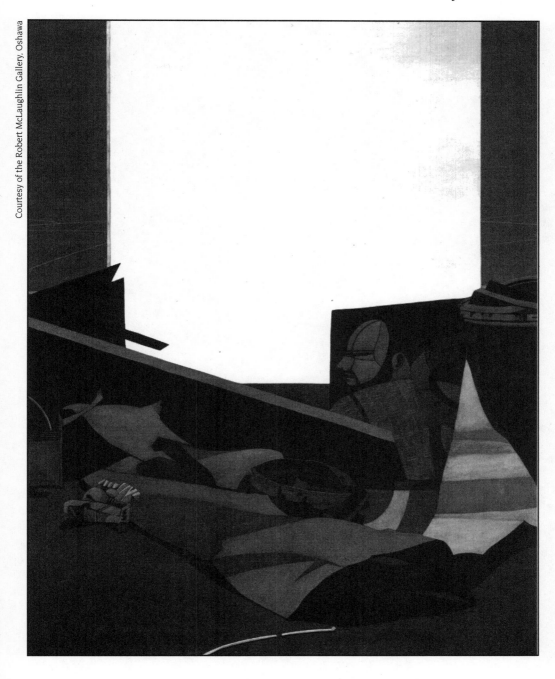

Ivan Eyre, *Sky Terrace*, 1971–1972
Acrylic and oil on canvas, 206.2 x 157.7 cm
The Robert McLaughlin Gallery, Oshawa
Purchase, 1980

Charles Wyatt Eaton, *Portrait of Miss Lillian Krans*, 1870
Oil on canvas, 76.6 x 63.8 cm
The Robert McLaughlin Gallery, Oshawa, Purchase, 1975

Woman, *Turn*). I also supported the exhibition program. From each retrospective I organized of major painters whose careers complemented the Eleven, I purchased major work, often with the advice of the artist, his peers, or a dealer, so that the paintings I acquired were "the best," and not only in my opinion. In this way, Coughtry's *Reclining Figure Moving No. 2*, painted as a class demonstration, Dennis Burton's *Mothers and Daughters* (p. 81), Gordon Rayner's *The Lamp* (Magnetawan Series), Louis de Niverville's *Early Morning* (p. 82), Ivan Eyre's *Sky Terrace* (p. 83), and Paul Sloggett's *Pecos* entered the collection. When I had to, since I could not always get the work through gift, I purchased in the historical area, buying the tiny, exquisitely painted William Blair Bruce sketch, *Old Tree*, two superb Wyatt Eaton portraits, of Lillian Krans (p. 84) and Hiram Krans, and a strong, large Otto Jacobi landscape. Nor did I neglect to purchase the work of the talented artists of the region such as John Lander or Nicholas Novak. I also started to purchase the work of gifted women artists such as Kim Ondaatje or Suzanne Gauthier; Alexandra Luke, whose collection founded that of the gallery, was a woman and a painter, and I knew she would have wanted me to support talented women. As in my years at the AGO, I kept my eyes open for someone to help me in my most important work: a donor who had what I particularly needed, paintings of the Group of Seven, in strength and in depth. Their work was in every public gallery that had a notion to be national – and a gallery with a national focus was what I wanted the McLaughlin to be.

Luck brought me the help of Isabel McLaughlin. I had known her since I was a student at university. I always loved her hearty laugh and her kindly ways, and the warm glance she gave as she looked down her slightly aquiline nose. When I came to Oshawa, she started to frequent the gallery. Each year she came to have tea and give us an annual donation of $5,000, which meant a great deal to our small budget. But she was a friend of McMichael's, and I assumed her collection would go to him.

From the time she was a student of painting in Paris, Isabel had always bought art. She did not see this as collecting. She was buying art to study, to nourish her own work. Her home showed the way she meditated on objects; she had created a rich meld of fine art

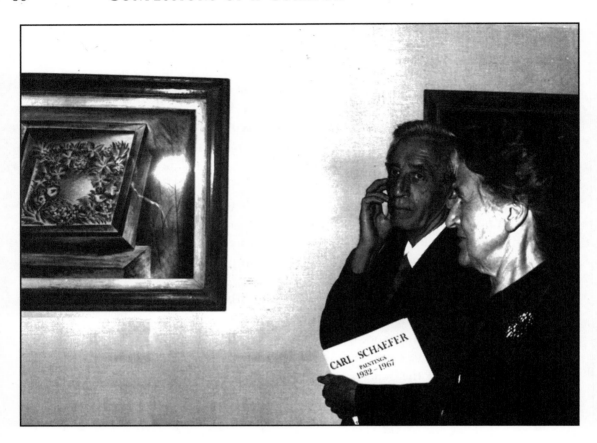

Opening, *Carl Schaefer Paintings* 1932-1967, the Robert McLaughlin Gallery, Oshawa, 1976.
Frequent visitors to the Robert McLaughlin Gallery: Charles McFaddin and Isabel McLaughlin.

and an assortment of things found in nature – shells, twigs, stones, flowers. "I never at any time thought of myself as a collector of art," she said. "Having worked in the world of art since the 1920s and been closely associated with artists and art, these things just seemed to happen ... I never thought of buying ... It was to see, to react to, to enjoy, criticize, analyze whatever was there. In some instances, interest and appreciation might develop over a period of time. In other cases, a quick instantaneous decision was made."

Isabel McLaughlin, *Flying Impressions*, c. 1945-1950
Oil on canvas, 67.5 x 90.5 cm
The Robert McLaughlin Gallery, Oshawa
Purchase, 1984

Photography courtesy of *Whitby Free Press*

Opening ceremonies for the expanded Robert McLaughlin Gallery, Oshawa, 1987.
From left to right: Arthur Erickson, Isabel McLaughlin, Ed Broadbent, Joan Murray.
On the wall behind Isabel is one of her gifts to the gallery, Roloff Beny's *Tamar*.

What she created in her collection was her view of art as a profession, as she and her contemporaries lived it – with intensity, dedication and boundless curiosity. It also reflects the distinct and personal taste of a woman who looked to art as a grace of life and found herself an actor in Canadian art history. The works she bought provided her as an artist with a visual reference library of images, which were reflected in her own work – her painting *Flying Impressions* (p. 87), for instance, showed her meditations along the

Isabel McLaughlin and Arthur Erickson, the Robert McLaughlin Expansion Party, 1985.

same lines as the great Lyonel Feininger she owned, *High Houses III, Paris* (p. 99), with its squeezed, articulated Cubist space and its colour range of subtle greys and blues. She had bought the Feininger, she said, because the shifting planes of the apartment buildings, zig-zag streets and people recalled the view from the Paris apartment she lived in during her last year at the Scandinavian Academy (1930), at the corner of the Rue de Tournon and the Rue de Seine.

Back in Canada in 1930, at the Canadian National Exhibition, she had bought *Wood Interior* by Emily Carr (p. 100). "It was like a breath of fresh invigorating air, totally different from anything I had been seeing in Paris," Isabel said. Yet to me the painting had a sense of movement and shifting form that resembled Feininger's. The Carr with its crowded composition and receding planes, particularly in the foreground, is one of the high points of the influence of Cubism on Canadian art. What Isabel probably focused on in the work was the restless twisting of the forest, and its specifically Canadian quality: the scene is British Columbia. The best of her work as a painter later, as in *South Shore, Bermuda,* would have the same vital, strongly designed

Isabel McLaughlin, *South Shore, Bermuda*, 1953
Oil on Canvas, 61 x 80.8 cm
The Robert McLaughlin Gallery, Oshawa.

quality; with time too, her work became more cubistic. And she too sought to offer through her work a quality that is characteristically Canadian, though one poetically detached from a slavish image of nationalism, as she is herself.

By the 1970s her collection had overwhelmed her personal space, both her house in North Toronto and the downtown apartment in which she lived later. She owned paintings by Hans Hofmann, with whom she studied, and members of the Group of Seven – Harris, Lismer, and Jackson – as well as many others ranging from English art with Ivon Hitchens to the Canadian Group of Painters (the group which followed the Seven and of which she had been president). She decided to lend the cream of her collection to Parkwood (the McLaughlin house had been made into a museum in 1972), where I went to admire them. So did Ian Thom, the curator of the McMichael Collection.

Noticing the lack of climate control of the house, Thom asked her whether she would allow him, "to provide them with a good home," as he said. He had every reason to hope that she would agree: she had long visited the McMichael Gallery with her friend Yvonne McKague Housser. It was now that luck served me. Thinking over Thom's request, Isabel decided that her paintings should go to Oshawa.

The gift fell in with other plans she had for the gallery, namely the building program. The gallery had been built in 1967 with a donation of $100,000 from Ewart McLaughlin, husband of Alexandra Luke. It was sized perfectly for the collection at the time: the group of paintings Luke had purchased, mostly by friends, many of them among the Eleven. With the passage of time and the growth of the collection, the building strained at the seams. Throughout the late 1970s and early 1980s the collection was stored, at enormous cost, at a company in Toronto, Bren-Art.

In 1974, the Board and I had decided to get going on an expanded building, one to be built primarily for new storage and staff facilities. The Board suggested that I get the ball rolling by raising half a million dollars. I asked Isabel to help; to my relief, she agreed to do so. The gesture was so magnificent that I suggested she choose an architect too.

"There's a young man I think you could trust – " she began, choosing her words with deliberation.

"Who is it?" I asked, thinking of the ceilings with exposed pipes which young architects so much liked in recent construction.

"Arthur Erickson," she said firmly. She recalled him as an art student to whom her friend Lawren Harris had once given a prize in Vancouver.

Although I was afraid that he might not accept such a small commission, I called him, and told him the story. "She's the only one who remembers I was a painter," he said. He was touched, and agreed to design the new gallery. Through that chain of events our beautiful new building, a jewel in Erickson's crown, was born.

Isabel's gift of money, so crucial a spearheading of the funds necessary to the building program, and her gift of the works stored at Parkwood to open the building demonstrated her confidence in the gallery, and led to many later gifts from other collections she had made: she gave work by North American native artists, more work by the Group of Seven and the Canadian Group of Painters, and work by friends such as John Hall selected from

more recent shows (I sometimes went with her on these shopping expeditions). She also gave us invaluable archival materials, among them the papers of the Canadian Group of Painters.

What she gave expanded our collecting mandate; from being narrowly focused on Painters Eleven we became a gallery open to contemporary currents in the art world, the widely based collection that we are today. For this change in our status we will always be greatly in debt to the intelligence, intuition, and enthusiasm Isabel McLaughlin brought to Canadian culture.

RITES OF PASSAGE

<div align="center">◆ ▷◈◁ ◆</div>

When John Scott and I were preparing his retrospective exhibition, we talked often about the opening. "I want to look my best," he said, "because the opening marks the point at which the artist is at the height of his sexual attraction."

When opening night came at last, John was in the midst of a debilitating illness, but he was so happy to be alive and in the gallery that he sat in a room at the back, crying. I was afraid that, for once, an artist would really not be able to say anything to the public at his opening. But after an hour, calmer, he came to the microphone. By then, I was so unnerved that I forgot to follow the usual formalities and ask the president of the board to bring greetings. I noticed my public relations officer signalling me. Only then did I realize my blunder.

So much for openings in 1994.

In the 1950s, openings, I've been told, were festive. The mood lasted for almost a decade, then an everyday atmosphere descended, and they became hard and professional – and more commercial. They are a happy enough event in the life of some artists, a way of gathering people to see work, a time to see friends, patrons, collectors, but for others, like Louis de Niverville, they are a tedious chore. As he says, "If I never go to an opening again, it's too soon." He is always charming, and smiles a lot, but for him the

opening that meant most to him was his first, at Dorothy Cameron's Here & Now Gallery in 1961.

There are artists who suffer excruciating pain at their openings. Leslie Reid told me once that when a show of her paintings opened at the Mira Godard Gallery in Toronto she went for a long walk: by the time she came back, it was over. There are also museum directors who behave like turtles. I once organized a show at the Art Gallery of Hamilton, and on the day of the opening I was visiting with the director, T. R. MacDonald, and nervously watching the clock. Close to the time, he said, "I guess it's time to go." We got into his car, "got lost," and drove around aimlessly for half an hour, neatly missing the opening. He was also an artist; that may account for his dislike of what is in some ways a rather formal social occasion.

And there is a truth to Scott's observation: an opening is something of a sexual rite. At the opening of the *Toronto Painting* show in 1972 at the Art Gallery of Ontario, Robert Markle publicly asked the show-stopper question: "How is your pussy?"

With the opening, some try to turn back time; they may diet to look beautiful, or buy new clothes, or even put on a suit for the first time in their lives, as Alex Cameron did for the opening of his retrospective. Others dress with engaging style; I recall one in a cap of metallic cloth and matching silver pantsuit. Cameron's was a grey suit with pink weave. I heard him saying to friends, "What do you think of my threads?"

Of the hundreds of openings I've attended, only two were unique. The first occurred at a twenty-five-year retrospective of William Ronald in 1975. The height of his fame had come in the 1950s when he showed with Kootz Gallery in New York, and the Museum of Modern Art and the Guggenheim bought his work. Once this glorious moment had passed, he continued to paint, sometimes well, but at openings tried to reinvent the happy past.

"Would you have people in the audience with cameras," he said to me, "not to take pictures, just for the flash? It adds to the party feeling."

A man of monumental size, he arrived at his 1975 opening in a tight red pantsuit, short cloak, and high-heeled boots. Accompanying him were two stunning Korean dancers. (When the show opened at other galleries he was accompanied by a local belly

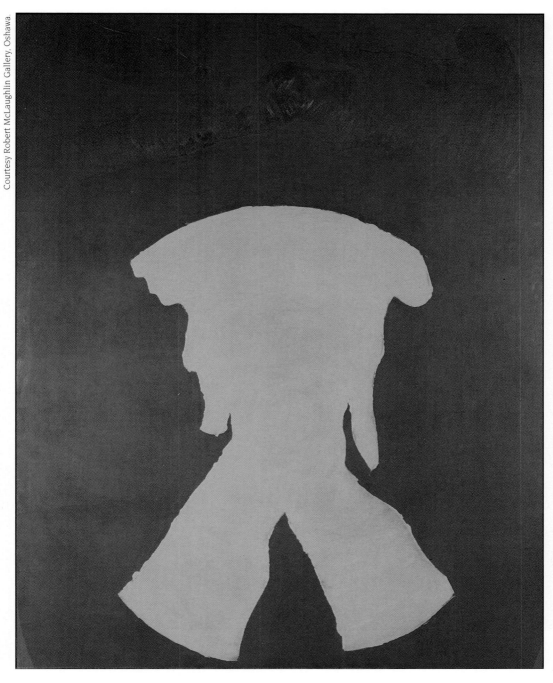

Michael Snow, *Turn*, 1961
Oil on cotton canvas, 228.5 x 177.5 cm
The Robert McLaughlin Gallery, Oshawa, Purchase, 1976

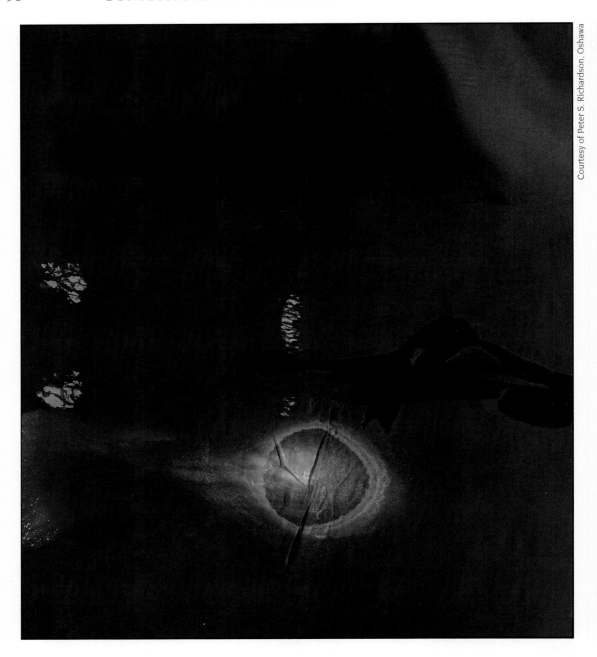

Gordon Rayner, *The Lamp* (*Magnetawan Series*), 1964
Copolymer acrylic on linen canvas, 193.0 x 160.0 cm
The Robert McLaughlin Gallery, Oshawa, Purchase, 1976

Alexandra Luke, *Journey through Space*, c. 1956
Oil on canvas, 210.7 x 148.5 cm
The Robert McLaughlin Gallery, Oshawa, Gift of the artist, 1967

Alex Cameron, *Dehra Dun*, 1994
Oil on canvas, 152.4 cm x 114.3 cm; 60 x 45"
Collection of the artist, Toronto

In 1994, Cameron visited Dehra, a town at the base of the Himalayas. His painting shows the tree line and in the background, a night-time mountain scene. Two more tree lines appear at the base of the central red area and at the top of the picture. The painting is partly about India, partly about Canada, says Cameron. The scene, with its geography of hills, mountains and pine trees, recalls Canada, but his use of brilliant colour reflects qualities of India, particularly its light. The division of the painting into three areas relates both to Indian miniatures, often divided into three separate areas of foreground, middle ground, and sky, and to Cameron's paintings of the 1970s, which he often divided into three areas.

Janet Mitchell, *Bird Dog*, 1972
Watercolour and ink on paper, 53.5 x 72.0 cm
Private collection, Calgary

William Ronald, *Darkness* #2, 1957
Watercolour and ink on paper, 48.3 x 63.4 cm
The Robert McLaughlin Gallery, Oshawa, Gift of Alexandra Luke, 1967

Emily Carr, *Wood Interior*, 1929-1930, Oil on canvas, 106.9 x 70.2 cm
The Robert McLaughlin Gallery, Oshawa, Gift of Isabel McLaughlin, 1987

Lyonel Feininger, *High Houses* III, *Paris*, c. 1913
Oil on canvas, 101.1 x 81.5 cm
The Robert McLaughlin Gallery, Oshawa, Gift of Isabel McLaughlin, 1987

dancer or a stripper. They added to the festivity too, he believed.) When the time came for the words to open the show, I discovered he was missing. For a moment, I was nonplussed. Then I remembered that in the gallery there was only one private office into which no one could see, my own. I opened the door to find Ronald seated on the chair facing my desk, wearing only red bikini underwear. My first thought was that he must be cold, and I noticed goose bumps on his skin.

"It's time to open the show," I said. "Let me help you on with your shirt."

"You don't like my body," he said, accusingly.

In 1988, at the opening of the ten-year retrospective of Rose Lindzon, organized by the Agnes Etherington Art Centre in Kingston, I asked her to say a few words. She began talking about the genesis of the paintings. In 1986, she had made a trip to Italy, where, at the Villa of Mysteries in Pompeii, she worked on an archaeological dig; in the summer of 1988, she returned to work there again. The excavation stimulated her towards inventions in the technique, process, and surface of her abstract paintings, and even accounted for some of the mossy colours and dug-out surfaces. Trying to convey her excitement, she found she couldn't stop talking. The story that began in so interesting a way was growing thin by the time forty-five minutes had passed. Even my own enthusiasm flagged, and I consider myself the most interested person at such an event. Participating in this drama with me was Robert Swain, then director in Kingston. I watched with admiration as he took the matter in hand. When Lindzon paused for a moment, he quickly stepped forward and said, "We'd like to thank you, Rose, for the excellent talk," and began to clap. Vigorous applause followed from the audience.

A crucial rite of passage for the artist is the retrospective. It usually comes to those who have been working for at the very least ten years: it signals achievement. I organized shows of this nature for many Canadian artists: Dennis Burton, Louis de Niverville, Gordon Rayner, Alex Cameron, Paul Sloggett, Ivan Eyre, even Painters Eleven ... I did so many that Adele Freedman called me "Our Lady of the Retrospectives" in *Toronto Life* magazine.

Like any exhibition, a retrospective is an artfully created arrangement, with the work displayed in a way that simplifies the

progress of an artist's development, making it clear to the viewer. For the artist it is a chance not only to show his work, but to review what he has done. It can be a landmark in his career: seeing the significant works of his past brought together in one space, an artist may find his steps are surer, his path confirmed; or he may decide on a radical change of direction. The catalogue publicizes the artist when the show is on view, and continues to do so even twenty years after the event. Such a show develops our sense of a national culture, but not every artist wants to be involved with so much work. Some fear that they (like Jock Macdonald who had a heart attack in 1960 on the heels of his retrospective) will die from

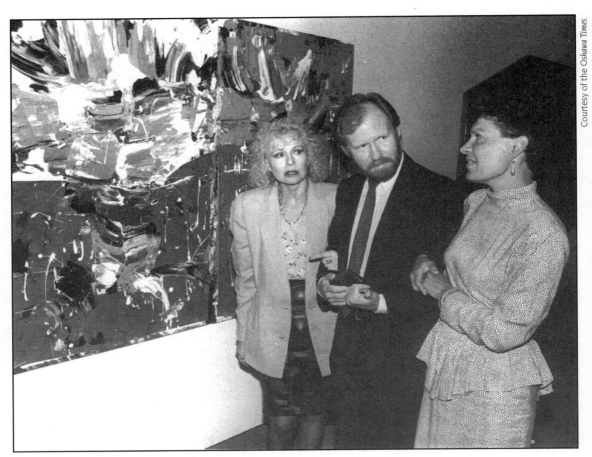

Courtesy of the *Oshawa Times*.

Opening of *Rose Lindzon: Ten Years*, Robert McLaughlin Gallery, Oshawa, 1988. (from left to right): Rose Lindzon, Robert Swain, Joan Murray.

the hard work involved. When I asked Louis de Niverville if I could do his, his first reaction was, "I'm not dead but I'll go along with it anyway." He enjoyed the opportunity of following his show to Newfoundland, where I had booked it at Memorial University Art Gallery; he never would have gone there otherwise.

"It's a good way to show who is still in the field," he said. "I think of myself as a very durable artist; I will be there till the last breath."

A third ritual enacted by each artist is the foray into the world of the dealers, the people who sell the work. This is usually a private *pas de deux* unless it erupts into public name-calling and lawsuits. Since they act as a link between the work of art and the art-buying public, dealers play an important role in identifying who is important. By their sales they help determine how much fame the artist will have. It is important to recognize that each dealer has a different style and tactics: some have enormous energy and are enthusiastic salespeople, some highly competitive, some more laid-back. There is no proper social behaviour: anything goes, as long as it works. What must occur in the end is sales or they are not doing their job.

The most successful dealer in selling the Group of Seven was G. Blair Laing. His father Archie had been a dealer before him, in the firm Laing and Roberts, founded in the 1930s in Toronto. I didn't know his father but realized how important it had been for Blair to have been allowed to organize an exhibition of the work of Tom Thomson in 1937 for Laing Galleries: it was his first big show and left its mark. Thomson was always a personal favourite of his, along with J.W. Morrice, and as the value of their work increased so did Blair's good fortune. Blair once told me that he only really needed five customers a year. They were spread across the country from Edmonton to Halifax. With a suitcase in hand, containing works by Morrice, Thomson and the Group of Seven, he visited them one by one every year, leaving works on their walls "to try." He never had one returned.

This big, sanguine, reserved man loved to show curators the private collection in the apartment over his gallery. His walls were stuffed with Morrices (he left them to the National Gallery of Canada), David Milnes, Thomsons, at which he looked with adoring eyes and over which he waxed grandiloquent. Behind their

back, he made cruel fun of scholars in the field. They hadn't learned the work through living with it, as he had done, he said. He had particular contempt for the Art Gallery of Ontario, which had forgotten to invite him to a special dinner for Henry Moore on the opening of the new wing: he felt that the omission was a deliberate slight, because he had been the first to sell Moore's work in Canada. He hated the gallery, too, because Martin Baldwin, one of the earlier directors, had not purchased from him a painting that turned out to be by Hendrik Terbrugghen.

Blair also spoke with contempt of women, although he worshipped his mother, who lived with him and was for years receptionist in his gallery. His divorce may have contributed to his misogyny. But whatever the cause, it was his dislike of women that set me on the wrong track in my thinking about Tom Thomson. He told me that Thomson would never have married Winifred Trainor, his girlfriend, since she was totally uneducated and unappreciative of his art. "In all the years I knew her," he said, "she never once spoke about his work. She expressed no interest in it whatsoever."

It was a long time before I realized he was wrong. Tom probably *did* intend to marry Winifred before he died. Education wouldn't have had much to do with his attraction to her, since he himself hadn't gone to high school. He had doubts, but not over Winifred; he doubted his ability to earn a living.

Among contemporary art dealers in Toronto one of the galleries that set the tone for the field in my years was that of Alkis Klonaridis. Greek by birth (he was born in 1943), Alkis had come to Canada as a teen-ager. It was at Forest Hill Collegiate, which he attended from 1958 to 1962, that he became friendly with David Mirvish. When he went to University of Toronto, he tried the engineering course but it didn't agree with him (he also tried accounting). Then he and Mirvish went to Paris to study French. They signed up at the Sorbonne but didn't attend one class: instead they studied the art galleries and museums. After Mirvish opened his gallery on Markham Street in 1963, it was run by Les Levine and a friend but the arrangement didn't work. The following summer, Alkis took charge. In this high-prestige gallery he learned the dealer's craft: with the cast in his eye, his slight figure, and intelligent though stammered comments, he quickly became a

fixture on the art scene. "Art to him was never a commodity, it was a way of behaving," Mirvish said. His friend Jane Corkin, who started with Mirvish as photography curator at about the same time as Alkis, recalled that he believed the purpose of art was to beautify life, an idea that became something of an anachronism as fashions in art changed. His time at the Mirvish Gallery coincided with its glory days: for over a decade it was *the* gallery in Toronto. David Mirvish's relationship with his artists was unlike that of other gallery owners. Most of them simply took a percentage of sales; Mirvish guaranteed them an income as well as making purchases himself from living artists, starting with Jules Olitski in 1964. His collection of colour-field abstraction became in time one of the most important in North America.

Mirvish's relationship with American artists provided an impetus to the changing role of the art dealer in America. His gallery helped introduce artists such as Jack Bush, Frank Stella, Kenneth Noland, and Anthony Caro. He championed the work of Hans Hofmann, Jules Olitski, Helen Frankenthaler, Milton Avery, and the Canadian sculptor Robert Murray. There was a certain air about what was shown at Mirvish: if the artists he selected didn't have it already, he created credibility for them. His gallery also played an active role in education. Many painters, gallery directors, curators (myself among them), collectors, and critics such as Karen Wilkin (today she writes for *The New Criterion*) in Canada and America treated his gallery as their classroom. He brought Canadians into a new relationship with the international scene.

In 1978, when Mirvish closed the business, Klonaridis opened his own space. Like other places in which he had his gallery later, it had a feeling of light; it also had a splendid view, looking out from the sixth floor of a building in downtown Toronto on Front Street. In his stable were artists he had introduced at the Mirvish, such as David Bolduc, Paul Fournier, K. M. Graham, and Dan Solomon, along with artists he discovered such as Gerardo Ramirez, a native of Costa Rica who became a Canadian. Later he added Alex Cameron and many others, both seasoned painters and newcomers to the scene such as Lynn Donoghue, Erik Gamble, and Tony Scherman.

I took a group of critics from the United States and England to a group show of these artists in 1980: Richard

Armstrong of *Artforum* and *Art in America* (he was later chief curator of the Whitney Museum in New York), Carrie Rickey of the *Village Voice*, Michael Shepherd of *The Times Educational Supplement, Arts Review* and the *Sunday Telegraph*, and Peter Townsend, editor of the English journal *Art Monthly*. They told me that when they saw the gallery they knew it was the dealing centre in Toronto. Alkis, they said, had the right combination of artspeak and hot talent. He was helped by his connection with Mirvish, of course, they added.

His taste, formed at the Mirvish Gallery, did incline towards an interest in American or Canadian abstraction. Such an interest was reason enough for John Bentley Mays, the *Globe and Mail* art critic, to dislike the gallery. Since the paper remains the most influential in Canada, Mays was the most influential critic from the time he came to it in 1980, a year after Alkis opened his business. A flamboyant, iconoclastic man with a modest academic background (he had previously worked at York University, marking papers on English literature), he once wrote that he broke with connoisseurship and its slavery to collectors. His criticism was characterized by abrupt changes in point of view. He might call Lawren Harris a "well-heeled bohemian, "rabbit-brained," and "fuzzy-minded;" he might praise the classical art at the Royal Ontario Museum, or the paintings of Agnes Martin at the Museum of Modern Art: one never knew what he would say next. Mostly, he saw himself as an observer whose taste was not allied with that of Clement Greenberg, the most influential art critic to emerge in North America during the post-war era. Mays' interests lay more with conceptual art, and since he was at heart a writer, he wrote well. Like Mario Amaya at an earlier date, another American (Mays was born in Kentucky), he enlivened the field. Like Amaya too, he had his band of admirers, and those who bitterly disliked him. At the opening of *Pluralities*, the National Gallery of Canada's big contemporary art show of 1980, I watched a group of artists, one of whom was Yves Gaucher, pour drinks over Mays. He handled the incident as gracefully as he could, laughing as more drinks were poured down his jacket.

In time, artists came to believe that a negative review by Mays was as good for their careers as a positive one. In 1994 an art

"Bored Game" devised for *eye* newspaper in Toronto allowed players who landed on a space that read "Mays gives artist's show a bad review" to "move ahead one space."

Alkis and Mays were natural enemies. Theirs was a battle between the spiritual believer in the full life of body and soul, and the cerebral believer in the life of the mind; on another level, it was a struggle between beauty and street smarts. Both men were loyal to their point of view and their delight in informed enthusiasms; both knew exactly how they wanted to live and what they wanted to get from life; both were highly vocal. Alkis, angered by Mays' harsh reviews of his shows, turned him out of a gallery opening one night. There were more confrontations, with Mays trying to placate Alkis through the usual art gallery peace offering, lunch, to which Alkis proudly replied, "You don't need to pay for me."

The conflict intensified. At last, Alkis hit on the ultimate revenge, he felt, for a personality like Mays: he circulated a petition to fellow art dealers demanding that there should be a second reviewer on the *Globe and Mail* art page. As for who that person should be, he asked me if I would allow my name to stand. He flattered me outrageously to get me to agree. "You have the ambition to be a good writer," he said. (After he said that, I knew how he got his artists motivated for their shows.)

Still, as a museum director I was simply too busy to write weekly art reviews. When I told him so, he spoke to me as bluntly as he did to any of his artists. "You will never be reviewed by Mays anyway," he said. "He dislikes you too much. You might as well allow your name to stand."

I couldn't argue with his reasoning.

Alkis counted the eighteen signatures he received on his letter of complaint as one of his triumphs in the art world. "Imagine," he said, "I got [and here he named some of Toronto's top dealers, among them Mira Godard and Av Isaacs] to agree."

Unfortunately, at this moment anyway, Alkis's timing was poor. The day the letter arrived at the paper, Mays received an award for art writing. "You would have hurt me if the letter had not arrived on this day," he told Alkis.

Naturally enough, from then on, Mays was careful never to review his shows. Alkis was unconcerned; he continued his ambi-

tious representation of some of Canada's more difficult and interesting artists. Even Alkis's death in 1993 went unnoted by Mays, though providentially, David Livingstone, a writer from the fashion pages of the *Globe and Mail,* wrote the obituary.

One of the qualities that made Alkis unusual among dealers was the totality of his commitment, but he knew that the dealer-artist relationship is a little like marriage and a lot like parenting. During his career he intensified qualities found in all of his artists. "He always did want the water bluer," said David Bolduc in a tribute to him after his death.

The kind of aspiration that inspires dealers brings them far into the world of the artist. Some of them even become artists. Dorothy Cameron was one of the important early dealers in Toronto: in 1959, she opened the Here and Now Gallery, and in 1962, the Dorothy Cameron Gallery. Always interested in sculpture, after her gallery closed in 1965, she selected and coordinated *Sculpture '67* in Toronto, then in 1968 and 1969 organized summer sculpture shows for the Stratford Art Gallery. In 1978, impelled by an inner necessity that stemmed from the loss of sight in her right eye, and encouraged by the Jungian analyst Fraser Boa, Cameron became a sculptor and installation artist. Her work was an extraordinary meld of sophistication and deceptive naivety, diaristic memory and observation. Despite her extensive knowledge of Canadian art, she felt no particular allegiance to it in making her own. She might draw upon the ceramic work of Joe Fafard and his studies of old people or on the boxed enclosures of Tony Urquhart, but her thought ran equally to American sculptors, such as Joseph Cornell and Ed Kienholz, and even to Florine Stettheimer (she was a semi-naive painter who was a friend of the Surrealists). More than any of these, Cameron used her dreams and her readings of Jung, plus the construction of puppets, dioramas, and children's toys, to guide her in creating her room-like settings of brilliant colour, tableaux of transformed memory. The show was one to wander through, much as Cameron must have wandered the museums she visited, themselves a form of imaginative landscape. She is clearly an original, a person who as a dealer used the art world for her own purposes and derived pleasure from its possibilities and its disci-

pline. She lived through all the rituals, the openings, the dealer's side of the relationship with the artist, and emerged as an artist. For Cameron the artist, her time as a dealer was an essential rite of passage.

THE MANY TREES OF THOMSON'S *WEST WIND*

In the beginning, I wasn't sure I liked *The West Wind*. I had entered the Canadian art field, though, and I knew I had to pay attention to this painting. I liked the feeling in it of the tree as a great cosmic force, and the way one red pine bends to the other in the shape of a harp. Tom Thomson knew (from his training in commercial art) that the use of contrasting colours gives a dynamic effect, and I liked the way he had applied an undercoat of vermilion paint, then left spaces all over the canvas, even inside the tree trunks, branches, and foliage as well as around the rhythmic hills and the foreground rocks, where the red could vibrate through the surface layer of paint. Still, even with his intention of conveying movement, the painting looked static and a little empty to me. I felt uncomfortable with it, as though there were something wrong with the picture.

The Canadian collection at the Art Gallery of Ontario in 1970 was without a permanent installation. As Curator of Canadian Art, I was the one who received letters from visitors who wanted to see the collection. One of these requests came from a couple in Detroit who counted it a high point on their annual trips north to visit the gallery – just to see *The West Wind*. I sched-

uled an appointment with them and when they arrived I took them to the viewing room near the vault. Preparators had taken the painting off the racks for us. We looked at it together. They held hands, as if in love, and gazed at the picture for a long time. I stood behind them, studying the canvas just as intently, trying to see the painting for itself and not as a reflection of what I had read. It was hard to do. They loved the painting, which I found hard to appreciate. What did they see that I could not? No Canadian curator could exist without *The West Wind*: I set myself the task of understanding it. Later, in preparing *The Art of Tom Thomson*, my 1971 retrospective, I discovered that Winifred Trainor, Tom's girl-friend, had said that he was "grieved" over the painting. Since it was one he had painted before going to Algonquin Park the last spring of his life, it was wet on his easel when he died.

Tom Thomson, *The West Wind*, and Joan Murray, 1972.
What was there about this painting that I was supposed to like?

Why was he grieved over the painting, I wondered? Perhaps he felt uncomfortable with it. At that time, J.S. McLean owned the sketch (in 1988 it was given to the AGO); I asked permission to see it, and carefully compared it with the painting. My first thought was of the difference: where the sketch, painted in the autumn of 1916, depended for its credibility on realism, the painting, developed in the studio during the winter months, was more vivid, even hallucinatory. It recalls a dream of nature, not nature itself.

In the painting, Thomson isolated and developed the motif from the sketch, simplified the design, and purified and strengthened the pattern in a way that reflects the international style of Art Nouveau, which was then very influential. For him, transferring an idea from sketch to canvas involved taking a mental step backward to deal with the subject in a different, more formal, way. In the painting, as though to indicate this mental process, there is more foreground space; the central image is pushed back. As I looked closely, I realized that the sky of the canvas was also different. When he sat by a lake in Algonquin Park, quickly delineating the scudding sky, Thomson had applied cream, blue, and grey blotches of paint to the sketch; later, after the painting was finished, he found that these were not enough to fill the composition, and judging by the little dots of paint that by accident slightly overlap the outline of the tree trunk, he decided to change the sky. This new version, with its large, rushing clouds, increases the sense of three-dimensional space – but perhaps it also helps to explain Thomson's grief over the painting.

At this point, I asked several naturalists and scientists – since they knew more about Canadian geography than I did – what they thought about the weather conditions in the painting, and specifically the sky. In the opinion of meteorologist Leslie Tibbles, "The sky is more of a spring sky … The clouds were painted later than the main motif. That's why they are not in harmony with the rest of the work."

When I again stood in front of the painting I thought I understood what Tibbles meant. The picture was a composite, and the different parts had not combined well; it has a subtle disharmony. If the wind is blowing the waves towards the rocks on which the trees stand, it must also blow the clouds towards the

viewer. Yet they seem to be moving backwards, into the picture, towards the distant hills. Thomson may have wanted to make further changes in the painting, but he was in such a hurry to get to the park in the spring of 1917 to record the snow that he left it as it was. He must have planned to change it at a later date, if he could. The painting was therefore a finished work, and a good painting, but one that had not pleased the artist. He would have worked on it more, if he had lived. Fifty years later, in 1967, the painting had become an icon of Canadian art. With all the changes in art, and particularly the taste for more spontaneity, later viewers saw the work through the prism of their own time. They would not see it with the artist's eyes – but I thought that I could.

In the years since then I have asked the painting different questions. One of them was whether Thomson might have found inspiration in Shelley's *Ode to the West Wind*, or in the poems of William Wilfred Campbell, a poetic "son" of Owen Sound, the town where Thomson grew up. He leaned more towards Shelley: the troubled sky of the painting recalls the wild west wind of Shelley's poem, "thou breath of Autumn's being," and winter will not be far behind the wind blowing through Thomson's picture. The water looks cold. He also may have been inspired by the title of one of Arthur Lismer's paintings, *A West Wind, Georgian Bay*, shown at the Ontario Society of Artists exhibition during the spring of 1916. (Today the painting, which is in the National Gallery of Canada, has the less exciting title *A Westerly Gale, Georgian Bay*.) When I studied it in Ottawa, I could not believe that Lismer's subject, a small windblown tree on a rocky shore, much influenced Thomson. Yet it had been painted from the kitchen window of a summer cottage belonging to Lismer's friend Dr. MacCallum, at Go-Home Bay; Thomson had also visited Dr. MacCallum, and had surely looked out the window at the little tree. With his *The West Wind*, he could have been making a joking reference to Lismer's. It was the kind of artistic banter that both men would have appreciated: perhaps Thomson, or more likely, MacCallum, even mentioned the comparison when they were on the fishing trip that they made together to Little Cauchon Lake in Algonquin Park in 1916. It was on this trip that Thomson painted the sketch (as MacCallum wrote later). Thus, the subject would have been a matter of a shared achievement.

At other times I wondered if Thomson thought of Ruskin as he painted. He had read Ruskin as a student, and the English critic, in one of his books, expanded on an allegorical view of nature. To Ruskin the vine was a symbol of waywardness, and the pine of steadfastness, since it refuses to bend with the winds. The two complemented each other, he said. Could Thomson have wanted to paint these polarities? During the winter of 1916 and 1917 he had painted *Autumn's Garland*, a canvas in which a garland of Virginia creeper twines around different trees, and then *The Jack Pine* and *The West Wind*. He may have been trying to make allegorical images of the nature of life, and perhaps his own life in particular, and his struggle to be a painter. It is possible that he even painted the career choices that lay before him that year, a year in which he renewed his dedication to painting. Not long afterwards, in a letter to his father written in the month of April, he said, "I will stick to painting as long as I can."

In *The West Wind*, Thomson continued his exploration of other ideas, too. Implicitly, he expressed his admiration for heroes such as Lawren Harris and Louis Comfort Tiffany, the great American designer of stained glass and the decorative arts. From Harris Thomson took the broad handling and the almost square format of the canvas, as well as the three-dimensional yet flat effect of the hills and foreground rocks. Echoes of Tiffany's ecclesiastical designs for stained glass, his expansive nature worship, and his fascination with the Art Nouveau style are equally front and centre in the large, richly coloured luminescent areas and shapes in both *The West Wind* and *The Jack Pine*.

Thomson's choice of the tree and the thoroughly Canadian scene conveys a message of "Canada First." In his paintings we can now see the first glimmerings of what was to become a Canadian tradition, distinct from those of America and Europe. His absorption in this theme can be traced through all the work he did that winter. He had already based one painting on the theme: *The Pointers*, his epic of logging in the Park. Here boats stream horizontally across the surface of the picture in a way that recalls Canaletto in his paintings of the Festival of the Doge. By evoking the composition of the eighteenth-century Venetian master, Thomson awakens our minds to the visual metaphor; he was saying that the pointers, the pointed boats of the loggers, are the gondolas of the north.

Today, as I sit in front of the painting in the Group of Seven room at the Art Gallery of Ontario, I pause to think about it again. It is a powerful canvas; resonating with its message of weather and wind, it expresses the divine as some of us imagine it in Canada. This is the sort of tree that would stand at the gates of heaven to open the doors of the kingdom.

Again and again Thomson painted trees on rocky shores, from the time of his first trips north. In the summer and autumn of 1916, he focused on the subject, and painted several studies of trees blown by the wind. At about this time, probably at Carcajou Bay on Grand Lake in Algonquin Park, he painted the sketch for *The Jack Pine*. The sketch for *The West Wind* was probably painted at Cedar Lake – Winifred Trainor, Tom's girlfriend, believed that it was. (Others thought it might have been painted further north, possibly in Pembroke.)

The pine is not the only tree in Canadian art; yet it is a tree that lurks in the unconscious of the country. In a nearby gallery hangs Archibald Browne's painting *Moonrise* (1898), which expresses an earlier aesthetic, based more on American and European models; it is an example of what is today called Luminism. The painting is one that Thomson, as a student, may have seen. What we notice first is the delicacy with which it evokes its subject: pine trees frame a night sky, with a bright moon apparently caught in their branches. Silvery waters below gleam with its light. All is quiet harmony. We feel that we could step onto the path that leads into the distance, and be rewarded by the view. It could never be mistaken for a Tom Thomson; it is far too gentle. Thomson wanted to evoke the power of the north in a picture – to slam a home-run. His was a new aesthetic, which through its simplified shapes, powerful contour lines, and bold use of colour foretold the advances of modernism in the twentieth century.

Today, eighty years on, *The West Wind* has become a symbol of Thomson. As I look at it, I find my mind drawn back irresistibly to the mystery of his death by drowning and I know I am not the only viewer who can never forget his tragic end. Such a death makes us think of one nature god in particular, Egypt's Osiris, who died each night and was born again with the sun. The Egyptians credited him with the introduction of agriculture. The painting has become a kind of fetish, a sign of the power vested in

the earth gods. In the Old Testament (Isaiah 65:22), it is said, "For as the days of a tree are the days of my people ... ," and the verse expresses something of the modern interpretation of the spirit of the painting. The image, inscribed in memory, seems almost a talisman to ensure the continuation of the northern landscape.

From the time Thomson painted it, it has been continually resurrected, like our memory of the painter. The first to use it in their work were Tom's peers, the painters who in 1920 formed the Group of Seven. In that year Arthur Lismer and F.H. Varley recycled his image of a tree against a rocky shore when they painted canvases of Georgian Bay, and in 1921 Lismer used the idea again in *Pine Tree and Rocks*, another Georgian Bay subject. By 1924 Carmichael was using the idea in one of his most important large oils, an image of a pine tree on a rocky hill over the Upper Ottawa River, near Mattawa. With time, the idea of *The West Wind* as a national symbol grew stronger. By 1934, Lismer was able to write in a magazine article that the tree was a symbol of the character of Canadians: pines, which stand steadfast against the wind, he said, are emblematic of our resolute nature. He called it a "powerfully inspiring motif ... a design – arresting, sombre, adventurous – and typical." Fred Housser, the author of the first book on the Group of Seven, *A Canadian Art Movement* (1926), compared the painting to poetry. "It is northern nature poetry," he said, "which could not have been created anywhere else in the world but in Canada."

With the advent of the Canadian Group of Painters, founded in 1933, Thomson was rediscovered yet again: many of the members had a Group of Seven phase as they developed their own style. Some of them took inspiration from Thomson – as do many novices trying to find their feet in the field. There was something rich about his work, something modern, which combined high art and moral seriousness about Canada. From Fred Haines, principal after J.E.H. MacDonald of the Ontario College of Art (and owner of two Thomson sketches), to Pegi Nicol MacLeod, who in a wintry sketch evoked Thomson's trees on a rocky shoreline, or W.P. Weston who in his 1934 *Whytecliffe* painted a tree on the edge of a cliff, later artists found in Thomson's work a seemingly inexhaustible source of motifs – and his single tree, recycled, began to be one of the rituals undertaken by every newcomer to Canadian art.

Through echoes of Thomson's work, artists transmitted social values, linking the wilderness to a growing national consciousness. His paintings gradually acquired the historical depth that only time can give, creating an idyllic picture of the North and classic Canadian culture. No new art movement could ignore the precedents Thomson and the Group of Seven had set. When Painters Eleven, the first abstract painting group in Ontario, emerged in 1953, they saw it as their role to replace the Group of Seven – with their own members and subject matter. The next generation of Canadian artists was even firmer: they wanted to reject the Group of Seven's great subject, the landscape. "Every damn tree in the country has been painted," growled Graham Coughtry, as he began to develop his theme of the female nude. Yet in his work the use of painterly texture reminded his colleague Dennis Burton of the Group of Seven. "I've always considered Graham to be a Group of Seven figure painter," he said in 1976.

With the 1970s, painters reclaimed Thomson for the cause of nature and the north. Harold Town and I had both written about Thomson, and we had seen in him an exciting painter, whose abstract and painterly qualities, though they had not previously been recognized, were as crucial as his subjects. By the early 1980s, yet another aspect of his work again seemed to fit the dominant political agenda in art: abstraction was on its way out, representation on its way back. Representation was becoming important again in art. In Canada, artists thought of Thomson.

Painters imagined Thomson as a Canadian innocent, driven by obsessive concerns. Usually his sketches were preferred to his major canvases. For Joyce Wieland and John Boyle it was the myth that counted, and they used it to underscore similar concerns of their own. Others referred to it as they created their own work: Gordon Rayner attached a man's hat to a 1989 painting he titled *Evidence II (Concerning a Drowning in Canoe Lake)*, and Michael Snow, in *Plus Tard*, played with where and how *The Jack Pine* was hung at the National Gallery of Canada. Rodney Graham's *Camera Obscura*, a 1979 multi-media work, included a Cibachrome print of an inverted tree, combined with a cardboard and balsa-wood model (showing the way it had been made using an early form of camera). The work's focus was on the precarious condition of the environment. The image of a tree was used again in 1995 in

Iconograph-a-Tree, a show by urban painter Brian Burnett at Gallery One in Toronto, in which every painting had the word *tree* worked into both the title and the subject: "Indus-tree" was one of them. The use of a Thomson motif adds a familiar quality to contemporary work, and painters who use it think of themselves as part of the family of Canadian art.

Best of all for such painters is the thought of Thomson's life in nature, painting sketches in Algonquin Park which he then developed in the studio in Toronto. In recent years it has directed many artists into the woods, bypassing urban centres of culture. The migration includes painters such as Richard Gorman, working near the Bancroft area west of Ottawa, David Alexander in Saskatoon, Rae Johnson in Flesherton, Ontario, and Alex Cameron, who travelled to Algonquin Park and points west. For all of them the study of the natural world became a grounding device for their work. Today *The West Wind* has entered the world of popular entertainment, as independent of its author as it is of its medium, appearing in Roy Macpherson cartoons in the *Toronto Star*, and on T-shirts, wristwatches, coasters, plastic placemats, jewellery, and framed reproductions sold in gallery shops.

My latest discovery about Thomson points us towards another branch on his tree of influence. As a youth he was trained by the naturalist Dr. William Brodie, who from 1903 until his death in 1909 directed the Biological Department of the Provincial Museum in Toronto. Colleagues later recalled the breadth of his interests. He was a scientist who had the eye of an artist, and he was a philosopher of sorts, seeking a deeper explanation of the phenomena he observed. The facts and surfaces of nature were invested with mystery for him as they were for his student, Thomson, who under his guidance gained the eye of a naturalist. As a result, he saw nature accurately, and conveyed his knowledge in his sketches. In some of his sketches, particularly those in which he accurately recorded the seasons in Algonquin Park, he is as much the observing naturalist as the shaping artist.

The gifted nature artists of the last decades of the century form one group of his heirs. Like Thomson, they paint nature; what is different about their work is the vantage point. They aim to portray what Robert Bateman calls the "particularity of nature." They see individual species, habitats, or interactions, and paint a

particular bird or mammal. For them it is this depiction that counts; the background can remain generic. Curiously enough, many of them grew up in the circle of naturalists around the Royal Ontario Museum, where Brodie worked earlier in the century. Here, in 1942, Bateman joined the Junior Field Naturalists' Club and became skilled in bird-watching and ornithology; he even remembers attending meetings in the ROM's Brodie room. Others, like Thomson, worked in Canada's national parks; Bateman spent his summers from 1947 to 1949 working as a "Joe-boy" (his words) digging garbage and drying (never washing) dishes at a government wildlife research camp in Algonquin Park in northern Ontario. Bateman later experimented with a range of painting styles, including that of the Group of Seven and Cubism, until an Andrew Wyeth show he saw in 1962 at the Albright-Knox Gallery in Buffalo, New York, convinced him that a realistic style was best suited to his artistic aims. If he had not had these experiences he might not have become the painter we know today as one of Canada's important wildlife artists.

An ornithologist who had the good fortune of studying with a member of the Group of Seven was Terence Michael Shortt. In 1938 he travelled to the eastern Arctic aboard the *Nascopie* in company with Fred Varley. Shortt, a brilliant observer of birds in the field, always said that Varley's instruction had been immensely valuable to him; the painter's advice on form and colour stayed with him, he said, for his whole life.

It may seem a long way from contemporary painters to Robert Bateman, but even so we have probably not come to the end of Thomson's influence. Every artist who wants to contribute to Canadian culture feels that he or she has to come up against Thomson, in one form or another, or so it seems. Any morning now an artist may wake up with Tom Thomson on her mind, and say, "I may fail, but I am going to do *The West Wind* my way."

Abstraction: Visit to a Small Planet

<div align="center">❖ ❧❖❀❖❧ ❖</div>

In 1973, I asked the director of the Art Gallery of Ontario if I could extend the period of art history I covered as curator. The end-date with which I was saddled – the 1940s – seemed a backward-looking point in time, and I wanted to do the fifties too. Nineteen-sixty seemed a good year to work up to: not only the year in which Jock Macdonald died but the closing date for Painters Eleven. I wanted to be modern, and Jock always seemed to me a painter whose career bridged the introduction of modernism into Canada. He had known Varley, and thus knew about the Group of Seven – and he had helped to found the Eleven. Bill Withrow was not in agreement with my idea: he thought my commitment should be to the earlier material, but 1960 stuck in my mind as something to aim for. That Painters Eleven was the primary concern of the Robert McLaughlin Gallery was a real inducement for me to join the staff. I decided to leave the Art Gallery of Ontario.

Abstraction from the vantage point of the 1970s looked as though it had an inspiring future; today, it constitutes more of a treasured moment from our recent past, with brave holdouts such as, say, Garfield Ferguson and Sydney Drum, hiding out in the

hills. What happened in the intervening twenty years is the story not only of art but of changes in art history, and thus deserves a chapter to itself.

An enthusiasm for Canadian abstraction was common to the younger staff members of the AGO when I was there. With my friend Eva Major-Marothy I went to the library to look at the paintings by Macdonald, which Miss Pantazzi, acting on the advice of Nancy Robertson Dillow (who had organized Jock's retrospective), had hung on the walls. Among them was his great red and black abstraction *Fleeting Breath*. In my office I later hung a canvas which was among his last, *Nature Evolving*. I enjoyed looking more closely at the image of fecundity, and its beautiful turquoises and pale yellows.

Within a few weeks of my arrival in Oshawa, I received a phone call from a university professor with a request to lecture.

"Why not do Painters Eleven?" he said.

Why not indeed? I admired the work of the group but alas, it was from afar: I didn't know much about them. They looked then, as they do now, like the group that, in their bold conviction that they knew what was good for Canadian art, might actually replace the Group of Seven. Although the Automatists in French Canada were five years earlier on the scene than the Eleven, their focus was on Paris, and as a result they had many recollections of the Surrealists in their work. The Eleven, who had sought and found inspiration in New York, looked fresher, tougher, and far more interesting.

That didn't mean I knew enough about them. I began to work with the material, interviewing surviving members, or relatives, students, critics, dealers, and acquaintances to build up a body of knowledge. I interviewed them individually, asking about their relationships with the others, Harold Town about Alexandra Luke, for instance, or Ray Mead about Jack Bush. By 1979 I had twenty-eight interviews in hand, an accumulated file of documents including a list of meetings, an exhibition history by our excellent registrar, Jennifer C. Watson, and a note by myself on the role of Clement Greenberg (with an interview and correspondence with Greenberg himself). I felt ready: I organized a retrospective of forty-eight works which circulated to eleven galleries across Canada. It had a major catalogue by myself, illustrating all of the paintings, ten of them in colour.

Later I heard from video curator Peggy Gale that the sight of the catalogue inspired her to begin a similar job at Art Metropole where she was working. The show put the McLaughlin Gallery's collecting guidelines on the map of Canadian art history, where they needed to be. As a result of our policy becoming more widely known, we began to receive gifts of P11 works. In 1979 Walter Moos gave us Hortense Gordon's strong *Colour Study*; he didn't even want a tax receipt, because her work at the time had little value.

Knowing from the Museum of Modern Art in New York that the best way to raise people's awareness of a landmark of art history is to publish work repeatedly, I wrote about the guidelines of the gallery in every catalogue I prepared. I lectured on them too, at art galleries and universities across the country. Today, Painters Eleven is widely recognized as an important chapter in Canadian art. Its members were included in the large exhibition of abstraction at the National Gallery of Canada, *The Crisis of Abstraction in Canada,* in 1992, and in an exhibition organized by Dr. Ross Fox for the Mead Art Museum at Amherst College in 1994, which toured the United States and Canada.

In the future, the reputation of the members of the group will only soar higher. We can take a tip from the evolution of the fame of the Group of Seven, which has grown progressively greater with the years. The Group of Seven helped to create our vision of Canada, and I believe that Painters Eleven made an equally important contribution, which will become clearer over time. As Arthur Lismer said of A.Y. Jackson's *The Edge of the Maple Wood*: "It created a feeling of settlement and permanency about a land of which my first impressions were impermanent and transient." In a similar way, the abstract painters created a way of seeing and expressing certain feelings we had about Canada, which until then had been unformed, impermanent. Or perhaps we should reverse what Lismer said of Jackson: the abstract painters revealed to us impermanent and transient impressions of what we had thought of as settled and permanent.

Thomson provides us with another clue to their future status: think of his life, chastely painting in the wilderness, with his easel set up in Algonquin Park, at home in a refuge from civilization, camping alone or with his fellows. The story is an archetypal

one, an aspect of our psycho-social fantasy life. The myth it evokes is similar to one dealt with in scores of movies, such as *The Deer Hunter*, or more distantly in *Star Trek*, where the theme is to "boldly go where no man has gone before." The main image is of male bonding in the face of the unknown. With Thomson and the Group of Seven, the unknown was nature; in *The Deer Hunter*, it was the horror of the Vietnam experience; with the crew members of the U.S.S. *Enterprise*, it was the untravelled worlds of outer space.

Thomson and the members of the Group of Seven superbly captured the spirit of "space" adventure. Sometimes they behaved like a group of young men in camp, raising their tents on the frontiers of Canadian art, in a way that for the time ironically accepted stereotypical attitudes toward the relationships of male and female, for no woman was admitted onto the crew. Not until a new group, the Canadian Group of Painters, was formed in 1933.

Painters Eleven embarked on a similar kind of adventure, though their new world was abstraction, a new kind of time and space. Painting abstractly was more like a visit to an unfamiliar planet. That the painters commonly used images such as doorways and gardens, the stuff of secret private worlds, emphasizes their view of the world of abstraction as a wonderland where rules of common logic were suspended: the home of the imagination. This time there were even women members: Alexandra Luke and Hortense Gordon.

Their quest and the rules that governed their exploration had in them some clues to the essential qualities what it takes to make a Canadian. Peter Harcourt, in *A Canadian Journey* (1994), discusses a suggestion of sociologist Marcel Rioux that, while Europeans are people of time, North Americans are people of space. "Our sense of space has always had more to do with development than with conquest," he says. "These temporal and spatial metaphors have affected our collective imagination, allowing us to achieve something like a Canadian myth." Rioux adds that if Americans have mythologized the frontier, the edge of the known, Canadians have mythologized the St. Lawrence, a river that was a route deep into the unknown. His conclusion is that the sense of Canada as a space that engulfs is central to the myth of survival in Canadian culture. Rioux's observation is unsurprising, even uno-

riginal; most Canadians recognize their land in any picture of wide open, snowy places. The image is a commonplace for our artists, poets and filmmakers, appearing in paintings by Jean-Paul Lemieux, films such as Claude Jutra's *Kamouraska*, as well as in the recent *Thirty-Two Short Films about Glenn Gould*. In the latter's final frames, the actor playing Gould walks away from the camera into a snow-covered wasteland, while a recording plays his performance of Bach's First Prelude from *The Well-Tempered Clavier*. In a letter to the editor of the *Globe and Mail*, a reader, Bryan Townsend, called it a uniquely Canadian cultural moment, as "powerfully Canadian as can be."

"Magnitude" is a word better applied to our spatial image of Canada: vastness. Albert Camus used it to describe the stupendous Quebec countryside from the viewpoint of Cape Diamond on his one visit to Canada in 1946. "For the first time on this continent a real impression of beauty and true magnitude," he wrote. Jack London used the same word in *In a Far Country*, his short story that articulates the "Code of the North," first published in 1899. "The magnitude of all things appalled him," London writes of Carter Weatherbee. "Everything partook of the superlative save himself … the immensity of the snow-covered wilderness, the height of the sky and the depth of the silence." Our Victorians understood the concept: "The Rocky Mountain immensity," they commonly described the paintings of the Rockies by T. Mower Martin, Marmaduke Matthews, and others. Yet trying to define Canada simply by calling it immense is not helpful, while the way Canadians try to define the space is: not only do they survey it with the help of tools, and eventually land registration, they demarcate it through their art. Canadian art is one of the surveying systems that help the country seem less unmanageably big – that is, measureless. One of the jobs of art is that it readies the country for assimilation by the intellect.

Yet talk of such mental mapping only reveals how akin we are in our imaginations to Americans, for whom one of the most important attributes of the United States is boundlessness. This sense of a vast landscape is for them a matter of pride, and in their art from the nineteenth century on they convey a feeling of wide open spaces. Robert Rosenbloom related Rothko's work to the landscapes painted by earlier Luminists such as Martin J. Heade:

he too conveyed empty vistas of nature as a primary source of energy and light. North Americans as a whole distill nature as they imagine it, abstracting its essential quality and transforming it into mythic imagery. From this viewpoint, all national groups are, in a sense, regionalists.

The Group of Seven and Painters Eleven evoked ideas in the American and Canadian psyche: they understood that their quest was one that involved spatial imagination, that they had to make a journey to make art. Thomson and the Seven made forays into the actual country, seeing their search as geographical. The Eleven recognized it in the topography of the picture plane. They also explored space, mapping landscape from above as Ray Mead did in *Beaurepaire Summer* (1958), or exploring details of its appearance, and thus providing boundaries. *Journey through Space,* Luke titled her important painting of around 1956: it has a cosmic energy and flow. *Infinite Waves,* Kazuo Nakamura called the flowing lines he created by painting oil over string on canvas in 1957. *As in Winter,* Walter Yarwood called a lowering dark abstraction of the cold blue-grey days. Their work often was directed towards a more mythic substructure than reality could offer: *Primordial Fire,* Jock Macdonald called his dynamic turquoise and red painting of 1957. *Darkness No. 2,* Ronald titled an exciting watercolour Luke bought (p. 101). All agreed they were on a "journey." The feeling of adventure is one of the qualities to which Canadians react in their work.

Part of the excitement stemmed from actual trips, some of them outside the country. Thomson had lived in Seattle, Washington, from 1903 to 1905. It was when he returned from this trip, after a failed love affair that hurt his vanity, that he determined to become an artist. Harris lived in Berlin from 1904 to 1907; in the latter year he went on a walking tour of the Tyrol, and then to Jerusalem and Cairo. When he returned to Canada he brought with him ideas of how to paint a picture, and of what the subject should be. Lismer and Varley had come from England so they looked at Canada with the eyes of tourists. MacDonald had worked in England in 1903, and returned to Canada with eyes opened by the paintings of John Constable, then in 1913 with Harris travelled to Buffalo to the Albright-Knox Art Gallery to see an exhibition of Scandinavian painting.

The show inspired in them a bolder vision, particularly of the "mystic north round which we all revolve," MacDonald said. They looked closely at Gustaf Fjaestad, among others. MacDonald said they found him a "remarkable gatherer and presenter of nature's pattern," and added, "we would know our own snows and rivers the better for Fjaestad's revelations." Study of the exhibition strengthened their idea of formulating a national art through landscape: "Our enthusiasm increased, and our conviction was reinforced," said Harris.

Among the Eleven, that absence made the art was equally true. Luke journeyed to Provincetown in 1947, and intermittently in the years that followed, to study with Hans Hofmann. In 1951, she attended a symposium in New York to celebrate the first official recognition of American abstract painting, listening to artists

Courtesy of the Robert McLaughlin Gallery, Oshawa

Kazuo Nakamura, *Infinite Waves*, 1957
Oil and string on canvas, 94.1 x 101.7 cm
The Robert McLaughlin Gallery, Oshawa
Purchase, 1971

like Willem de Kooning and Robert Motherwell. In Amsterdam in 1948 Macdonald met Greten Kaehler, a weaver from the Bauhaus school. They had long conversations about Paul Klee, her teacher; Ronald visited New York, and its galleries often, then moved there in 1956. The list could go on. Journeys meant physical trips as well as spiritual and painterly ones.

Artists who undertake journeys today find the same kind of refreshment for their work. Time away provides a measuring stick with which to size up problems – often they can be faced when the individual returns, or at least may present a different face. Thus, travel can be of enormous advantage to an artist, leading to giant strides in art. Janet Mitchell, in Calgary, for instance, had been introduced to automatism by her friend Marion Nicoll, who had it in turn from Jock Macdonald, who learned of it in 1943 from Grace Pailthorpe, an artist with links to the British surrealist movement. ("Sit quietly, and let your hand write by itself on a page," he said to Nicoll. He meant for her to detach her mind. Her hand would move automatically.)

All Mitchell needed was a hint. That and a visit in 1950 to New York, where she saw the work of Marc Chagall and Paul Klee, made her open her mind to a new kind of art. Like Macdonald and Nicoll she found that "automatics" meant a form of advanced play, which provided the composition with a sense of organic movement and the work with greater freedom. For her, the final result was an intense realization of the life force flowing through all things, or as Dylan Thomas described it, "the force that though the green fuse drives the flower." Her distinctive vocabulary combines an imagery of shallow depth, loosely drawn and painted, with happy hues and passages of bright colour. She particularly enjoys pouring a darker colour over a lighter background, then, with a pen, lightly touching up the forms that result – people, birds, dogs, cats, sheep, a fish (see p. 102). These crowded forms in an apparent state of flux provide a glimpse of the artistic process itself.

Gordon Smith in Vancouver, with his British background, had always been a colourist with a cool range; he thought of his painting in terms of the earthy tones of Graham Sutherland. What changed his mind about colour was a trip to Egypt in 1978. It wasn't his first trip (it was his fourth), yet somehow on this one Egypt made a difference. He went into the desert and saw twilight descend. "When the sky comes down at night and hits the hori-

zon, it's like a Rothko painting with purply greys, browns, and pinks," he said. It was the sight of the Egyptian sky that helped him to handle colour better. The impact on his work was not immediate but gradual, like a delayed reaction, but at last, he said, "It really got me."

In British Columbia, the place where he lives is so beautiful, wrapped in tall pines, with a spectacular view over the Strait of Georgia, that he finds the landscape hard to paint. What Egypt gave him was a sense of space: spatial seeing helped change the tempo of his work. "After Vancouver, the nakedness of the space in Egypt was incredible," he said recently.

Alex Cameron found some answers in paintings he made after a trip to India in 1994. His best-known paintings are those of the 1970s – abstractions of shapes that soar in his "skies," mysterious travellers who sail above rollicking earths, as in his *Nubian Sun Dance* (1977). Today, he is still painting voyagers but his trip intruded on his long-standing preoccupation with the interplay of myth and reality in Canadian landscape. An abstract painter who sometimes works from direct observation, Cameron has also consistently sought to incorporate the symbolic values of Thomson and the Group of Seven, and art-historical allusion in order to impart a spiritual dimension to his subjects.

Cameron's wedding of the actual and the symbolic is successful. He has united the two – with images drawn from his trip to India – the top of a house here, a recollection of a temple there – using the tripartite division that was so much a part of his work of the 1970s and, as he found, of Indian art (see p. 103). The bottom third of his paintings is usually the Canadian part, but in the sky above we find a mythical happening, the appearance of a god perhaps, or just the trace of his footsteps through the sky. These are the gods of the sun and of life, he seems to say: the allegorical overlay is subtle but creates a feeling of transcendent animation. With their strong and unusual colour combinations and powerful linear handling, these paintings radiate a quality of eccentric fantasy. They suggest that Cameron has conjured up not one but many exhilaratingly intense visions, and decided to apply them one after the other, like musical themes on which he can develop unexpected variations. He, like Gordon Smith, helps us better understand what we are to do about Canadian art, or where we have to go to be able to do what we should.

Alex Cameron, *Nubian Sun Dance*, 1977
Acrylic on canvas, 186.2 x 140.0 cm
The Robert McLaughlin Gallery, Oshawa
On permanent loan from Her Majesty The Queen, in Right of Ontario, 1978

HAROLD TOWN

—◆•▧•✳•▨•◆—

When I think of Harold Town, dead at sixty-six of cancer, I realize that what I will miss most is his gravelly, nasal voice, speaking in his down-to-earth way, with the occasional theatrical flourish. To me he was satirically funny, and worse, he was often right. I will always remember his imitations of me as Pollyanna, the girl with a good word for everything and everybody. I often felt like some prim lady with a big hat as I sat listening to him. But I always recognized his genius. For me he was an artist of unique panache and style whose gaiety and invention were everywhere in his life and work.

He was maddening, but lovable; noisy, but simple at heart. Once he said to me that his smart talk came from once being a kid who hung around a pool hall. "If you weren't funny in a pool room, you better be a good bullshooter or something because it was a club-like atmosphere," he said. Town was, perhaps too much, the Voice.

It was as the Voice I knew him best because I was a good listener. As an oral historian I found it vital to listen and not interrupt. I hoped to provide that perfect ear for which every artist yearns. In my research I had at least one great Canadian predecessor, Marius Barbeau, and I liked to think of him biking around the French-Canadian countryside, collecting the folk songs and arte-

facts of French Canada. The songs I collected were of the living, and sometimes they were not so much songs as barbaric yawps (as Walt Whitman said) of pain. Some of Harold Town's utterances were certainly that.

He helped teach me that the artist's words are not only a record and a log of progress; his talks with me were also a way of developing spiritual strength, mine as well as his. Town required the curator not only to listen but to love him uncritically. He turned to me like a child to his mother, as if my presence were proof of the authenticity of his life of hard work. On one memorable occasion he insisted on showing me every one of the toy horse paintings he'd done up to a certain date – and there were hundreds. On another he proved he was the first artist in Canada to use burned areas in collage. That time he swung canvases around so wildly that pieces flew and works scraped against each other. Horrified, I heard the shuddering and scratching of frames hitting glass.

The archivists and curators were to be evidence for Town of – what? Town once said "I paint to defy death." We were to be the witnesses who could testify that he had defied death. But curators always fell short. They never understood enough, never knew enough. He never allowed them any power of discrimination: Certainly no one was permitted to edit a show of his work, a key curatorial function. He regarded curators as innately lesser beings, like serfs who ought to know their place.

What I learned from him was that archival material, no matter in what depth, must always fall short of capturing the artist. Even the most extensive archival interview record is only an accumulation of detail, not a serious reflection on the past, though if it is accurate it may expose the artist's younger self, chronicle inconsistencies in the formation of his personality, and reflect shifting tastes and loyalties.

With this in mind, I recently looked again at the record I kept on Town – the interviews, correspondence, the box of clippings, a lone diary entry and photographs (even one of Town and myself). It is primarily the interviews that continue to be of interest, for they reveal the Voice.

My first record of Town is from 1971, when he talked at the Oshawa Gallery. I wasn't there, but I have a transcript. His

words make sad reading. He said, "Death is the only certainty that we have," and "It's a jungle inside of me: It's a snow-driven landscape. I walk in there and hope to find something." "I'm not sure that in some ways I'm not really simple-minded and maybe even childish and I'm not again sure that that's not an advantage." He talked about the drinking he did (he liked vodka), about baseball, and decorating Christmas trees. He talked about making art and about his parents, "very simple and nice" people who had encouraged him, he said. He talked always about drawing. "I can't remember a time when I didn't draw ... I drew over friends, under bridges and down the street. I drew in sand." (Something in his voice reminded me of Dylan Thomas in *Fern Hill*: "... and nightly under the simple stars / as I rode to sleep the owls were bearing the farm away" ... the same exaggeration, the same cadence.)

Painters Eleven was formed in 1953 because the situation of abstract artists was so abysmal, "No gallery of consequence was concerned over young artists in Toronto," and "The Toronto Art Gallery was afflicted with society exhibitions which repeated themselves ad infinitum." He spoke movingly of the group's innocence ("We never expected to sell any pictures") and their background in commercial art (his own and others). He believed, he said, in bravery. "You've got to just get up and do it every day or you don't exist as an artist."

Then about midway in his talk, the whining started. His anger was directed at earlier curators, "whey-faced Englishmen who fell off the boat." Perhaps he meant Dennis Young, my former colleague at the Art Gallery of Ontario, then curator of contemporary art. "At my last painting exhibition not one member of the Art Gallery of Ontario came near the show," he said; they hadn't come to his drawing retrospective either. He said he had met one at a party and started yelling at him. "I'm not so sure there isn't something in my nature that tries to annoy people like that anyway," he said. With that he began to abuse the McLaughlin Gallery. "This is the Painters Eleven Old Man's Home," he said.

What Town was weaving that night, and in the many talks, broadcasts and articles that preceded and followed, was the myth of himself as verbal wit. He wanted to be thought of as a wit and aesthete as well as a painter. Many of the articles written about him in his early years mention his debonair way of dressing. The young

man, as can be seen in a photograph taken of him at the Ontario College of Art, already had that important asset in any art community, style.

In later interviews I talked at length with Town about Painters Eleven. He had become a close friend of two other members, Oscar Cahén and Walter Yarwood, and the three were inseparable for a while. He stressed how open, free, and wild the meetings were. The group was loosely organized and unstructured. Being in it had absolutely no effect on his art, he said. But it offered the artists a chance for communal action, and gave younger artists something to "aim at, denigrate, disparage and finally, try to supersede." He said he believed the painter must try to divest himself of sophisticated vision. When he was doing *Tyranny of the Corner* he did "a terrific shape" in the four corners of the canvas.

Courtesy of Betty Waisglass, Oshawa, who donated the photograph to the archives.

Harold Town (1924-1990), photographed during a class at the Ontario College of Art, Toronto. The Robert McLaughlin Gallery, Oshawa.

Yarwood came to his studio to borrow something or to talk and Town said, "Look at those terrific shapes in the corners," or "Jesus, isn't that a sensational idea" (he told me the story again later). Yarwood said, "Yes, they are arrows." Town said, "Holy shit, they *are* arrows." It is necessary occasionally for an artist to reinvent the wheel, providing that a new function is provided for it.

He confided, "I tend to exacerbate any situation I am in." As our relationship matured I began to find that I exasperated Town more and more. One time in 1980, interviewing him on the erotic in his work, I must have looked puzzled when he told me he was the first artist in Canada to depict oral sex. He did it in 1962, he said, and as proof, he showed me a small drawing hanging in his front hall by the door. I looked at it, but perhaps because Town made me feel nervous standing beside me, I couldn't make out where the bodies were supposed to be. "It's very hard to read," I said, trying to be diplomatic. Town realized, to his horror, that on this occasion at least I couldn't "see." I can remember his barbaric yawp.

The interview, I should add, hadn't gone badly. We'd started by talking about the club to which Town belonged – the Swordsmen's Club, a group of Toronto bon vivants, and his book of illustrations for Canadian poems, *Love Where the Nights Are Long*. Town praised Daumier but curiously, despite his love for Picasso, he found Picasso's erotic drawings too impersonal. "They're too classical to be really erotic." He spoke admiringly of Japanese and Indian erotic art. I mentioned Graham Coughtry's love for Ingres's *Turkish Bathers*. "That would figure for a guy that's spent his time painting one picture over and over again," Town said. He believed erotic art should be about "whatever you get off on, but what the hell can compare to the fact?" "Sex is basically an impossible situation," he told me:

> No one's desires can be perfectly matched, no one can feel exactly the same desire at the same time … Somebody wants a bit more at a time. That's inconvenient. Someone doesn't want it at a time that's quite convenient so the idea that it can be perfect makes it forever interesting. It's the fact that it's never perfect and never even comes close to it that makes it permanently fascinating.

His own work of the 1950s didn't seem erotic to him. He was a formal artist, and had just looked at shapes (here he told the arrow story again). But did I know he wrote poetry? He began to recite his own love poem. My impression is that it was quite good.

In 1987 he showed me a new series, *Stages*. By now I was nervous when he showed me things. These paintings, leaning against each other on a bench, showed bright geometric forms overlapping, sometimes ten layers deep or more. Above them on the wall was an Indian tantric painting he owned, which contained the same intense, tiny, overlapping images, though it was painting and not an assembly of cut-outs. Trying to find the right words, I said of Town's new work, "They look like tantrics."

"They look like nothing else," Town said. "They're unique. I'm frightened by the reaction," he added, "people like them so well." He glared at me.

After his retrospective at the Art Gallery of Ontario in 1986 he began his acerbic comments to me in earnest. There wasn't

Courtesy of the author.

Harold Town, 1980
Harold glared at me.

enough money spent on the catalogue, the show should have had twice the space, the gallery hadn't borrowed the works it should have, the hanging was crowded, the roof leaked, the lights were out on part of the show for four days, and the preparators put a screwdriver through a picture. Still, it had been an incredible experience; the crowds were extraordinary.

But he had long since ceased to be chic. "The problem with my drawings is that I'm a virtuoso and virtuosity is not fashionable." He thought of himself, he said, as a kind of idiot in some ways because he did everything the hard way. He had refused even the grants that most Canadian artists accept as their due.

By 1986 I had begun finding Town less fun. I'd become less an archivist, I believed, more a critic and curator. I'd begun to believe in the curator's right to edit the artist's work and to act as more than the artist's apologist and cheerleader. At the Art Gallery of Ontario the hanging of the retrospective chronologically backwards (from the latest works to the earliest) was simply, I felt, a mess. It had been done to underline his great diversity, Town said. But that was never in doubt. The problem was, and remains: where's the Town in the work? The hanging made Town harder to find than ever. In the 1960s with *The Great Divide* he had a minimal and "psychedelic" period. Then came the *Stretches* of 1969, the *Snaps* of 1976, the *Eccentrics* of 1980, the *Toy Horses* in 1982, and the *Musclemen* of 1984. No wonder Robert Fulford, writing in the *Toronto Star* about the AGO retrospective, exclaimed over the number of Town styles, "You could blink and miss a whole period." Throughout, Town was drawing. He is on display, yet elusive, indefinable.

Town himself, for all his wide-ranging intellect, never seemed to ask himself that most searching question. The question Gauguin asked in *Where are we going? What are we? Where do we come from?* Town never did take stock of his understanding of the physical world, never added up his intellectual ledger. Perhaps he felt there would be no final sum. Perhaps, in the end, he believed in himself less securely. The drawings, he knew, were his essential, irreducible self; he'd always drawn. The rest seemed to be a series of hopeful projections and reachings out to the world. Hence the defensiveness, and his claim that his work was unique. Perhaps the only thing he believed in, completely and always, was his own

spontaneity. Possibly that's why he responded so suddenly to inspiration, why his style and subject matter changed so often and so quickly – too quickly (in 1986, in my interview on his retrospective, he agreed that his changes had always been "somewhat abrupt.") One time, describing a change of style, he said simply, "one thing slipped into another." Another time he said, "the stuff just appears." He also told me, "The bug walk drawings [he did hundreds] started the very day the toy horse drawings ended. There were no bug walks in that exhibition but they started that very day. I knew there were no more toy horses there. They just vanished. I was no longer interested and it just happened like that. Snap!" (He snapped his fingers.)

All he wanted to do in painting, he said, was surprise himself. He did not want to shut off any part of himself. To ask himself where he was going, he believed, would be destructive. "What you've got to be is involved with your work to the point that everything else is in essence obliterated," he said. That explained his myopia where his own work was concerned. He could not build on success in a single work since it was his path as an artist that was his success in itself: he only knew himself in and through the act of creation. He had to keep going. Only through continually reinventing himself could he know himself.

When I questioned Town in our last interview about being the Voice, he said, "I've never seen myself as flamboyant. But I realize[d] that I could be flamboyant and funny, which is not true of many Canadian artists. I mean, a duller lot you're going to have trouble finding." His voice was part of his persona, his self-image, he said, even though he wasn't so concerned with that by 1986. People had to remember his years of hard work, he said. "Thousands of things poured out and where do you think they came from? I had what? – slaves in the basement?"

In a way, although he was competitive, he was drifting, gliding. He once said he imagined that if he were any animal, he'd be an eagle, the king of the air. An eagle has peculiar eyesight: it can see both at a distance and close up. In the same way, Harold Town seemed to me to be able at one and the same time to see the contour of the earth and the tiny bug in his garden. In my imagination I still see him soaring above the crowd of Canadian artists, uttering his eagle screech.

At the end of one long interview I asked him, "What should I ask you that I haven't?"

"I don't know what it is you want," he said. That was pure Town, questioning the questioner, but those words haunt me. What was it I wanted, really? What does any archivist want? Surely the answer is that we want to hear the voice of the subject, especially such a dazzling artist as Harold Town, talking, talking, talking forever.

THE JOURNEY OF ALEXANDRA LUKE

❧

When I first came to Oshawa, I saw her painting *Journey through Space* (p. 104) and knew I didn't like it. I thought its image of outer space a cliché and that the composition seemed to have spun out of control. The whirling vigour of the central comet-like shape disturbed the character of the canvas. Big holes on either side made the viewer's eye bounce from pockets of sky to the surface of the turbulent image. I wasn't sure I liked the way it was painted either: Luke had brushed strokes on roughly, placing blue and tan areas across cloudy blue or cream-coloured ones; she had painted black strokes and flicked skeins of white paint to form a lacy pattern, reminiscent of the way Jackson Pollock flung paint across the surface of his pictures. Still, I did like her blues, creams, whites, and blacks, which together with the more literal sky-like patches suggested tumultuous spatial experience. I also liked the way the painting was open-ended in meaning: the subtle undercurrents were a good metaphor for our magical, sombre but glowing spiritual life. She had got that right, I thought.

I turned it around to read what was written on the back. There I discovered a label in Luke's handwriting with a second title, "Macrocosm." Luke's friend Madeleine Rose helped me understand what the word signified in her work. She belonged to a discussion group in Oshawa organized by Luke. One of the topics

about which they compared ideas was the significance of the writings of the mathematician and mystic Pyotr Demianovich Ouspensky, particularly his books *In Search of the Miraculous* (1949), and *The Fourth Way* (1957), in which he explained his years with his teacher, G. I Gurdjieff. They also belonged to the Society for Traditional Studies in Toronto, as well as to the Gurdjieff Foundation in New York, and its affiliated branches in Mendam, New Jersey, and Armonk, New York. Sometimes they made pilgrimages to these places for more study.

Rose simplified Ouspensky's teaching so that I could understand. "As above, so below," she said. "What goes on in the universe goes on inside oneself." He directed attention to the inner life so there would be light instead of darkness, she said. "We live in darkness but as we travel through life we have glimpses of light."

Ouspensky spoke of the macrocosm, the large world, and of the microcosm, the small world. The universe is regarded as the first, he said, man as the second. He believed the idea helped to establish the idea of the unity and the similarity of the world and man. Luke's painting, therefore, concerned both the universe and the individual, the outer and inner man. In a notebook, she expanded the thought. "The manifestation of the laws of one cosmos in another cosmos constitutes what we call a miracle," she wrote. "The cosmoses refer to problems of dimensions." Following Ouspensky, she thought of the macrocosm as a starry world in the midst of the Milky Way, and in her painting she strove to convey that image.

Now I understood the painting better. Yet as I grew familiar with the collection I found that it was an anomaly in the body of her work: the painting's spontaneous sprawling handling had blank spots. The impassioned areas, where light seemed to flash through the clouds, were not allowed to develop. In the rest of her work she paradoxically gave immediacy to emotion by distancing herself from it. Her calligraphy of line became clearer and involved more in the way of an ensemble – her colour sense changed, became lighter, more yellows and brilliant colour crept into her work as well as more forms (though these were less defined), and more texture to the surface. There was more geometry, more structure, less of an attempt to depict three-dimensional space. *Observance to a Morn of May*, painted about a year later, is more

typical, and more consistent (see p. 177). It is structured in terms of rectangular shapes that recall those of Luke's teacher and friend, Hans Hofmann, with whom she had studied from 1947 on, and show his influence. His concepts had always intrigued her: the study of space, filling the surface so it contained no meaningless passages; plasticity; forces and counterforces, his "push and pull" theory; his rhetoric of "plastic sensing" (he related the object to the shape of the paper or the outside picture plane); his colour intervals; and colour as form. She had understood quickly his essentials of a good abstract (movement, shape or negative space, rhythm, the injunction that the work "breathe a life of its own," so that it contains the "mystery of creation"). Her friend Yvonne McKague Housser who went with her one time to study with Hofmann recalled how she tried to sort out what he meant by his phrases of tension and negative and positive space, and the whole sense of expanding the work rather than confining it. In her first days of study with him, a student next to her said he had never known anyone to "get it so quickly." By *it*, he meant Hofmann's idea of reducing form to a series of shifting planes moving in space to express plastic, three-dimensional form. One thing Hofmann never did was show his students his work: he did not want to influence them to paint the way he did. (Clement Greenberg said that he was a good teacher for exactly this reason.)

Luke did see his work, though, and his influence appeared with new vigour in her work. It was at about this time that she and her friend Isabel McLaughlin visited him in Provincetown and then in New York. On one of these visits to his Cape Cod house, McLaughlin had purchased *The Chinese Nightingale*, a canvas of 1944 with what seems to be a sketchily indicated exotic bird placed at upper right (see p. 178). Below it, Hofmann painted a brilliantly coloured, spatial, abstract passage – perhaps indicating the bird's song. Nor was this the only painting by him the two women were able to study. In the house they both got a chance to look at the paintings on his white walls. "They sang out," McLaughlin said. "With the white walls, white ceiling, and floors painted pumpkin colour or gorgeous yellow, but everything else white, the paintings on the walls were simply stunning." In 1956 in paintings such as *Towering Spaciousness* he was juxtaposing squares of blue against an orange background, and building up the

surface with a palette knife in colours of red, yellow, green and white pigment. Luke recalled his way of painting in *Observance to a Morn of May* where she used blocks of colour to contribute to the effect of golden sunlight in early, tranquil morning. She was like Hofmann in maintaining a distant reference to nature: the sun seems to peek out beneath the wing of a bird. That Luke used the image of a bird also refers to Hofmann, and perhaps specifically to the canvas owned by McLaughlin. The idea of juxtaposing such shapes on a background of shifting planes was certainly illuminated by Hofmann's practice of placing forms in space.

In 1987, Isabel McLaughlin came to the gallery to view the Alexandra Luke retrospective, *Continued Searching*, with which we opened the new building. She stopped short at the sight of the *Journey through Space.*

"Who did that?" she asked, startled.

When I told her it was Luke, she said, "It certainly is not typical of her work." Her comment reinforced my idea that the painting was very unusual for Luke.

Through the years I have worked in Oshawa, my knowledge of Luke has increased, as has my admiration for her, both as a person and an artist. I could see from her photographs that she was an attractive woman, with the rounded, pleasant face of a Rhenish Madonna of the medieval period. She was athletic enough to be photographed on a horse – and that was in the 1950s when she was busy founding Painters Eleven. (She was the only Canadian artist I associated in my imagination with Dale Evans, of Roy Rogers fame.) From all accounts she was as pleasant a person as she seemed from her snapshots, and she had devoted herself to, and defended, the arts at a time earlier than my own, when the incomprehension she met was much greater. She had to be much tougher than I've ever had to be, I thought. When she first went to study with Hans Hofmann in Provincetown, Oshawa must have been completely baffled by her experiments. It was always to be a town with more of a reputation for sports than for art.

Even today the city's main industry is General Motors of Canada, and its power as an industrial centre fuels the history of its growth ("The City that Motovates Canada" it is called on a sign on Highway 2 leading into the city). McLaughlins were always in the picture, from Robert, founder of the carriage works in Oshawa in

Alexandra Luke and Isabel McLaughlin on horseback. Outside Tucson, Arizona

1878, to his son Sam, the first president of General Motors of Canada, Isabel's father. Almost everyone in Oshawa is affected either directly or peripherally by the Motors. For example, in 1956, when the population of the city was almost 50,000, a five-month strike at the company ended with an agreement covering 17,000 employees. They were not all Oshawa residents, of course, but presumably they all had an impact on regional tax rolls.

Life in the city was much like urban life elsewhere in Canada: social life had a distinctly British cast. Women were shunted into role-playing and socializing. "Unless a woman joined a bridge club she was nobody," recalled Jo Aldwinckle who came to Oshawa about 1930 from Hythe in Kent. Still, as was usual in such communities there was a core of people who appreciated art – Isabel McLaughlin, who had left in 1921 to study art in Paris; the art teacher at O'Neill Collegiate, Dorothy Van Luven, who helped

to inspire Luke to become an artist; painter Sylva Armstrong; and Aldwinckle herself, whose brother Eric became a Canadian war artist, and who after 1972 when Parkwood, the historic home of the McLaughlins, became a museum, served as the director. The group acted as a catalyst to form others. In 1930, Luke and her friends founded the Oshawa Women's Lyceum Club, and three years later it started Saturday morning art classes at Centre Street School. In 1945 Adelaide House, Oshawa's YWCA, opened and from then on, as a member of the art committee, Luke devoted much time to the exhibitions presented there. Along with Van Luven, she hung sixty-nine shows.

"Kind," friends described her, "good." Thomas Bouckley, the archivist of Oshawa, recalled that when he was in Oshawa General Hospital in 1967, at the same time that she was there, dying, nurses told him that she was one of the nicest patients they'd ever had. She would not be a good subject for a biographer; she was too dignified, too lacking in the kind of temperament usually associated with artists. On a visit to Montreal she hinted to Marian Scott that Oshawa was a difficult town for art, but she did not dwell on it, or indulge in self-pity. She was in fact the kind of quiet, unassuming heroic figure who in life is usually ignored by and depended on by everybody: a strong woman, in the sense of one of Margaret Laurence's women. She could be the leading character in one of Laurence's novels, the kind of person whose virtue is taken for granted, but who is rediscovering for herself the secret music that dances in everyone's head. She was that rare thing, an artist who had no need or impulse to live the life. On the surface, all remained decorous. Nor did she did sacrifice everything to her personal obsession. She maintained her household, responded to social obligations, served her community, and supported many organizations such as the Oshawa Skating Club, which she founded in 1939; the Oshawa Historical Society, of which she was a charter member; the Henry House Museum Committee, of which she was chairperson. Her prodigious energy and organizational skills revealed themselves at every turn. Within the Painters Eleven group, she was the one who sent out invitations, and hammer in hand, helped to hang shows. Meetings were held in her studio or her home. Within her family, she played much the same role, of getting everybody going. Particularly at Christmas family gather-

The original seven members of Painters Eleven, *1953.*
Everett Roseborough's publicity photograph taken to advertise *Abstracts at Home*, the show at Simpson's department store in October 1953, which brought together the painters who founded Painters Eleven (1953-1960). (from left to right): Tom Hodgson, Alexandra Luke, Oscar Cahén, Ray Mead, Kazuo Nakamura, Jack Bush, William Ronald.

 Although Luke's placement in the photograph may have been due to the photographer's whim, it seems to reinforce her central position in the creation of the abstract painting group. She had already organized a show of Canadian abstraction, the *Canadian Abstract Exhibition* in 1952, which circulated through Canada and the United States.

ings, she organized plays or an act, musicals or reciting. Constant activity is a key to her character. She was a person who resisted leading a private existence. As an artist, she could not afford to get too involved with life in that sense.

Yet she had a more spiritual side: she believed that the evolution of the spirit was the only true way of life, as she wrote in a notebook. Her yearning appears in the romantic name she took as a painter: Alexandra was her middle name, Luke her maiden name (in private life she was plain Margaret McLaughlin). She wanted to be liberated from imprisoning realities, from the materialistic world. She felt she had to paint, and she worked at it diligently, applying businessmen's hours, even at the cottage when others might be at rest.

The novelist Ruth Prawer Jhabvala, in an essay titled "Myself in India" (which serves as the introduction to her story collection *Out of India*) once asked herself the problematic question whether she herself, born in Germany of Polish parents, and educated in England, could be considered Indian. Her answer to this question was no. "I have lived in India for most of my adult life," she said at the beginning of her essay. "My husband is Indian and so are my children. I am not, and less so every year." India is a country that offers a special problem of adjustment, she said, for the sort of people who tend to be liberal in outlook and have been educated to be receptive to other cultures. But it is not always easy to be sensitive to India: there comes a point where you have to close up in order to protect yourself. Her strongest human ties are there, but she is the wrong kind of person to live in India. To stay and endure, one should have a mission and a cause, should be patient, cheerful, unselfish, strong.

If I had interviewed Luke at the time she painted *Journey through Space*, she might have replied, somewhat like Jhabvala, that she had lived in Oshawa for most of her adult life though she had been born elsewhere, in a more cosmopolitan place (she was born in Montreal in 1901 and lived there till 1919) but she was growing less and less an Oshawan. Oshawa, she might have added, was a town that one either loved or hated; it offered a special problem of adjustment for people like her, who were artists and hence aesthetically sensitive. But to paraphrase Jhabvala, it was not always easy to be sensitive in Oshawa: there came a point where she had to close

up in order to protect herself. She lived there because her strongest human ties were there: her husband Ewart, as a member of a branch of the McLaughlin family, and she as a member of the Luke family, were pillars of the community (his family had been important in Oshawa since the nineteenth century, hers since the early years of the twentieth). To stay and endure, one had to have a mission and a cause. Culture was her mission and painting her cause; and she was faithful to her ideals to the best of her ability. She tried to be patient, cheerful, unselfish, strong – a model patient. In an early notebook, she wrote words from the Bible that she had taken to heart: "We then that are strong ought to bear the infirmities of the weak."

She was not, in other words, the type that usually came to the land of General Motors to work on the line or as a doctor or social worker. Her painting was modern, her influences European, her preoccupations aesthetic and spiritual. Her way of adjusting to life in Oshawa was to ignore a large number of the people who worked at the Motors. Her problem was essentially one of cultural adaptation.

The problem, in a sense, is at the centre of her paintings. Many of her works have titles that point us in the direction of her thought (often a form of escape): *journey* is a word she used often. Others were *adventure*, and *encounter*. She knew that it was only human to be attracted to that which one is not, to long for that which one does not possess; she recognized how delusory most such longings are, but she craved transcendence – transcendence of uncertainty, of mortality, of the banality of day-to-day life. In her paintings, she was always seeking, travelling, reaching out for the impossible.

The longing for transcendence took the form, in her life, of a passionate interest in spiritual action from widely varying areas. She was a member of the United Church, but wishing to reach a higher plane of consciousness, she delved into Ouspensky, transcendental meditation, the Rosicrucians, and Baha'i, the faith uniting all religions.

Another avenue of spiritual adventure was modern art – in 1933, only five years after her first art instruction, she was already on the side of this new faith. It should be as pure an art as music, she said. The word "pure" again points in the direction of her

thought: art had to transcend the material world. Otto Rogers, a painter and a member of the Baha'i faith, spoke in 1987 about the desire for transcendence and its impact on his art. It was something that made him discontent with a minimum response, he said, and with ordering known arrangements. "I am led to a juxtaposition of diverse elements which one might not expect to be together." For Luke, simply being an abstract artist was enough to express her discontent with known arrangements. Hence her commitment to abstraction, her organization in 1952 of the first Canadian all-abstract show (which travelled throughout Canada and was of crucial importance to the nascent Painters Eleven), her help to Painters Eleven, her work for artists in general.

She befriended many, purchasing their work, helping them get work in Oshawa, providing support. (From a Painters Eleven show she purchased Ray Mead's *Bouquet*, works by Ronald and others; these paintings later formed the core of our gallery's collection.) Luke was trying to make sense of the world. The words she used to describe her way of painting also hint at her philosophy. "Be watchful, search out powerful rhythms," she said. "Select the points of reference, establish vertical and horizontal lines and the axis. Then come the planes and negative space – with the integration of the whole … this is the way I work." "We are all asleep," she wrote. "For instance, how many of us *look* carefully and enjoy the beauty around us – we are so blind in the fruitless vortex of materialistic living we don't see any more." She was trying to see more.

Reflecting on Ouspensky's book *The Fourth Way* provided a pathway through her difficulties. In a notebook she wrote about the prison of the ordinary, materialistic world. Her first step was to recognize the boundaries, her second a plan to surmount the walls. The walls that kept her in were partly self-created, made of her own strong emotions, she said. Sensitivity was another restricting wall but a necessary one, she thought, because only through it could she see the beauty and feel the rhythm of life. A third wall was lack of confidence in herself; a fourth, lack of memory; a fifth, habit.

Her children felt the turmoil within her. Her husband gave only limited support, psychologically and financially; he belonged to that large group of artists' husbands who like their wives to have

a hobby but dislike any more demanding activity. He liked her earlier, less experimental work – landscapes and still lifes. When she went on her annual study trips to Hofmann, he took her paintings down from the walls of their home to hang his favourites, watercolours by Frederick Arthur Verner, of Indians and buffalo (these works today are in the McLaughlin Gallery collection). Her daughter, Mary Hare, remembered that her mother was pressed for time. When she came home from school, her mother was never there, she said: it was a point of resentment with her. Luke does seem to have regarded her rather absently, preoccupied as she was with other things.

It took a daughter to pinpoint her inner pain. "She was very frustrated generally, with her art and with her position and with her family," Hare said in 1978. "This was one of the reasons that she was searching." "She was always looking for something – for more peace, tranquillity which she never had," she said.

Luke would have put it differently. Life had to be got through somehow, she might have said. The secret of her work is its complete immediacy. Very little about it was deliberately considered or planned. The meaning had to be supplied by the viewers, she would have said, which is why looking at her work is an experience of a kind of purity. In undertaking to become a painter, she was moved by curiosity and compassion and longing. Her *Journey through Space* is a joyous expression of her sense of irreligious religion. With her customary understanding and charity, she is trying to express a new system of thought. She probably chose the subject because she wanted to meditate on the energy involved in the discovery of new worlds. Never one to draw attention to herself, she is absent in person from the painting, but her essential self appears in the shower of comets, large and small, travelling headlong through space. She would have thought about the way such objects move in paths about the sun: she was doing her best to follow a similar course.

Seen in this light, her painting is loaded with meaning of a particularly Canadian sort: she is talking about space travel, science, the future. The scale of the painting suggests Luke wanted to bring her motifs to the canvases' edges and beyond. It is a space only slightly removed from the viewer's own, and this establishes a connection between us and this otherworldly woman. Yet there is

something undefined about the painting, and it is this impression that suggests that Luke was a person with a certain vulnerability. Although there are depths to the fields, nothing is explicit. The final effect is inspirational but baffling, as life must be for any traveller en route to a distant destination.

EMPOWERMENT AND THE CANADIAN WOMAN ARTIST

Empowerment, meaning having or attaining power in one's life, has become an important term in current parlance. "To empower" has been used in the dictionary sense for years, meaning "to invest with legal authority," or "to enable." The way it is used in women's studies, to mean bringing those on the margin into the mainstream, has a slightly uncomfortable fit when it is used in the context of Canadian art, because Canadian culture, for some observers, is itself on the margin, trying to find a way to situate itself in the mainstream ("the mainstream" is always defined as New York or Europe).

At this point, many writers would pause for a few statistics – about what percentage of women constitute Canadian art, for example, where they are concentrated, or where and how they live. Such figures are not relevant for us because we know that women artists have long constituted more than half the population of artists – we need only look at art schools for proof of that, and of course women live everywhere (or should we say they are concentrated in laundromats or supermarkets?). There is also an excellent and readily available group of books of feminist theory on women and art. A good starting point would be *Feminist Art Criticism,*

edited by Arlene Raven, among others (1988), and *Making Their Mark: Women Artists Move into the Mainstream, 1970-85*, a catalogue of a 1989 exhibition. But these texts discuss American art. To open a discussion of women's art in Canada it is more fruitful to approach the idea of empowerment from several different angles – the empowering or disempowering effect of the Canadian art milieu, the empowerment of women artists by other women and their art, and the empowerment of all of us by women artists and their work. In sharp contrast with other fields of endeavour in Canadian life and business, women have had comparatively enormous success in art. Today we consider Emily Carr a star of great magnitude, comparable in every respect to members of the Group of Seven, and we count among leading contemporary artists women such as Joyce Wieland, Irene Whittome, Joanne Tod, Geneviève Cadieux, Liz Magor, Betty Goodwin – there is a long and distinguished list.

Many of the directors of museums are women. The National Gallery can almost be called a matriarchy: it has had women directors for the last twenty-five years. Joyce Zemans was in recent years the head of the Canada Council; Susanne Rivard-Lemoine laid down the structure of the Canada Council Art Bank; *artscanada* and *Canadian Art* have had women editors since 1967, from Anne Brodsky to Susan Walker, Jocelyn Laurence, and Sarah Milroy; *Vie des Arts* was founded and run from 1964 till 1986, the year she died, by Andrée Paradis; Pat Fleisher founded *artfocus* in 1992, and is its publisher and editor (before that, she founded and edited *Artpost*, and *artmagazine*); *C Magazine* now has a woman editor, Joyce Mason. Ydessa Hendeles started her own art foundation; Mira Godard and Sandy Simpson are among our most prominent dealers. In Oshawa, a woman who had been trained as a nurse, Alexandra Luke, was a member of Painters Eleven. The group held its first meeting in her studio between Oshawa and Whitby, in 1953.

But despite this obvious and widespread success, over many years, many women still feel excluded or marginalized. Those who make crafts are excluded from the category of fine art: in Oshawa, Jane Dixon, a painter-stitcher, has never been allowed to enter her work on fabric in the annual juried show of the Oshawa Art Association since fabric art is not considered an

acceptable category by that group. Calgary's Mary Scott uses fabric as an art material for just that reason – her swatches of parachute silk and hanging plastic are a protest against "fine art." And there are museum directors in regional centres, who champion women's art, as I do in Oshawa. Women's art is given a significant place in the McLaughlin Gallery collection guidelines: I know of no other institution in the country with the same commitment, though many galleries regularly exhibit women's art. We should also realize that in dealing with empowerment in Canadian art we must recognize that there are two different levels – an artist can be known and highly respected in the art world, yet never really break through into mainstream public awareness.

We in the art world watch developing artists with something akin to motherly pride as they make their way into shows, have their first reviews, then rise to the heights of say, a review in the calendar section of *Canadian Art* magazine, and then in the *Globe and Mail.* However, an art-world reputation, so fervently argued or defended, a matter for so much gossip and bitter in-fighting, can only become a mainstream reputation with a full-scale retrospective, preferably at one of the three major institutions – the National Gallery of Canada, the Art Gallery of Ontario, or the Montreal Museum of Fine Arts. Such a show often arouses the interest of the international media, especially the American magazines *Art in America, ARTNews* or *Art Forum.* The artist may then be included in a group show that travels abroad, perhaps he or she will have international sales, give a few radio interviews, be reviewed in *Maclean's.* And when that happens a Canadian Art Star is born.

Among mainstream art stars we can count only two women – Emily Carr and Joyce Wieland – although several are up and coming. Both Carr and Wieland have had retrospectives at the National Gallery of Canada – Wieland in 1971 and Carr, curiously enough, with an all-out show only quite recently – in 1990 – though there have been numerous smaller retrospectives on other occasions, notably at the Art Gallery of Toronto in 1945 (the year of her death). Among the artists moving into a star position we must count Jana Sterbak, who had a retrospective at the National Gallery, and Joanne Tod, who had a retrospective at the Power Plant in Toronto, both in 1991. We can add to the list Irene Whittome,

who had a retrospective at the Montreal Museum of Fine Arts in 1980, and Vera Frenkel, who recently has won a number of important awards for her work, among them the 1991 Toronto Arts Award, and the 1989 Canada Council's Molson Prize. In 1992 Frenkel was invited to Dokumenta in Germany where she was given her own site for an interactive video installation.

Now that we can name our stars, we can look at how empowerment works. Two examples will show us empowerment in action, either in terms of an artist's life, or her work. The first incident is for me one of the most touching in Canadian art. Joyce Wieland attended Central Technical School in Toronto from 1944 to 1948, and in the first few days she met Doris McCarthy, who was a teacher there. McCarthy was the first woman artist Wieland had met, she became a powerful role model. McCarthy's example made Wieland realize that she could be an artist. In 1978, over twenty-five years afterwards, Wieland was still calling Doris "the most exciting woman I'd ever met." She told me:

> I never knew there were women artists. When she walked into the classroom with the tweed skirt and the Shetland sweater she always wore, you could feel her warmth and her kindness. The first and biggest influence that came from an artist was when my friend and I went out sketching outside the city limits and we each brought back paintings. Marguerite Jenkins and I showed them to Doris McCarthy. She said "Marguerite, it's too stiff." She saw some rolling things in mine of a landscape and she said, "You've got to have that movement." McCarthy was A.Y. Jackson and all those people. I've felt now that I've gotten direct influence through her, of the whole Canadian landscape. She said, "This is more important. That expression comes in a movement of the land," and that was the first time that ever happened! From then on, I worshipped the ground she walked on. I imitated her. I even wrote her a note when she had her last show because I never told her what she had meant to me.

... She was a very great teacher. She was the first Bohemian I ever met. I had never seen an artist and how they acted. I was fascinated by the way she dressed and she drove a Jeep. She wore these great big boots and big Army coats and things. I thought, "Wow, I can dress like that if I want to." So I did.

How did McCarthy see Wieland? McCarthy told me recently she considered her student to be a "poor little kid not getting proper support from home." "Wieland was very talented," McCarthy says, and recalls how she fought to get her out of the general course and into the art course, a crucial step which put Wieland on the path to becoming the artist she is today. Clearly, from her own account, we realize that what Wieland gained from McCarthy was a sense of her mission as an artist, and a living example of how she might conduct herself in the art field. It was not so much a matter of technical advice; there was some of that too, but there is no trace of any influence of McCarthy's work on Wieland as a mature artist. The influence was personal.

In another incident of empowerment, the influence was all on the artist's work, and the empowering agent was not a teacher but a painting, and beyond the painting, the reputation of a woman painter, Emily Carr, who by then (in 1942) was bedridden. Joan Willsher-Martel, at the age of sixteen, visited the home of friends in British Columbia. There she saw a Carr painting of trees. "I was very influenced in my choice of subject by that painting by Carr," she said recently. Her work as a mature artist uses the British Columbia landscape, but abstracted. Her technique, seemingly obsessive, details the landscape through Monet-like paint bits, which echo the process of photomechanical four-colour reproduction, building up the image through a screen. The effect is of forms silhouetted in the midst of gorgeous, atmospheric curtains of colour. Carr is in there somewhere, but Willsher-Martel's work is not so much the result of reasoning as an instinctual reaction to Carr's love of the B.C. forest. She has dipped into the wells of thought beneath Carr's art, but her work suggests more the nature of visual experience than a specific place. What we feel when we see it is its mystical association: She seems an heir to the

Romantic tradition, and she herself sees her work as part of a larger quest for spirituality.

The empowerment of women by women can occur in different ways. First of all, through the work of these artists a woman can articulate specifically female insights, how we feel about ourselves: primarily the burden of being a woman. It's as much internal as external. I think of Jana Sterbak's *Vanitas: Flesh Dress for an Albino Anorectic*, 1987, about which so much ink was spilled when it was shown in her exhibition, *States of Being*, at the National Gallery of Canada in 1991. I personally did not find the flesh dress disturbing: the dress, which was made of twenty-three kilograms of raw, salted flank steak, which decayed and had to be replaced, looked to me simply pretty and even fashionable, as though it were a re-creation of a dress of the 1920s. Diana Nemiroff, in the catalogue, saw it as a much darker vision, calling it "a profoundly ambivalent object ... both body and garment, interior and exterior, human and animal, external horrifying metaphor and decaying fleshly presence." The artist, on the other hand, was quoted in the catalogue and newspaper accounts as speaking of the work as a *memento mori*, or reminder of death. The work made a direct reference in both structure and motif to the Vanitas paintings of the Baroque period and to the philosophic issues behind them, such as the passage of time and the meaning of life. That the meat aged, dried out, and had to be replaced was appropriate to the intention of the work. There was one more issue at stake that I thought obvious, although no one mentioned it: the flesh used to make the dress, as a metaphor of the body, made an ironic reference to the way women have been regarded, by some men, as simply flesh: "a piece of meat."

Women artists can be at their fiercest when they paint a piece of meat; the heart of the matter is rage. Mary Pratt in her *Service Station*, 1978, for instance, painted half a moose carcass hoisted on a truck in a garage, but the subject seems more personal. Pratt, when she was painting this work – so different from her usual mellow subjects – was thinking, she said, of one of her children who had been in the hospital and what she'd gone through as the child's mother, the body as a piece of meat again, this time her child ("they treat you like a piece of meat," she might almost have said of her child's time in the hospital). Viewers may see more in

the image if they study the posture of the legs and the way the body is tied, with its overtones of cruelty. "A female statement about a male world," is how Mary Pratt described it to me.

Joanne Tod sometimes paints women's underwear and legs, but her subject is less sexual display than the identification process by which we get to be known. In the 1990 painting *No Compensation*, 1990, which figured prominently in her recent retrospective, she pointed out that both women and natives suffer from what she says is "an inaccurate identification process." Here we see a native and also a person dressed in Indian clothes – Betty Hutton, wearing buckskin in a still from the old movie *Annie Get Your Gun*. The figure of the woman is reversed and dropped down – it doesn't really conform with the internal logic of the painting. Over the painting she laid a pinstripe grid reminiscent of an early Frank Stella painting, which doesn't "fit" her realistic imagery. Thus her title, she said recently, "refers equally to native rights and not compensating for the glitch in the overall logic of the picture."

Woman artists also can focus the viewer's attention on specifically female imagery. Joyce Wieland was one of the first women artists in Canada to refer to menstrual blood in a work, in her painting in the National Gallery of Canada, *Heart On*, 1961, where she used red ink to describe some of the romantic "accidents" on a sheet. "It's meant to do with birth and blood," Wieland said. She made the bed a kind of theatre: "The curtains and the things that are tied; the corners; love; blood and all the things that go with it." Wieland added "There is a tragedy in the centre of that thing. It has a lot to do with my mother's death." In her work at this moment and later, there are secrets in some of the pockets she's built into the work by gathering cloth or paper together – messages, pages of texts she finds relevant.

Mary Pratt has repeatedly stressed the personal and aesthetic fulfilment found in accepting a woman's environment, which for her primarily is the kitchen. Her jam jars, lunch boxes on the window sill, her Christmas turkey (p. 179), seem charged, expectant. Often we feel some epiphany is about to take place, though the only indication we can see of any angel visiting is in the light. Her pictures are effective for being of utterly commonplace objects, which underline the ordinariness of women's lives. They bring dignity both to the objects and the lives of which they are a reflection.

Joyce Wieland paints more openly some women's inspiration, as in her canvas *Artist on Fire*, 1983. "I painted a ... sort of hero ... in a state of sexual arousal," Wieland said in 1987. She continued:

> Although the woman in the canvas is an artist, and seems to be me, she finally began to look like Madame Pompadour, with her familiar hair style. The flames coming out of her back portray the way I felt when I was painting her picture. The painting is really about creative fire and sexual fire.
>
> The setting seems to be at Versailles. I enjoy putting myself into a historical context and acting out history as a character in my paintings. Not that this happens all the time; but when it does, I take great pleasure in playing the part.

For many, *Artist on Fire* is not so much a provocative statement of desire as a happy fabrication exalting women. An element of reality, Wieland's own face, pierces the dreamy soft-focus of the technique so that we look into the scene as into a theatre; the curtain has risen and we perceive life as it ought to be, according to Wieland. The work is a landmark since it contains what I think is the first erection in a major gallery painting in Canada.

There are others who have dealt frankly with women's sexuality such as Donna Ibing who likes to make fun of the way men have seen women. She turns the tables. What men have done to women, she does to men – taking off their clothes, making them sex objects, walking on them (literally – she puts the pictures on the floor so you can walk on them). Look for instance at her version of Manet's 1863 painting *Le Déjeuner sur l'herbe* – of a recumbent man with food placed strategically on his body, and compare Joanne Tod's treatment of another Manet, his *Olympia* in her *Amway Consciousness*, 1987. Ibing takes the clothes off the arrogant man in the original Manet, and covers him with food, so he's the lunch. Tod uses Olympia's reclining position to criticize a woman without consciousness of the environment (see p. 166). Linda Ward Selbie looks at the objectification of women in the eyes of men. In works like *Dressmaker's Form* and *Trash Queen* she uses

Donna Ibing, Le *Déjeuner sur l'herbe* #2 (*Fast Food*), 1991 (floor piece)
Oil on canvas, 193.0 x 101.6 cm
The Robert McLaughlin Gallery, Oshawa. Purchase, 1995.

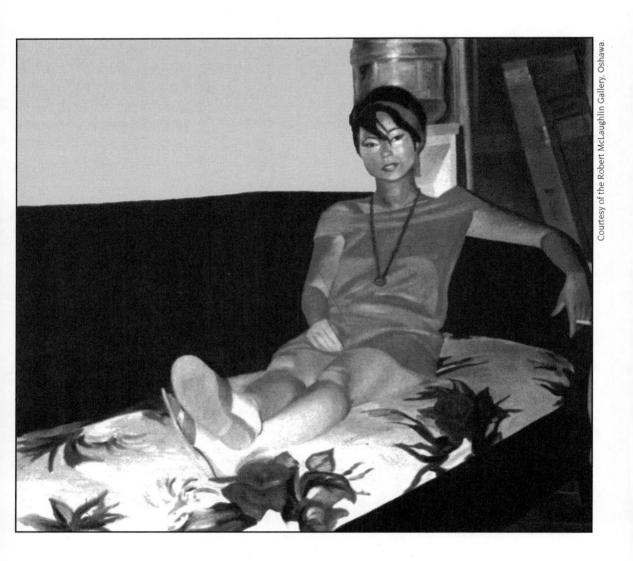

Joanne Tod, *Amway Consciousness*, 1984
Oil on canvas, 142.4 x 177.6 cm
The Robert McLaughlin Gallery, Oshawa
Purchase, 1985

images from a store window or the Mardi Gras in New Orleans surrounded by Sunshine girls from the Toronto *Sun* (p. 168). She's angry about women who allow themselves to be objectified as they are in the *Sun* – that's why she cuts off the heads (they're brainless, she means). She's also trying to emphasize that the viewer who looks only at the torso isn't interested in the face or mind. Natalka Husar treats bravely our desires for food, glamorous clothes, and how we have shut them in a closet in *Have My Cake and Eat It Too*, 1988 (p. 169). Here we see an interior, with an old-fashioned portrait of Husar on the wall "looking like a commodity," she said recently. She's all gussied up, and her plate is practically empty (she's eaten her cake). By contrast another figure of Husar appears in the work in a pink terry cloth bathrobe as a real woman, closing the door unsuccessfully on a pile-up of massive imagery. There is also a child Husar pushing an old Husar, a blind Husar carrying a Black Forest birthday cake, and a knight with a Cinderella shoe that doesn't fit. At the lower right are mismatched shoes. Husar is looking at them as though they were toys (Big Girl Toys, she calls them) or fetish objects. They're the sort of shoes we can't resist buying, but which in the end we never wear.

Husar's work expresses our fantasies, our fears, and a few of our stereotypes. That she is Ukrainian counts too – we notice in her imagery the girl in the Ukrainian outfit with black tape across her eyes (her account is "censored"). "She's my ghost," says Husar. Though riddled with anxiety, Husar's work is celebratory, as though a make-believe Jack in the Beanstalk had produced a real giant. And so it can, if we look at her *Dream/Scream*, where Wonder Woman catches a Ukrainian Easter egg – the kind that are so pretty on the outside, but dried up within. Here, Husar lets social icons invade her subconscious/dream world. The main empowerment Husar offers is that she is both the model and creator. She's confronting the demons within. She may be angry about being a woman, or saddened by it. But she cannot deal with life, she says in her work, until she looks in the mirror and accepts the woman she sees there, and all that woman is.

Much of this work involves risk, as does any art involving personal exposure. But the specifically economic risk it involves is no greater than that of other forms of art in these bleak times. Feminism, in fact, sometimes seems to be a reason for purchase, in

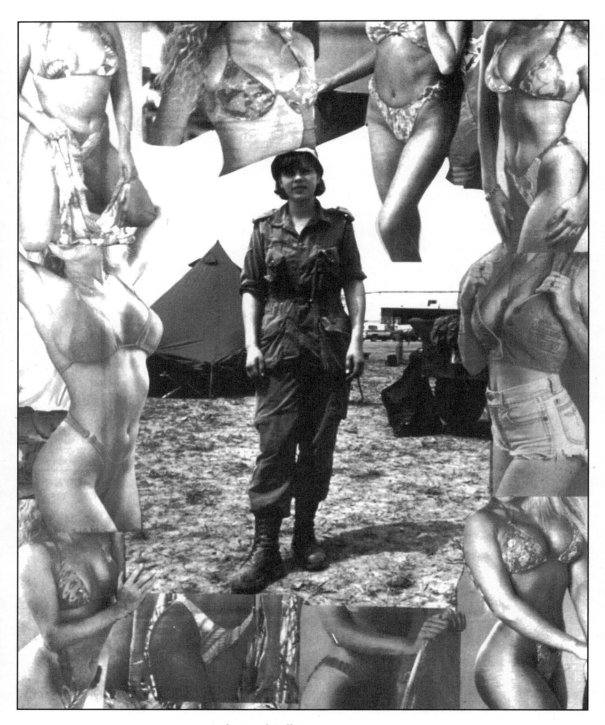

Linda Ward Selbie, "Reserve" 1991,
Dye coupler print/Newspaper collage, 76.2 x 61.0 cm.

Natalka Husar, *Have My Cake and Eat It Too*, 1988
Oil on linen, 178.6 cm x 203.4 cm
The Robert McLaughlin Gallery, Oshawa
Purchase, 1990

some places. The more politically motivated the art, the more interesting it seems to potential key investors such as, say, the National Gallery of Canada. The curators there apparently share the political views of feminist artists. Women artists not only do not pay a price for being feminists, they are looked at askance if they want to be simply artists, as opposed to *feminist* artists. Critics, reacting to the winds of change, respond with special interest to committed feminists. Nor has the intensely personal imagery in feminist art caused it to be set aside in a ghetto or sub-group, as sometimes happens in the United States. We have no National Museum of Women in the Arts like the one in Washington. Perhaps we should. On the other hand, that museum is not always known for the high quality of its shows, and what we want is more female art stars. I personally would like to see a more extensive old girls' network, a national system of mutual support. It would help us recognize that although the struggle of the individual woman artist may sometimes seem hopeless, the gains made collectively by women in art are beginning to look like a revolution.

THE PRAIRIE GANG

<center>⊰⋅❀⋅⊱</center>

I always thought of the Group of Seven as a male gang, learning to paint behind the outhouse somewhere. As I grew to understand the group around the Isaacs Gallery, I thought of them as a male phenomenon too – even though Joyce Wieland was much in their midst. Yet Gordon Rayner always had Graham Coughtry in mind as he painted, or other friends, like Robert Markle or Dennis Burton. It took a visit with Ivan Eyre at his home on Pembina Highway on the south edge of Winnipeg to make me realize that there were many such peer groups in Canadian art, bound together by friendship and rivalry; and one of them was on the prairies. These vast, endless, flat expanses had had two bards of paint: William Kurelek and Ivan Eyre. What I hadn't recognized was that Eyre had been affected by Kurelek's painting. When Eyre and I took a walk in the autumn of 1980 we looked at the landscape that infused his work. On that chilly, rainy day, we stopped to look at a fence-line. "I like to paint them looking right down the centre," Eyre said, "and I used this device in *Valleyfields*, which I painted this year. I got the idea from Kurelek's paintings. He was the only one I know who painted fenced fields the way they really looked in the west."

The fellowship of painters from the prairies is, of course, entirely one of the imagination; Eyre never met Kurelek. Yet there

was a sympathy between them, one that stemmed not only from their western background ("You and I belong to each other," the prairie said to him, Kurelek once wrote) but their date of birth: both grew up in the 1940s. Kurelek was born in 1927 in Whitford, Alberta, seventy-five miles northeast of Edmonton, and moved when he was seven to Stonewall, Manitoba, just west of what he described as a great, free, flat bogland. Eyre was born in 1935 in Tullymet, Saskatchewan, then in 1938 moved to Red Deer, Alberta, and then to various places around Saskatchewan. They were thus youngsters in the anxious times of the war years. Almost as a result, I thought, their work demonstrated a taste for the sombre, the macabre, the expressionistic (critics *always* liked to call Kurelek's work by names like that). Kurelek's art possesses, some said, the passionate intensity of a Bosch or a Brueghel and indeed, these northern Baroque masters were among his heroes, but Eyre loved them too, responding to their sense of the fantastic. A love of the land is central to both men's work. Kurelek almost never painted landscape as such, but during his lifetime he painted the length and breadth of the country, and Canada's physical presence informs almost everything he did. This landscape element, its descriptive power and precision, its authenticity, its use as both compositional armature and conveyor of emotional content, unifies his work. For Eyre too, the land was a major theme in which he evoked the enormous space of the prairie, but he applied it to an invented world. His landscapes appear true to many climes, and people often tell him that they recognize scenes he has painted. "I was there," they say, "I know the place," in the muskeg country of Northern Ontario, the volcanic islands of Hawaii, or the jungles of Brazil – places that Eyre has never seen, except in his mind's eye.

One of the touching qualities in Kurelek's work is his way of being amazed by reality. He responded with wholehearted wonder to the natural world, and this makes his vision fresh, direct, and authentic. His work is often based on first-hand observation. He used tellingly the nuances of weather. From the beginning, he favoured the panorama – a distant, high horizon, a limitless expanse. "The single outstanding feature of prairie landscape, just as of the ocean, is *expanse*," he wrote in 1970. "And I figured if I kept my human figures their usual size but increased the area of the painting itself, the end effect would, by sheer contrast, be

expansive." Monumental grandeur is inherent in the structure of some of his paintings. "I work more in world terms," he said. Eyre also drew upon specific sites from memory or observation, such as a cattle pen recalled from his childhood in Ituna, Saskatchewan, a favourite rambling horse barn a few hundred yards northwest of his studio, and cement factories on the southwest corner of Winnipeg. He also liked to paint castoff or derelict machinery, such as a Parson's dredger from the early days of ditch digging.

Yet despite their love for reality, both of these artists in their painting drew upon qualities of abstraction. Kurelek greatly admired some of the more abstract painters in the Isaacs Gallery (especially Rayner, to whom he wrote a fan letter about his first collage show, in 1975). Eyre in his early work had painted non-objectively, influenced by Arshile Gorky and Willem de Kooning. Both liked to use an abstract way of composing: Kurelek often around a strong central vertical to dispose simple geometric blocks in space; Eyre often in horizontal bands that zigzag into the distance.

What differed in their work was the message. For Kurelek the Roman Catholic, it was Christianity that counted. Christ often appears in his work, whether up in a tree or on the cross, and he is at his best when painting parables. Even the initials with which he signed his work feature a cross. For Eyre, painting is a way of probing the nature of existence. There is a mystical sense of revelation in some of his paintings; his vision is intense and, like Blake's "world in a grain of sand," often focuses on the cosmic within the microcosmic. He was, and is, preoccupied with paradoxes, and his paintings, with their visual puns, illusions, and shifting viewpoints and perspectives, are often vaguely unsettling. In 1965 Barrie Hale compared the two artists in the Toronto *Telegram*. "If I read both right," he said, "they would appear to have the universe nicely divided between them – the sacred for Kurelek, the profane for Eyre."

Yet of the two, Eyre is the greater picture maker. Kurelek's technical knowledge was slight, his usual painting technique almost preposterously simple and rough: he applied a gesso ground to masonite board, then either oil or acrylic (sometimes in the form of spray paint), then outlined the composition with ball point pen. For texture, he used coloured pencils; for fine details, he

scratched, scrubbed, or brushed the surface. He finished by adding details in pen. This method of fill-in-the-shapes inclined to flat areas, a two-dimensional surface, and a finicky effect. Moreover, he had a simplified sense of colour and form. For one period in the early 1970s all his barns were the same shade of red, and his figures can be lumpy or stick-like. "I have had little full dress art training," he said in 1962. "My colour, composition, method of paint application, etc. were arrived at mostly by intuitive groping rather than by systematic scientific enquiry and practice. In a word, I would not say I am a painter's painter."

Eyre, by contrast, *is* a painter's painter. In the beginning he was a student of the museums. He had a developed, though laid-back sense of colour, and often favoured barley or citrus yellow overall, along with powder blue and faded mauve or lavender, or grey combined with warm pink, brown and purple. In 1978 in *Cold Lake*, he used purple and brown with a small yellow split to divide the scene. As an artist, he loves to experiment and regards each painting as an attempt to create a vivid, though not necessarily understandable, universe – "to present a complex world lucidly," he has said. His work may begin from a few decisive moves on canvas. Ingenuity is his keynote. In some of his paintings, where he wants an especially luminous glow in the sky areas, he uses a pure white ground under oil paint. The remaining parts of the painting are done in acrylic washes or strokes most often applied over a darkened base colour, and he sometimes applies glazes. He believes that the act of painting is "like being dropped into the wilderness with few supplies and little gear – one has to be attentive and ready to innovate."

Eyre developed the use of the subconscious into a strategy; Kurelek discovered it only in passing, and never deliberately cultivated it, though he was pleased, he said, when the painting took over and dictated to him. Sometimes, when he was under heavy pressure, things appeared that he hadn't planned, and he would use them. Perhaps this method of working helps explain the many beautifully painted and curiously elusive details in his work, the entrancing white horse gazing out from behind a silo, a garden by a house, a half-emerald, half-olive pine tree, houses on the horizon, foreground weeds. By contrast, Eyre's way of working intentionally drew upon this way of deep sensing; he acted as a co-ordinator, he

felt, bringing together separate, even contradictory elements into a whole. He had had a recurrent dream as a young painter of a loud, high-pitched noise accompanied by a chaotic build-up of machine parts, he told me. Suddenly, everything came together in a co-ordinate movement. The dream suggested an image not only of his identity as an artist, but of an event that influenced his commitment to painting

Eyre has written about his four years at the University School of Art in Winnipeg (from 1953 to 1957), and about what might be called his spiritual conversion. It was in the west studio in the late afternoon, when the low sun shone in through the high dormer windows, that he experienced what might be called celestial music – a unique combination of humming, ringing and melodic flow. "It was as if everything had fallen into place," he said, curiously echoing his description of the dream.

In Winnipeg in 1957 his work, with its delicate, shifting planes and general air of whimsy, as in *Woman in Interior,* showed the influence of Bonnard. (The winner of the Winnipeg Open, this painting was purchased by the gallery, and through another stroke of luck, illustrated in *Canadian Art.*) However, as an art student between 1955 and 1957 he was, through books and reproductions, consistently drawn to the German painter Max Beckmann (amongst a host of other artists), and particularly to his later paintings. An interest in Beckmann (1884–1950), was common among artists of the 1950s, particularly those exploring figuration. He was a pivotal painter in the exploration and portrayal of such universal themes as alienation of the individual, the character of human relationships, and man's inhumanity to man, and made striking use of unusual compositions that combined different kinds of spaces in one picture. Particularly well-known are his self-portraits, in which he often pictured himself with a penetrating, hypnotic stare. Throughout, his rough, linear drawing style dictated his painting format. It was this that fascinated Eyre. "Beckmann's peculiar roughness and vigour satisfied an interest and need of mine at that time," he says.

At the Institute of Fine Arts in Minneapolis in 1958, Eyre saw two bold Beckmann works; the triptych *Blind Man's Buff* (1945) and a *Self-Portrait.* "The triptych has panels of different sizes with the centre the largest. I was struck by the forcefulness of

the drawing with its heavy black contours, directness and strong colour. I particularly remember one yellow-fleshed figure in the grouping," he says. "I believe that it was there that I saw one of his strong full figure self-portraits in a black suit with a gently detailed and modelled sullen face set against an interior space in which a heavy, fast, wide slash of yellow ran vertically behind the figure – a successful pairing of the slow (quiet) and the fast (loud)."

In 1957 he painted *Man in Black Suit,* in response to his study of reproductions of Beckmann's paintings. The visit to Minneapolis in 1958 confirmed his earlier feelings about Beckmann's art, and set the course for his future development. Things happened quickly: by 1959, he received his first appointment at the school, teaching drawing. He was twenty-four years old.

For Eyre, the luckiest period of his early career was in 1953, well before he had taken up painting full time. Dr. Ferdinand Eckhardt, a member of the staff of the Kunsthistorisches Museum in Vienna, where he had been in charge of developing art as a popular medium of education, had become director of the Winnipeg Art Gallery, and quickly began extending his sphere of influence over the art community. Eyre grew up in central Saskatchewan, but heard about Eckhardt and his wife, the talented Sophie-Carmen (Sonia to her friends), the musician and composer, when they came to Winnipeg. Mrs. Eckhardt had been a child prodigy, gifted at both piano and violin, and had studied at the Conservatoire in Paris at the age of nine, under masters such as Vincent d'Indy. At the age of eleven she gave her first concerts in Paris, Geneva and Berlin, but her teachers discouraged her because she showed interest only in composition. It was in this area that she later excelled. In 1920 she married the German Expressionist painter Walter Gramatté, a friend of Beckmann's (the couple lived with him in Berlin in 1921 and 1922), as well as of other members of the Bridge, Erich Heckel and Karl Schmidt-Rottluff in particular. Gramatté died young (in 1929, when he was only thirty-two) and full of talent, as we can judge from the work reproduced in the catalogue of a show dedicated to the Eckhardts in Winnipeg at the Gallery in 1987. In 1930, Sonia met Eckhardt, who was working in Berlin as an art critic and freelance writer; in 1933, he was hired as public relations

Alexandra Luke, *Observance to a Morn of May*, c. 1957
Oil on canvas, 177.8 x 101.6 cm
The Robert McLaughlin Gallery, Oshawa
Gift of Mr. and Mrs. E.R.S. McLaughlin, 1979

Hans Hofmann, *The Chinese Nightingale*, 1944
Oil on board, 117.9 x 92.8 cm
The Robert McLaughlin Gallery, Oshawa, Gift of Isabel McLaughlin, 1987

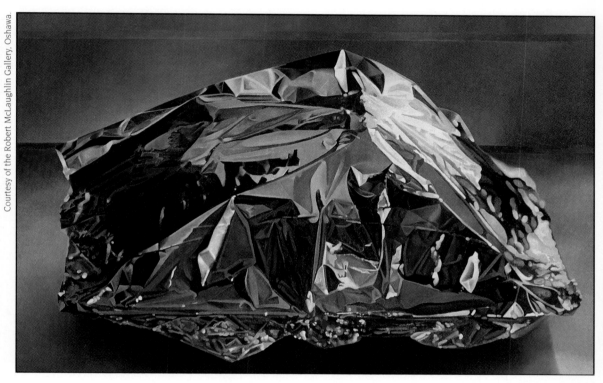

Mary Pratt, *Christmas Turkey*, 1980
Oil on panel, 45.8 x 59.9 cm
The Robert McLaughlin Gallery, Oshawa, Purchase, 1981

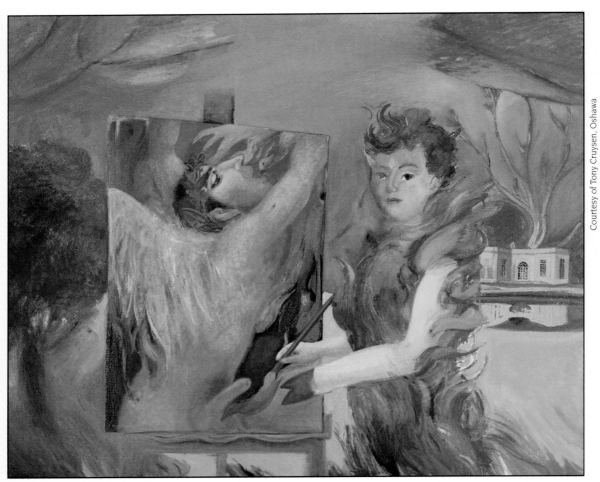

Joyce Wieland, *Artist on Fire*, 1983
Oil on canvas, 107.2 x 130.0 cm
The Robert McLaughlin Gallery, Oshawa, Purchase, 1984
"The painting is really about creative fire and sexual fire," said Wieland.

Ivan Eyre, *Valleyfields*, 1980
Acrylic on canvas, 142.3 x 162.7 cm
Private collection,
"This is one of the works in which I was somewhat influenced
by Kurelek's fenced field paintings," writes Eyre.

Herzl Kashetsky, *innocence* (1977)
Acrylic on masonite, 49.5 x 33.7 cm
Private collection

Sir Frederick G. Banting, *Barn*, 1931
Oil on panel, 21.7 x 26.7 cm
The Robert McLaughlin Gallery, Oshawa
Gift of Alexandra Luke, 1967

Courtesy of the artist

Richard Sturm, *Shore Lunch*, 1993, oil on canvas, 152 x 213 cm
Collection of the artist, Peterborough
Sturm was influenced in this painting by memories of the Kawarthas, where he has a summer
studio: an image of a walleye fish is at the centre.

officer at a pharmaceutical firm; they married in 1934. Eckhardt, although he had his doctorate on the medieval illuminated manuscript, the Utrecht Psalter, was by background as much as temperament a person with advanced tastes in art. A sensitive soul, he wanted to share his enthusiasms with others. In Winnipeg in 1955 he introduced the first open juried show in Canada (it lasted through twelve exhibitions), as well as bringing in blockbusters of a kind the city had never seen before. One big show of Vincent van Gogh at the gallery in 1961 featured eighty paintings and eighty watercolours and drawings from the Kroeller-Mueller Museum near Otterlo, and was the occasion for more than 50,000 *paying* visitors, as a history of the gallery proudly reported.

It was his advanced way of thinking that made him leave the museum in Vienna – although he loved the environment with its thirteen Brueghels, ten Velázquezes, the *Madonna in the Meadow* by Raphael, almost forty Rubenses and eight Dürers. In Winnipeg he quickly began to build on his taste for, and indeed his incessant desire for, a great collection: in the area of the Old Masters he purchased fine Flemish and German panel paintings of the Gothic period, and modern international masters such as Henry Moore, as well as exhibiting and collecting contemporary German Graphic art. He also was anxious to collect Canadian classics such as Emily Carr, whom he viewed as an Expressionist. He soon discovered Ivan Eyre.

It was Eckhardt, who, since he owned work by Max Beckmann, could have provided the environment receptive to Eyre's tastes in art, and particularly his later drawing style – distantly reminiscent of German work; yet what Eckhardt loved in him, he said, was his sense of "Domesday horror," such a familiar element in the work of artists in Germany, particularly artists of the movement of which he had already been so enthusiastic a promoter. By 1966, the gallery was organizing an exhibition of his drawings, followed in 1969 by a circulating exhibition. Eyre was the artist the Eckhardts would have liked to create if he had not already existed – but that they had encouraged in him some aspect of themselves apparently did not occur to them. Eyre in turn must have felt the same about them, and particularly about Eckhardt – that he was the director he would have had to create if he did not exist. In 1974, in his painting *Director*, he paid his dues to this

dynamic man: facing away from the viewer and at left in the canvas is Eckhardt. A hand thrown up against the shadow reveals his energy, strength, and purposefulness. He looks preoccupied, busy, just as he was in the gallery where he ruled. He was decisive: the kind of person who if he liked you would quickly try to draw you into his life. I lunched with him in 1972, a year before he retired, when he had been director of the gallery for over twenty years. He

Courtesy of Sheila Spence, Winnipeg Art Gallery.

Ivan Eyre, *Director*, 1974
Acrylic on canvas, 142.0 x 162.0 cm
Winnipeg Art Gallery
Gift of Ivan Eyre on the occasion of Dr. Ferdinand Eckhardt's ninetieth birthday

had a powerful presence and he was action-oriented: over lunch he tried to hire me, assuring me that once I had lived in Winnipeg for five years I would have formed so many friendships that I would never leave. Perhaps that is what happened to him. Winnipeg is a town that exists through its friendships, says Winnipegger Pat Bovey (she is today a museum director in Victoria, British Columbia, but she worked at the gallery with Eckhardt).

I recall that when I told Eckhardt I had come to town to see Eyre, he said, "That's one of the two best studios in town" (the other happened to be the other studio I was visiting, that of textile artist Charlotte Lindgren). He was always to be supportive of Eyre. When Eyre's work was shown in Frankfurt in 1973 at the Kunstkabinett, largely due to Eckhardt's efforts, he spoke at the opening. In his heart he may have felt that Eyre was proof that he had made the right decision in coming to Canada, for here was a product from a distant city that he could bring home and introduce with pride to his native land.

I wish that all gallery directors could be magicians like Ferdinand Eckhardt. Once or twice I have imagined that I felt something like his magic passing thorough my own gallery. On one occasion I was in St. John, New Brunswick, visiting Herzl Kashetsky, a painter who, some of the time, likes to create still-lifes in the studio using as props objects in his home. To paint *innocence* he placed on a shelf a doll with long blond hair, who looked like a Maritime belle in her white dress with pink trim and matching pink hair ribbons (see p. 182). He surrounded her with objects that indicate the range of choices available to women as they grow up, from smoking (an ash tray with cigarette butts and a pack of Craven A), to money (as indicated by coins and dollar bills), drinking (a glass of red wine), and religion (this I took from the painting's candlesticks and postcards of angels). At the edges of this oval picture, to further the effect, are a calendar, a mirror (we see a little of the artist as he paints), a plant, the already mentioned postcards of angels, and, as I noticed with delight, the cover (a painting of a garter-belted woman) of the catalogue I had prepared for our retrospective of Dennis Burton in 1977. It was a catalogue that had been hard for me to prepare. In it, Burton spoke candidly about his life and paintings, their inspiration ("garterbeltmania," as he called it, was a major theme of his work), and evolution. Not

only had the subject repelled me but I found the harangue unnerving even as I coped with it. "Why, you used my catalogue," I exclaimed, delighted to think that the brochure had proven of interest.

"Was that *your* catalogue?" Kashetsky said, turning to me with surprise.

I have to admit that I bought the work.

CANADIAN WORKING-CLASS ART

<div align="center">✦◆❋◆✦</div>

In 1974, Barry Lord's *The History of Painting in Canada*, subtitled *Toward a people's art*, set out to chronicle Canadian art. In spite of its political intentions (the book was a socialist document by a committed Marxist) it was consistently interesting. "Knowing the history of our art as a part of the heroic struggles of our people is a powerful weapon in the hands of a colonial people," said Lord in his introduction. "It helps us to understand what we are fighting for." A song written by Peter Flosznik, a member of the Canadian Liberation Movement (as were Lord and the members of his editorial committee) lent a martial air to the first pages of the book. "Three hundred years a nation/ And a colony we are still," it began. The last two lines of the refrain sounded hopeful. They read: "The sky is red there in the east,/ It's revolution's dawn." So did the last stanza, which began, "Well, now we see the working class/ Arise to take the lead."

The book had a very high un-put-downability factor, but when it came to describing how the art market worked, I got nervous as I read about the Imperialists, the Compradors (a Portuguese word by way of China, meaning sell-out), the Curators (they were U.S. citizens, pro-U.S. formalists), the Editors, Publishers, Critics, then the Dealers, the Artist, the Work of Art, all resting on, at bottom, the People. The top-heavy structure of

the system allowed a few imperialists at the top to control the many artists at the bottom, said Lord. He was a little subtler in his discussion of "Paintings of the Working Class," in which he examined material ranging from the lumberjack paintings of Edwin Holgate to the art of the New Brunswick painter Miller Brittain, one of whose pictures was titled *Workers Arise!* That chapter culminated in a discussion of the work of Frederick B. Taylor, who, though born into a wealthy family, painted workers in war production plants. Art that sprang from the people, said Lord, and upheld the dignity of the nation was work such as that of folk artist Arthur Villeneuve (the French-Canadian nation, he meant, in Villeneuve's case).

Lord's speculations were wildly at odds with the art field I knew. His version was a conspiracy; my version was more a Road to Golgotha – a path of almost certain suffering and sacrifice, which called for faith on the part of the believers. Critics found the book wanting in historical perspective. Today his version of Canadian art has suffered the usual fate of such politically opinionated documents – it is not listed on bibliographies for students of Canadian art. Yet readers could not help but be dazzled by the drama of his story. The book sank – but not without trace. In its wake, scholars and teachers of Canadian art struggled with the memory of Lord's simplifications. Lord had created a myth, and Canadian art has ever since been struggling to make it a reality.

Lord himself was an early proselytizer for a cause. When I was first introduced to him in 1968 at the Art Gallery of Ontario, he told me with some amazement that I must be the only person in the art world in Canada who did not know who he was. It was true: he was notorious, I discovered. His wild hair, dark complexion, expressive eyes, and slender, impassioned figure were widely recognized. He had held a variety of jobs: he was editor of *artscanada* for a memorable period in which he produced an issue in a record format that puzzled librarians did not know how to file; curator at the Vancouver Art Gallery and the New Brunswick Museum, organizer (curator again) of the *Painting in Canada* exhibition for the Canadian pavilion at Expo '67; art critic for the *Toronto Star*, and later head of education at the National Gallery of Canada, where he annoyed the hierarchy at the institution by suggesting in print that Canadian art be hung with the International section, since it too was worthy of serious attention.

I never forgot his idea of a working-class art. In Oshawa, I got to meet many members of the working class. Some of them made art. Gordon Law, for instance, worked at General Motors of Canada in Salvage Repair for close to thirty years, then became a folk art sculptor. He had taken some art classes, and his father, Ivan Law, had been a folk artist, so he was not as untutored as some critics believe folk artists to be. Nor was his attitude unlike that of other artists I knew: he had a practical mind that inclined him to do things instead of talking about them, he said. The product he created, however, was different from high art: it looked less worked on. Law's small figures, with their straight, erect, self-contained poses, and their earnest but delighted faces (even when he depicted monsters from Greek mythology), were inclined to be simple in execution.

In Port Perry, I had the good fortune to be able to test my theory against the collection of folk art of Pat and Ralph Price; we showed it at the gallery, and showed Ralph's work too, when he became a folk artist. This "people's art" has directness, and a fresh, spontaneous feeling, but these are qualities that can also be found in the work of contemporary Canadian artists, such as Tony Urquhart and Joyce Wieland, who both liked to claim that they were folk artists because they worked in a similar manner.

In 1981 I met Alma Duncan, who, during the Second World War, as an unofficial war artist drew workers in industry. A tiny, energetic woman with candid blue eyes and a sweet smile, Duncan is one of the great draughtspeople in Canada, and her work has been collected by some of the great institutions for prints and drawings such as the Brooklyn Museum in New York. I very quickly began to think of her as a good candidate for a retrospective and visited her in 1985 with this plan. In reviewing the vast quantity of her work I was startled to discover an unknown series of industrial drawings that dated from the period 1943–1947. She had returned to industrial subject matter in 1956 and 1958. All she needed for a good show was to bring the story up to date, I told her.

To my delight, she complied. She celebrated her sixty-eighth birthday while visiting Stelco's new plant at Nanticoke on Lake Erie, and later did drawings at Maclaren Industries in Quebec. The result was a show in 1987 that detailed her development over nearly fifty years.

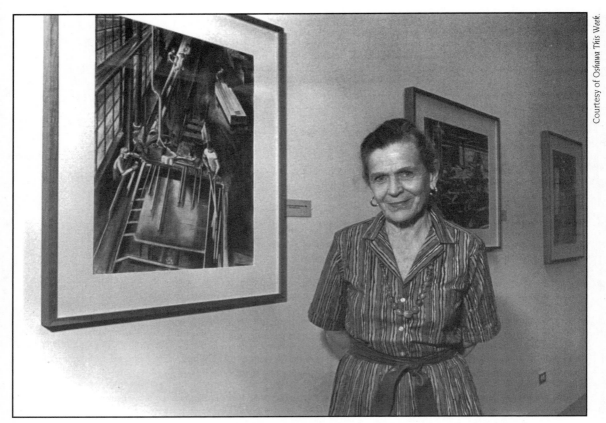

Alma Duncan at the opening reception for her show, *Alma Duncan and Men at Work*, the Robert McLaughlin Gallery, Oshawa, 1988

This was the first of what I hoped would be a series of industry-oriented exhibitions in the gallery, but unfortunately what it demonstrated about the everyday life of the people was that there were very few of them left in the industrial workplace. When Duncan began to work in industry in 1943 she created powerful images of men at work through her drawings in black chalk. Always she had a feeling for the virile power of her subjects and the way they adjusted to their dark realm. Her gift for observation expressed itself in the movement of the workers, and she emphasized form. "I see shape, then like to see what's happening,"

she said. Sometimes there were curious interplays in her work; men and machines might seem to be attached through the sensuous windings of a pipeline. Each was almost a part of the other, she felt. With time her sense of the scene before her grew larger, her people smaller: in her pastels of the 1950s men scurry like ants. By 1985, she drew industry swept bare of man's presence, so that it looked like a giant's kitchen or a vast stage set. The activity had been stepped up. Her drawings were like that too – basically abstract, with a slight reference to people or trucks. As in earlier work, the men were powerful forces that combined with the machines to make the pattern, but now there were far fewer men in the echoing halls.

It took John Scott to gave me another idea of what a working-class artist might be. He internalized the idea within the subject – himself – and allowed it to cover almost anything to which he felt drawn, though he preferred certain philosophic or sociological issues. Lord's book had appeared when Scott was studying at the Ontario College of Art in Toronto. He thought it a good history, and it was used around the school, especially by students who, like him, were interested in left-wing politics (he is a committed Marxist and feels he has a Maoist approach to art). His teachers, such as Joyce Zemans, who gave the general introductory course on nineteenth- and twentieth-century art and a special seminar on contemporary art which Scott attended, did not focus particularly on Lord. Gary Michael Dault, another of Scott's teachers, found Lord's Maoist thesis a form of special pleading: "banal" was his judgement. Yet Scott, who was interested in art history and had considered becoming an art critic, seems to have scooped up the substance of the book and found that it culminated in himself.

He had already seen himself as a working-class hero. He was a Motor City kid from Windsor, Ontario, familiar with Detroit. When he said he was a working-class artist, he meant that as an artist he subsisted at a low economic level, and thus had a sympathy for working people. He felt no particular solidarity with Joe Hill, nor did he elevate the working class in a Fabian sense. He was simply a member of that class. Yet he also meant that the reverberations of Marxism appeared in his art and formed an intellectual and artistic framework for his activity. The status of the

sexes, the nature of gender – such matters now occupy the art process more than ever. Scott was a pioneer in his approach to them.

It was at Dault's insistence that he finally began his professional art career. In 1976, his final year at the college, his teacher gave him some paper and told him to start drawing. Since he did not believe he had the drawing skills necessary to make art, he traced figures of Lenin. The result was Scott's first contribution to a serious gallery show, at the Sable-Castelli in Toronto. Five years later, at the Carmen Lamanna Gallery, he had his first solo exhibition. By then he had realized that political art that criticized was to be his focus; he used nuclear war and technology as subjects of that show. He fulfilled a need of the moment. He was an artist his audience would have had to create if he hadn't existed. Soon critics drew alongside his work, particularly Dault, who was now writing for the *Toronto Star*. They responded with reviews, observing, analysing, inquiring. Scott took bigger steps. At one moment he expressed concern over nuclear war in huge drawings of airplanes and cruise missiles labelled *Carnivore*; at another his subject was Cambodia. Working-class art meant, for him, a diverse range of inquiry into many subjects including his own life. He examined his physical condition, writing in *Canadian Art* about his illnesses – such as Bell's palsy, which he contracted about 1980. Sexuality, motorcycles, television, film and death were other subjects he examined in his writings. He saw death from a comic viewpoint: like finding yourself stuck in a private screening of *The Exorcist*, he wrote. How to distance oneself from mortality? He recommended opting for a healthy embrace of carnality. Intelligent as always, he knew that this option is not always possible.

His shows, from 1981 till today, though diverse in their effects, are united by his sensibility. It's always John Scott who talks to us intelligently, whether through his first mode of presentation, the large Expressionistic drawings that culminated in a show in 1987, or through the 1989–1990 constructions that fascinated critics: works such as *Selbst* (a patch of his own skin tattooed with three roses and a number, displayed in a case), *Glamour* (a two-edged sword, though without a handle, set on a piece of cloth on a sword stand in the style of Japanese artefacts), *Witness* (a Magnum hand-gun with a prosthetic glass eye set into the handle of a

revolver). These take-offs on fetish objects set the scene for larger construction/ installations such as his Trans-Am car.

His vision of working-class art was painterly; both his drawings and constructions used techniques that we often associate with Abstract Expressionism: a dramatic presentation, a fused, not too preachy narrative, a raw poetry. The cause was a point of departure, not an excuse for a theoretical tract. Yet his work always turns the viewer towards discussion, as though he were in class. The world in his work is reduced to a succession of ideas, warmed by a sense of black humour and the macabre.

Linked to it is the subject of the industrial world. Scott views this too with an impartial eye. In the 1930s, he said, we had a utopian notion of what the industrial world might be: the world might be saved through industry, we believed. However, in his installation piece *Waterworks: 100 Workers*, he looked at workplaces that grind up lives both physically and spiritually. He used as his example the R.C. Harris Filtration Plant, and recorded the locations in the plant where accidents had occurred – not information that was easy to obtain.

Other contemporary approaches to working-class art point up his difference. Carole Condé and Karl Beveridge were other workers in the trenches of political imagery in Toronto. They made large Cibachrome photographs to trace political issues, say the history of a strike by women at a newly unionized plant in *Standing Up* (1981), or (most important for Oshawa) *Oshawa* (1982–1983), a photo-narrative history of Local 222, the United Auto Workers of America, the union that represents workers at the General Motors of Canada plant. These artists choose to develop an oral history, in which they combine the collective experience of the Labour movement with the workers' point of view. From it they extract texts to superimpose on their photomontages. Their scenes are constructions, part imaginary (with realer-than-real sets and models), part real (the words) so that they convey a specific kind of lesson. The words embedded in the image make the point but the horror of the situation is summed up in the figures, and the space between them. With the Local 222 works, paranormal scenarios where the façade of family life played out in a room with kitsch objects collided with black-and-white scenes (often blown up photomontages of the moment of political conflict) glimpsed

through a screened-off wall or through a window in the background. The effect created was of a lack of drama or tension in the figures, so that the montages chillingly combined an air of boredom and triviality with historical drama to expressively convey the peculiar quality of working-class life.

Today, more artists are getting into the act. One of Canada's latest hot commodities, Attila Richard Lukacs, in an exhibition in Montreal in 1994 showed huge Old-Masterish canvases of nude working-class men wearing miners' lamps on their hats. His was a curious idea, less political than sexual in its focus, but it indicates the development in the use of working-class imagery. It seems to be a subject that goes straight to the heart of contemporary society. Artists will surely return to it again and again, and it will always be something for viewers to consider, a combination of subject and provocation that stops them in their tracks, however briefly.

CRITICISM RECONSIDERED

—◆✦❋✦◆—

In the second half of the twentieth century, writers who laboured long and valiantly in the fields of Canadian art considered it their duty not only to cover art exhibitions for newspapers and magazines but to broadcast on the Canadian Broadcasting Company, host television shows, curate, and write books. Robert Fulford will be remembered for these accomplishments and more. He is the shining example of a writer who crossed over, from one field to another, turning with equal facility from sports writing to commentary on the arts and literature to broad-ranging cultural criticism in the *Toronto Star* and more recently the *Globe and Mail*. He also edited (from 1968 to 1987) *Saturday Night* – and along the way wrote on Canadian art, in magazines such as *Canadian Art*, and in books such as *The Beginning of Vision: Lawren S. Harris* (which I wrote with him in 1982). Fulford's ability to think critically about art was fuelled by an ambitious vision equalled by few art historians. The irony of his position was that he sometimes knew more than the historians, and though he seemed anxious to embrace their point of view, he must often have found them silly and banal. His thinking was a noble amalgam of acute observation and a knowledge of art's metaphysical shadow, and his method of setting culture in the general context of the history of ideas recalled his hero, Marshall McLuhan.

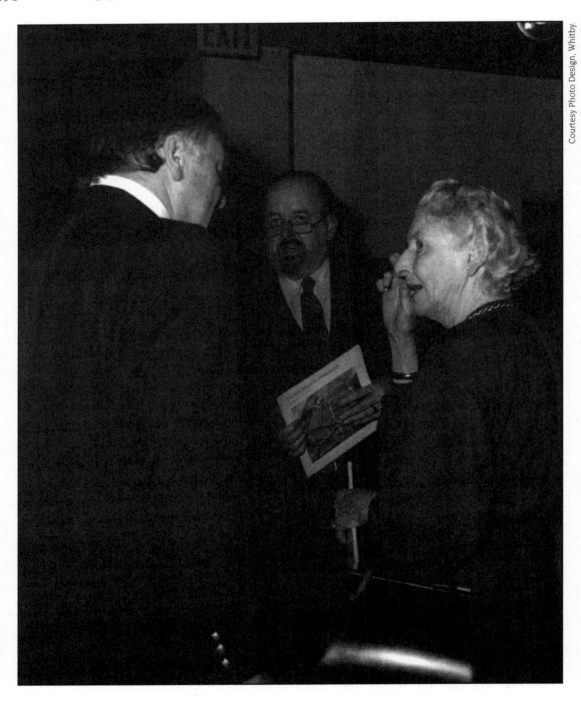

Opening, *Painters Eleven in Retrospect*, the Robert McLaughlin Gallery, Oshawa, 1979
(from left to right): Ray Mead, Robert Fulford, Stewart Bagnani

Working with Fulford was a sharp game of wits but it was also like going to a specialized, highly eclectic university. There was something donnish in his personality as well as his gaze, a penetrating glance from above or behind glasses. His face is long; he has a high forehead, a long straight nose. In stature he is tall and ample. He demonstrates brilliance as a raconteur and persuasiveness in argument with the elegant, easy variations of his mind. His genuine cerebral power is characteristic of only one world, the university – though, paradoxically, he did not even graduate from high school.

In the cast of his thought and the scholarly nature of his disposition, he did not fit the thesis of the late Barrie Hale, art critic from 1964 to 1969 for the Toronto *Telegram*, and author of a study of Modernist painting in Toronto, *Out of the Park*, published in 1985. Hale argued that "A kind of symbiotic professionalism existed between the established artist and newspaper editors and critics from the Group of Seven's day until deep in the 1960s; they exchanged cachets, as it were, for they were much the same sort of people." Hale was perhaps thinking of his own position: he saw himself living the life of the artists he wrote about. Chunky and shy, he spoke with a diffident and nervous manner. He always seemed to swerve his head down and speak out of the side of his mouth. He liked to live on the edge, and he behaved like a hero in a private eye mystery by Raymond Chandler or Dashiell Hammett, about whom he'd written at the University of British Columbia (class of 1960). Hard-boiled but perceptive, he portrayed a world of urban cowboys who painted brilliantly and partied outrageously, but were haunted by a sense of the fragility of life. He was trying that life on for size, and wanted his writing to take the reader into these strange places. To do this, he wrote about the *necessity* of modern art. He was a proselytizer for a cause. The cause was mysterious, a love story that could never work out, a tale of doomed romantic obsession.

Hale's vision made existentialists out of artists he admired and liked. He regarded Graham Coughtry as a seeker after a distant "presence" in his work, and he found a terrifying ambiguity in Coughtry's two-figure subject-matter. In such painting the audience (including the critic) was supposed to supply the emotion and

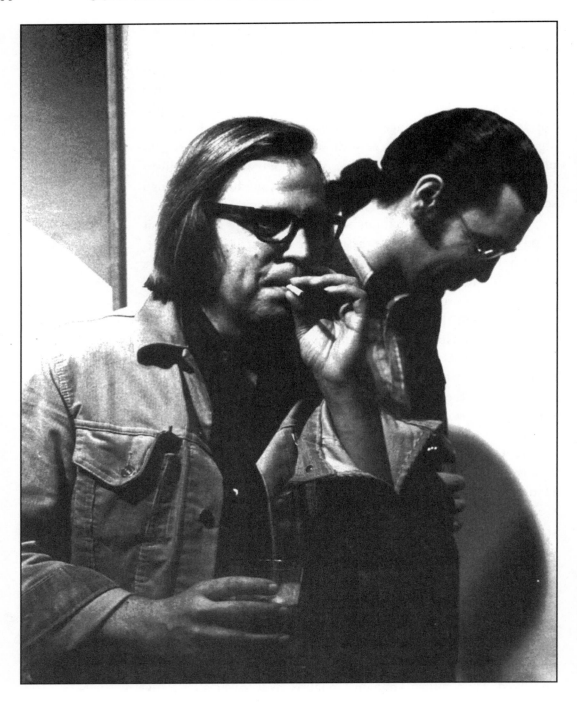

Opening, *Dennis Burton Retrospective*, the Robert McLaughlin Gallery, Oshawa, 1977
Barrie Hale (left) and Dennis Reid

root for the artist. For Barrie, the journey these artists made was towards a future that was a riddle he wanted to puzzle out. His own life was passionate and self-destructive. He worked to burn it up faster in a dramatic way, warring with alcohol, checking into hotels with a case of vodka for a binge. He felt trapped. Under these circumstances, his imagination, like that of his readers, was forced to take over. Yet he applied control to his writing life for a time. Like the careers of his subjects, many of whom had crossed over from commercial to serious art, his career was a crossover from criticism to the world of curating. From writing for the *Telegram*, then for the *Toronto Star*, he developed into a curator. In 1972, with Dennis Reid, he organized the *Toronto Painting 1953-1965* exhibition for the National Gallery of Canada, then in 1976, with myself, the Graham Coughtry retrospective for the Oshawa gallery. He considered the artists and the work for his book *Out of the Park* the major preoccupation of the last twenty years of his life. He had moved to Toronto in 1963 from Vancouver. Toronto was his idea of what a city should be, and he delighted in his apartment on Sultan Street in the heart of downtown. With its simple, functional setting and furniture, the walls painted in flat colours, it was the appropriate setting for a character caught in the nightmare of life. His 1981 article in *Quest* magazine on "The Apartment," his own, is one of his best.

Hale saw himself as a kind of entrepreneur in the art and word industry, depending (like all genuine entrepreneurs) on a unique mixture of self-reliance, fresh ideas, and exceptionally hard work. For him, art criticism meant living within the scene. At openings, he was always off in a corner, talking to the artists, the dealers, the collectors. Dennis Burton remembered him, at one of his openings, lying on a bed in the Holiday Inn (where Burton was staying), listening to Burton talk into a tape recorder. Talk was crucial to him; he liked to burrow into a subject, and get to the real truth of the moment. In the use of such material in his writing, he was living out one of the most potent techniques of *film noir*, its semi-documentary quality. He had once written a novel and destroyed it, but his friends believed it was still on his mind. His friend, Gary Michael Dault, called him a "closet novelist." His background was English language and literature: at UBC one of

Robert Markle, *Falling Figure Series* I, 1964
Tempera, ink wash on paper, 58.7 x 89.2 cm
The Robert McLaughlin Gallery, Oshawa, Purchase, 1982
Barrie Hale was not only a critic but a collector.
I purchased this Markle from him.

his favourite professors was George Woodcock. He stressed in an unforgettable letter to *Saturday Night* in 1978 that he had no guru. Typically, he called upon the French existentialist writers when casting about such for a model. He hadn't had a guru, he said, "since Camus was insensitive enough to die before I got a chance to talk to him."

For Barrie, just as there was one group in Canadian art that was deeply interesting, there was one gallery that enthralled him – the Isaacs Gallery. The gallery was the subject of an exhibition in 1992 organized by Ihor Holubizky, senior curator of the Art Gallery of Hamilton, *Small Villages: The Isaacs Gallery in Toronto: 1956-1991*, about its impact on the scene. In its day it was one of the places crucial to the introduction of modernism in Toronto, acting as mail-drop and home away from home for artists, critics, curators, and collectors. Isaacs' back room, his crowded storage area with its fabulous feel of a treasure box, was for some curators even more important than his exhibition space. The gallery held important shows by Graham Coughtry, Greg Curnoe, Robert Markle, John Meredith, Gordon Rayner, Michael Snow, and Joyce Wieland; along with the folk art Isaacs handled were William Kurelek, Jack Chambers, and, more distantly, Mark Prent. Isaacs was an idealist who advanced artists credit. He was repaid when their work sold.

Av Isaacs himself is a singular figure. With his bushy eyebrows, deepset hazel eyes, broad triangular nose, moustache, strong, rounded chin, thick neck and burly frame, he looks as forceful as some of the Inuit artists whose work he carried in the second gallery he opened (in 1970), the Innuit Gallery. "You've got to be hungry to be a good dealer," he told Rayner once, but his pattern was more that of patient endurance: he never pressed a curator or collector to purchase, preferring to wait till "the next time."

His amiable attitude towards professionals paid off. Curators like myself would watch for the right opportunity to complete their "set" of his artists. I visited his gallery, hoping for the chance to buy the right Joyce Wieland. I grabbed it in 1984, when I saw her thrilling painting, *Artist on Fire*. This self-portrait of a woman painting a masculine angel in a state of sexual excite-

ment concerns creative fire and sexual fire, her two great subjects. Isaacs even arranged a discount because the price, at $15,000, was too steep for us.

No doubt his ability to wait for the purchaser to come to him was due to the long years he had spent in the field: he had learned how to endure. Born in 1926 in North Winnipeg, he had come to Toronto as a young man, and worked first as an assistant in the Secord Animal Clinic on North Yonge street. Then in 1950 he had opened a framing and art supply shop on Hayter Street near Bay, in what passed for Toronto's artistic village. He gradually drifted in the direction of current, local art, hanging pictures on the supply-shop wall by students and recent graduates of the Ontario College of Art. Two of the friends he made were Coughtry and Snow, and they urged him to become a full-time dealer. After a two-month trip to Europe, mostly spent visiting museums, he opened the Isaacs Gallery in 1961 on Bay Street just below College. For the new space, with its gallery at the front and work-space at the back, Coughtry designed a chair, bench, table, and coffee table. Always conscious of the necessity for good design, Isaacs hired Irving Grossman as architect when he moved to his new location on Yonge Street. He retained the format he had developed: the visitor walked through the gallery to the dealer at the back. In 1987, he moved closer to the Art Gallery of Ontario, to John Street.

Barrie Hale liked Isaacs because he provided a sense of family. He was like a father or a mother, critic and artist alike could talk to him, and his advice was usually pragmatic. Isaacs revered the early twentieth-century dealer, Ambrose Vollard, and like him wished to be a tastemaker. Like Vollard, he even became a publisher (Vollard had backed Rouault's *Miserere* series). His gallery had a fast pace, with an ever-changing constellation of shows ranging from the with-it painters to wooden patterns from a bathroom fixture factory to Indian miniatures to folk art. His way of combining disparate but related worlds in a single show was without parallel in Toronto. In the autumn of 1977, he showed in one exhibition Baluchistan wedding jackets, woven serapes from Bolivia, a camel harness from Afghanistan, ikats (woven cloths) from Indonesia, Navajo woven rugs, African sculpture, and Quebec hooked rugs.

Opening, *Gordon Rayner Retrospective*, Robert McLaughlin Gallery, Oshawa, 1979
Graham Coughtry, Avrom Isaacs.

Gary Michael Dault doing the honours at the opening of *Painters Eleven in Retrospect* at the Robert McLaughlin Gallery, Oshawa, 1979. On the wall behind him hangs Harold Town's *The Fence*

Like Barrie, Isaacs had the *film noir* feeling that "you're dying while you're breathing." In his heart he had a deep sympathy for his errant youngsters, the artists, with their faintly disreputable lives. He believed that through art, he was working out problems, getting somewhere. He may have felt that the world of art had entrapped him, and he was trying to puzzle out his relationship with it. The variety of his shows provided a partial answer. Holubizky compares his gallery to the sixteenth-century cabinet of curiosities, the *Wunderkammern*, and both the dealer and his gallery were full of surprises, often revelations of his eclectic taste. Like Barrie, and perhaps like most of the artists in his stable, he was a loner. He wanted to take his audience to different places, then get them out again, but the journey was one they had to take

by themselves – after buying a work of art, of course. Unlike Barrie, he did not extend his work environment into his personal life. He left much of the anxiety caused by the system at work. Greg Curnoe talked him into buying a good bike, and he began to take cycling trips.

One of his great strengths as a dealer was his ability to assess individuals. His father had been in wholesale dry goods, and his first thought had been to be a salesman for his father. His second thought was to become a mechanical engineer; his third, to be a veterinarian. None of these ideas worked out, so he took political science and economics at the University of Toronto. His education gave him a sense of historical perspective. He developed a feeling for artists through a thorough study of their development over time. "You see an artist, you admire the work, you explore the artist. That's point one. Six months, a year later, when you get another body of work, you see that body of work and then you can analyse the artist's development from point A to point B, and make an assessment." Despite his philosophy, the selection process always boiled down to instinct. Like his artists, he cultivated the subconscious. "I swirl the thought around in the back of my skull."

Barrie Hale was not the only critic in thrall to the Isaacs. We were all in its debt: Fulford and I, and curators such as Dennis Reid, whose *A Concise History of Canadian Painting* (1973) was launched by a party at the gallery. But by 1993 Isaacs could say, "The younger generation does not seem to have heard of the Isaacs." The art community quickly forgets its pioneers. "Canadian art devours its young," said David Bolduc once. Its old, too.

Other critics on the scene were not so focused on a gallery as Barrie Hale. Sometimes they regarded their experience in a community as more crucial. The editor of *artscanada*, Anne Brodzky, had worked as education officer at the London Regional Art Gallery, and in the magazine, she often featured London artists such as Greg Curnoe and John Boyle. Gary Michael Dault, who had taught at the Ontario College of Art for five years, starting in 1970, wrote his best pieces for the *Toronto Star* from 1975 to 1980, about people of whom he was fond. These ranged from Barker Fairley, painter, poet, and friend of the Group of Seven, to former students such as Peter Hill, Brian Kipping, and John Scott.

Like Hale, Dault curated. As an artist himself, one who had made a late start, he felt he had a special ability in this area. His pictures were often on the exquisite side, collages and drawings and small formats, lyrical and full of light. John Bentley Mays referred to them as kin to journal-entries, and sometimes they were laden with language and allusions to the history of ideas. In his writing, too, he was accustomed to conveying his reflections. He had become an art critic, he said, because it was a useful smoke screen to put between himself and real art. His criticism tended to be less analytical than it was sensuous and poetic, full of invented words and, to some irate readers, "muzzy" thought. For him the act of reviewing was a department of literature, and his immensely readable prose was something that came up under his hands while he worked – as if it had a life of its own. In his talkative way, he was creating a roadmap through a universe wildly blooming with ideas and impressions. Like Fulford and Hale, he turned his hand to books: in 1981, *Barker Fairley Portraits* and in 1983, an essay on "The Alternate Eden" in *Visions: Canadian Art Since 1950*.

The essays in *Visions*, which investigated postwar art along five different paths, point to the reason writers from the world of journalism will probably continue to write books on Canadian art. Livelier than many a chronological survey on the same subject, the text generated ideas as much as it presented them. The foreword by the editors (Robert Bringhurst, Geoffrey James, Russell Keziere and Doris Shadbolt) mentioned that the jazz sextet was the model that came frequently to mind in connection with the way certain themes were shared and developed. Each writer should be able to blow his own horn by his own lights, they said, and each of them did. The result was a multi-faceted presentation of the tremendous variety of Canadian art during the period. Canadian art history was the winner.

What Is to Be Done?

<div align="center">◆⊰❀⊱◆</div>

When Leslie Fiedler analysed what was to be done in English literature in 1982, he talked of creating a new kind of criticism. To be truly new, however, such a criticism had to develop a new sensibility open to the popular arts. He advocated avoiding academic jargon, the hermetic codes which secular hierophants use to exclude the uninitiated. Criticism should be generalist, he said. The scenario is now a familiar one, and grassroots anti-hierarchical criticism is the mood of the day, at least in English studies.

Models of such studies also exist in Canadian art history; some of the longest-lived and liveliest ventures into non-elitist amateur criticism are the experimental artists' magazines, one of which was *Artists Review*. Founded in Toronto in 1977 by painter Milton Jewell in reaction to the purplish prose of the *Globe and Mail* art critic, James Purdie, and affiliated with Artists' Cooperative, Toronto, it provided a forum for certain admirers of Canadian art (many of them artists). It published, for a small, enthusiastic audience, interviews, reviews not yet up to the level of the newspapers or magazines – and, of course, naive criticism as well. Exhibitions might be described as "well worth seeing," "good," or "beautifully hung." "He makes good paintings – that's enough," wrote Jewell on Harold Klunder. Reviews sometimes ended with simple encouragement: "Keep reaching, Diane!" man-

aging editor Merike Kink concluded her review of a show of drawings by Diane Pugen in 1979. The result was eminently readable, particularly in the writing of Jewell or veteran artists such as Tom Hodgson. The magazine favoured artists writing about their own experience, such as Alex Cameron who in 1979 described his participation in the Daytona Motorcycle Classics.

One of the strengths of the *Review* was the way it satisfied the hunger of the growing Toronto art community for immediate feedback. Furthermore, criticism of artists by their peers (sculptors reviewed sculptors, painters painting) conveyed the excitement of the moment, at least to its impassioned, cohesive audience. The reviewers cared, though occasionally the friendships were a little close for criticism. "Does this mean you're calling off our camping trip this weekend?" Peter Blendell replied to a 1978 review of his work by Nancy Hazelgrove.

Later versions of the artists' forum continue today in Toronto in magazines such as *WorkSeen*, begun in 1989 (in 1992 its name was changed to *Artword*). Though most such journals prove ephemeral, it is still in existence, its contributors as smugly parochial as ever, which is to say, uninterested in critical methodologies invented in the last several years. Yet that this magazine for artists by artists has survived so long suggests that it fills a need: the publisher's note in the Winter 1994/1995 issue reminded readers that it was started by a group of working visual artists who believed that the voice of the artist had been lost to academics, curators, scholars, and critics. They wanted, and still want, plain talk about art. Interviews are at the heart of the magazine, and news about groups such as Art Terre in Quebec, which creates site-specific work in a rural area of the town of L'Ange-Gardien. (To view it, you must wander a one-kilometre trail through woods, fields, meadows, and over a stream.) Pages from artists' notebooks are reproduced, there are poems (often about artists) and personal narratives, about art teachers, exhibitions, any aspect of art. One section features diary entries from a debonair person-about-town, a frequenter of smart salons and avant-garde studios, as in the days of Manet.

This grassroots form of art criticism has a homely quality; its simple style makes the reader forget that the literary forms placed before him are well-known procedures of the field and have

aesthetic qualities of their own. Interviews may vary with the time of day, the season – and the interviewer's mood. Artists' notebooks have some validity as documents, but are highly subjective records. Yet the simplicity of these "rules" suggests a way of introducing Canadian art history into the hearts of the public.

Recasting such study as fiction is one of the traditional ways to enliven a subject: think of Joyce Wieland's movie *The Far Shore*, which re-created Tom Thomson as a freckle-faced, fair-haired hero who swam in the buff with Céline Lomez. The only trouble with this kind of information is that the public may prefer the essentially sentimental version it portrays of the artist's life, rooted as it is in a fantasy deeply implanted in our minds.

What we have to do is chip away at the myths, explore them for what they are, before we pass on to new monuments. The literature that had helped to make Thomson a heroic Natural Man, for instance, involved the writer Blodwen Davies. In 1935, she subtitled *A Study of Tom Thomson*, "The Story of a Man who looked for Beauty and for Truth in the Wilderness." She discussed the legend of Thomson as a woodsman but decided in the end to see him simply as a "positive man." Like many who explore material that strikes a chord, she became engrossed in her subject, and often called him a genius.

In the early 1930s, at the time she was writing her book, she was deeply involved in a love affair with a man who loved nature, a friend of the Group of Seven who went on painting trips with Jackson (and whose work looked like his; see p. 183), Dr. Frederick Banting. Banting's biographer, Michael Bliss, treats her harshly in his book *Banting: A Biography* (1984), saying that, "she was not particularly attractive physically, being prematurely white-haired and either willowy or droopy depending on who described her." He characterizes her as "a kind of original groupie to the Seven, the starry-eyed, innocent, vulnerable adorer." On the other hand, her friend Yvonne McKague Housser, in her letters to Isabel McLaughlin (Housser had been her teacher at the Ontario College of Art and remained a close personal friend), mentions her energy and helpfulness. Blodwen had a little house near Markham, where Yvonne lived, and they liked to share holidays, days which might otherwise have been lonely (for Housser too was alone), such as Christmas. In 1943 they opened Christmas stockings together,

Housser wrote McLaughlin, and McLaughlin recalls Blodwen as short and plumpish but nice-looking and with a sense of humour. Bliss thinks she may have met Banting while researching her biography of Thomson. She asked his advice, as a doctor, on the medical evidence surrounding Thomson's mysterious death, but Bliss also heard another version of their meeting that suggested Jackson referred Banting to Blodwen for advice about writing.

However they met, what is clear is how much in love Blodwen was with Banting. In her poem about him, which she titled "Music where there was no music before," she wrote about the ways in which he had spoken to her of his dreams. Banting and Thomson may have seemed somewhat alike to her: they had the same kind of pragmatism, and even shared certain habits, such as their laconic conversational style. Banting, said Jackson, was dour, and we know Thomson said very little, especially outside the family circle. Distance and reserve were part of his character. In writing about Thomson, she expressed her heartsickness over Banting — Fred, it appears, had promised to marry her after the scandal of his divorce in 1932, but the marriage never took place. Thomson, of course, was no more a natural man, a man at one with nature, than any urban dweller with a love of the outdoors. His father and grandfather before him had been avid fishermen and hunters, and he knew how to hunt and fish. He had learned how to cook and made an excellent camp cook, but canoeing was something he had to be taught. One friend, Mark Robinson, recalled that he had to help Thomson beach a canoe in a storm, and Thomson whispered to him not to let on that he didn't know about canoeing. He didn't want his friends, the painters, to find out. He learned quickly enough, in any case.

Yet a natural man is our wish-fulfilment fantasy in our national epic, the story in which Canadians are peace-makers and the country a model for a culture where different races live together in peace. Consequently, the politics implicit in the myth of Thomson are still at work in Canadian art history, ploughing all before them so that artists today are still going out into nature on the assumption that the activity is a way of confronting what makes a uniquely Canadian artist.

"I never lose a sunrise," Thomson said. The meaning of his words includes a reference not only to the way he liked to fish at

dawn, but to the way he took the opportunity to see or paint a sunrise, perhaps because he had never before known sunrises such as the ones in Algonquin Park. He may have been a newcomer to the ways of nature and art, but he was a quick study. In a way, so were and are the host of artists who followed him, all of whom yearned towards a way of persuading history to run backwards.

Whatever the ideological arguments of our nature painters, it seems evident to me that at the deepest psychic levels such artists are moved by an irrational fear of today's complex world, a desire to avoid painful issues, which they assume to be inevitable once they face up to reality. In their attitude, they may not be unlike Thomson himself who, we sense from his art, viewed Algonquin Park as a refuge from the painful reality of the First World War.

Since the 1940s in Canadian art, artists have been on their way to creating another inadvertent epic, though this one is the other side of the coin — that of the trip out of the country. For most, this means going to New York. Many of the early modernists in Canada looked to American artists as spiritual allies and mentors, and to American exhibitions, particularly those of the Museum of Modern Art, as beacons of what art should be in the future, their future. What they brought back, inevitably, was generalized and incomplete. A case in point occurred with William Ronald himself, founder of Painters Eleven, and the one who would have been voted by most of the members as "most likely to succeed."

Even before he went to New York, he was influenced by Jackson Pollock's dribbled and scrawled surfaces, and loose dripping brushwork, and by the strong shapes of Franz Kline; with them in mind, he created paintings such as *Before the Snow,* the work which he showed in the 1953 *Abstracts at Home* exhibition in Simpson's department store that served as the seed for the founding of Painters Eleven. He also loved the work of Bradley Walker Tomlin with its calligraphy and all-over hieroglyphic surfaces — "Zen," was the word he used to describe him. Helen Frankenthaler, Clyfford Still and Mark Rothko also figured in the pantheon of artists he mentioned later as those he admired. Yet the crucial figure for him was Willem de Kooning, especially his black-and-white abstractions, which he had first seen reproduced in the pages of *Life* magazine. Like most emerging artists of the period, he regarded the real competition as de Kooning, and when he

finally saw his paintings in the flesh, he swallowed their technique whole, appropriating their fragmented composition and explosive look, the sketchy unfinished quality in which paint is dragged on part of the surface, dripped on others, the richly textured layering. He described de Kooning as a very infectious painter as though from him he could catch a disease, and he caught the organic quality of his images with their references to human anatomy, though as his own subject-matter, he preferred to develop more of a central image. From about 1955, the time he first used it, he made it the *leitmotif* of his work. His result had a poetic quality, especially in his best work, such as *J'accuse* of 1956. His large central forms, such as heads, carcasses of animals, or bodies, reinforced his psychological improvisations, and the spontaneous way he liked to paint. Such painting seemed to embody the artist's inner being and thus to be in a sense, existential. Ronald acknowledged the philosophic debt. "Man's painting," he wrote, "reflects the vital, exploratory, restless, reflective reinterpretation of his own meaning in the world." He was always searching, he said. Painting, he believed, was a form of discovery and exploration; the Group of Seven before him had known it, as had Alexandra Luke. American art history had heard the same story from its early painters and its moderns.

Today artists are still on their way to New York, if not in the flesh, then in their hearts. Getting a U.S. green card is as big a problem for some as figuring out what to do in their work. Richard Sturm, a Buffalonian by birth, came to Canada from the United States in 1968; now he's trying to go back. In between he has pursued an extensive painting career, showing at the Isaacs in Toronto in 1979, as well as at the Art Gallery of Peterborough, in Oshawa, and at the Anderson Gallery in Buffalo. The paintings in the Toronto show were images of chain-link fences, not a novel conception, but the work itself looked original. He approached a chain fence as a grid structure which focused the image lying behind it, often an industrial building. In time, he concentrated more on the interstices of the fence itself, pushing shapes to reveal themselves for what they held within and letting the grid dissolve towards the study of optics, to light itself. Gradually his work acquired a shimmering surface; dots began to fall all around. Viewers felt as though they were in forests of confetti, digging

through a dazzling underbrush of light and air, to discover the edge of a truck on the sunny side of a street, buildings and computer parts, and then as time passed, creatures from the deep (in the *Oceania* series), and today, interior spaces. As he developed his visual insights, he honoured painters such as Jackson Pollock, Mark Tobey, Larry Poons.

The direction of Sturm's art differed from that of his peers. It stems from a different time-zone and maturation point. He is a late bloomer. The sense of seizing the day gives his work an ebullience, an optimism, a sunny warmth. His paintings have the brilliance of Byzantine mosaics, an effect that is highlighted by the three-dimensional quality of his surfaces. Underneath his surface layer, another layer of colour seemingly moves, suggesting that his story is an unfolding one. In their joyous visual rhythm and mysterious depth too, his paintings recall mosaics.

Sturm expresses his insights into colour through a number of literary and philosophic figures who form the background to his art: among them are Charles Olson, Martin Heidegger, and Ludwig Wittgenstein. "First, we shall think Being in order to think itself into its own element," wrote Heidegger. Sturm cherishes Olson's remark, "There are only eyes in all heads, to be looked out of." And he is painting chance, the principle of randomness, using chaos theory in the application of his dots, and observing (as Olson suggested) "the success of accident." Such ideas are alien to, yet somehow sympathetic to, his Canadian self. In the catalogue to his 1994 retrospective at the Oshawa gallery at one point, Sturm wrote, "Sometimes a hand or a phrase reaches out and pulls you back on track."

His track is pointed towards New York, but as he moves towards making his dream a reality, he has built a summer studio a hundred kilometres north of Peterborough, in the Kawarthas. In a sense, he has appropriated an earlier dream of Canadian art – the land as refuge. For him, the dream is less about a closed-off area of national park than about the whole country. To his mind, Canada is the garden to which he will be perpetually going back even while he is planning and scheming how best to get away.

When I began my account, I wrote about Sybille Pantazzi in the library of the Art Gallery of Ontario, inveighing against Canadian art history. "You call this a history?" she said, but it was

to people like me that she spoke, and we knew we were the future.

At the same time as Sybille ruled in the library, there were others who would help to form that history with which I was to become so deeply involved. Some of them were there with me at the gallery: Alex Cameron worked as a preparator (he got fired in 1972), and Richard Sturm was the slide projectionist and general

Richard Sturm photographing art classes from the roof of the Art Gallery of Ontario, 1969

assistant in the education department from 1968 to 1969. Cameron and Sturm were artists even when they worked at the AGO. Their careers grew, in time, to the appropriate dimensions for me to organize their retrospectives.

So while Sybille was carrying on about how the study of Canadian art lacked science, lacked rigour, lacked inspiration, moles lurked in her very own gallery, a little distant perhaps from the library – down the hall or in the basement – but nevertheless they were there. I like to visualize the old Art Gallery of Ontario that way, as a burrow with tunnelling creatures. Yet all the time, I felt instinctively, the artists were there, too – maybe up on the roof, like Sturm, who one day climbed onto the top of the building to photograph children's art classes. We curators believed that soon, with the growth of Canadian art history, we would catch up with him and the other artists who were up on the roof, out in the woods, or lost in the cities, making art.

Index

Note: See page 223 for list of works reproduced in this book.

List of Illustrated Works of Art

List of Figures